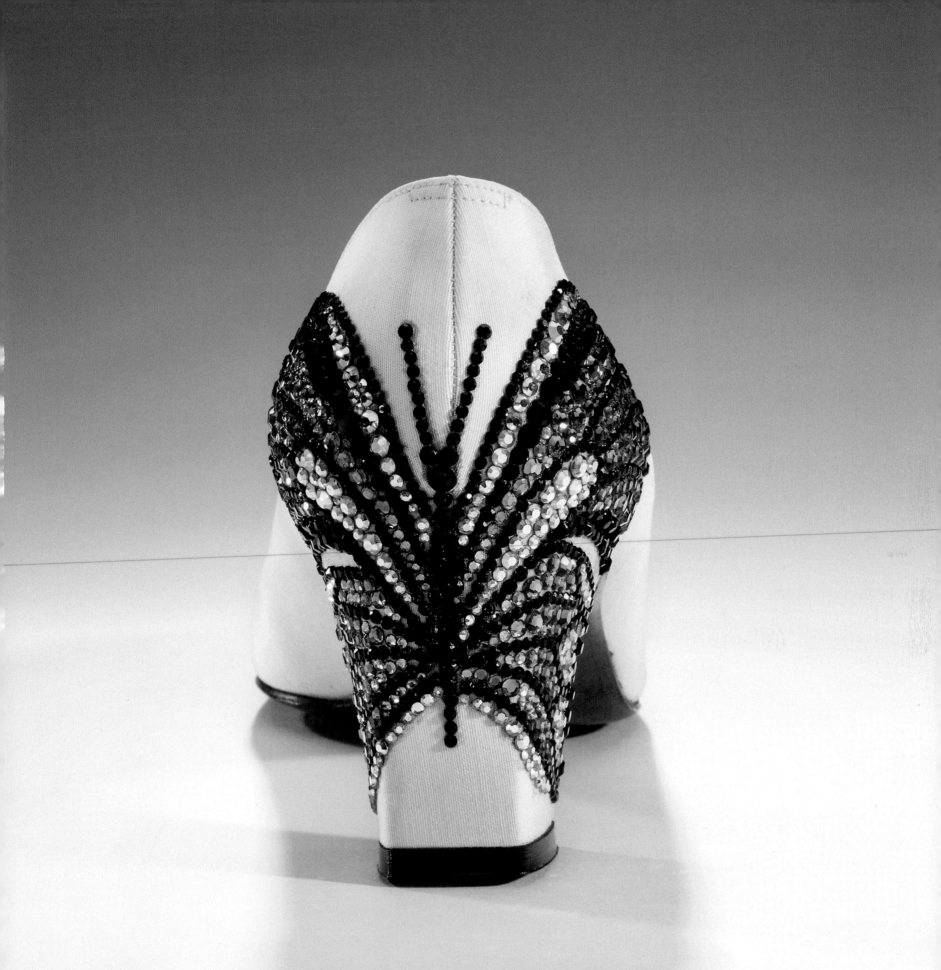

The WORLD at YOUR FEET

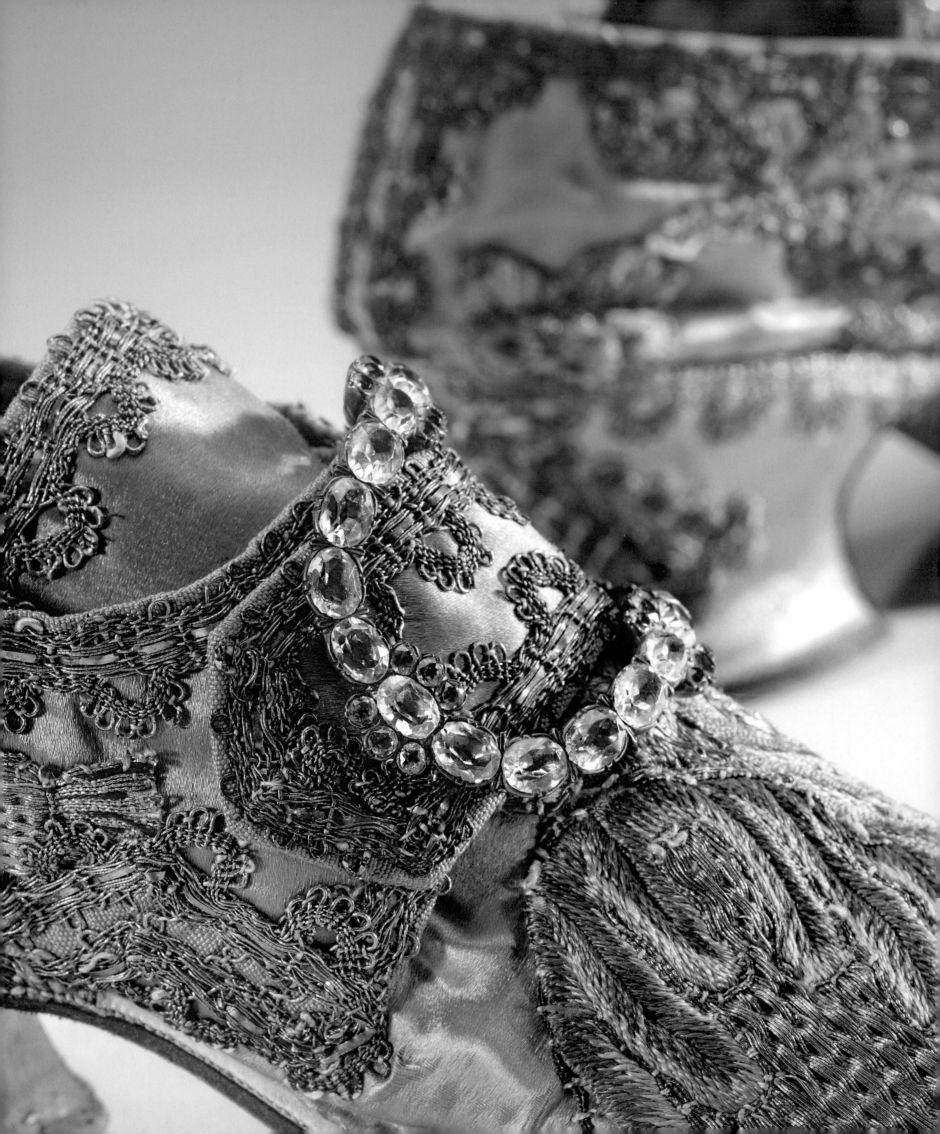

The WORLD at YOUR FEET

BATA SHOE MUSEUM

ELIZABETH SEMMELHACK

PHOTOGRAPHY BY RON WOOD

Rizzoli **Electa**

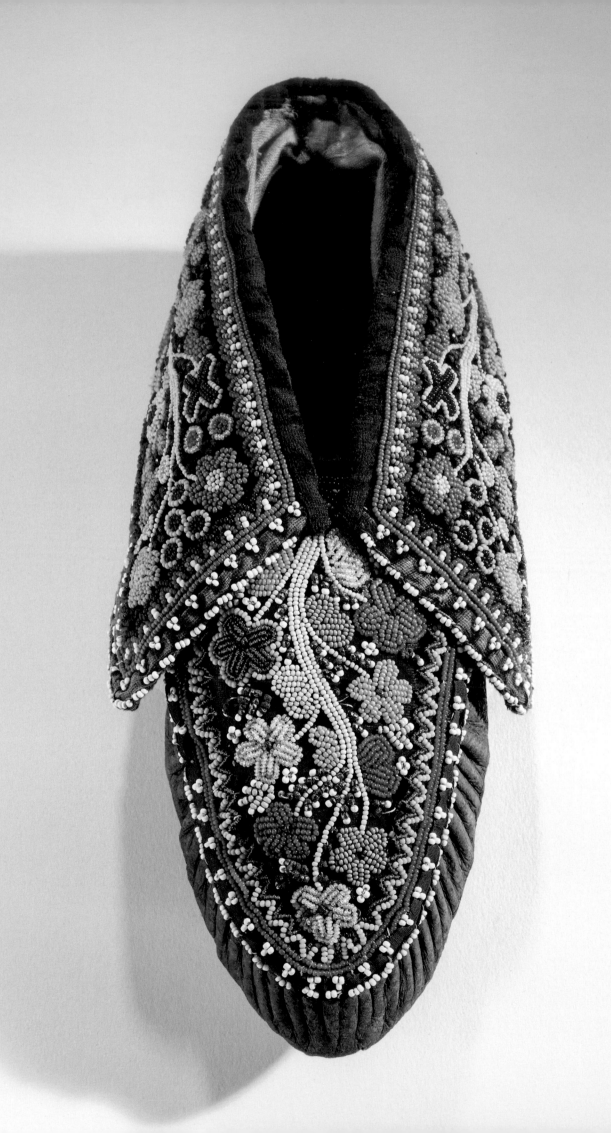

contents

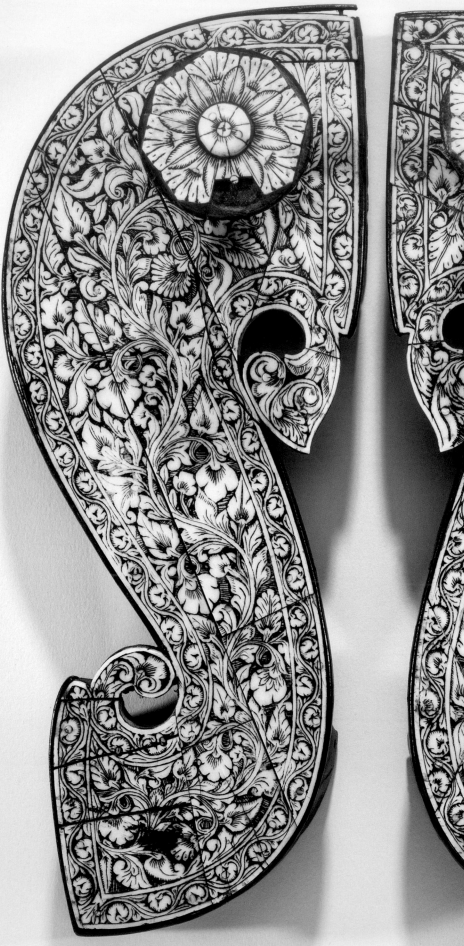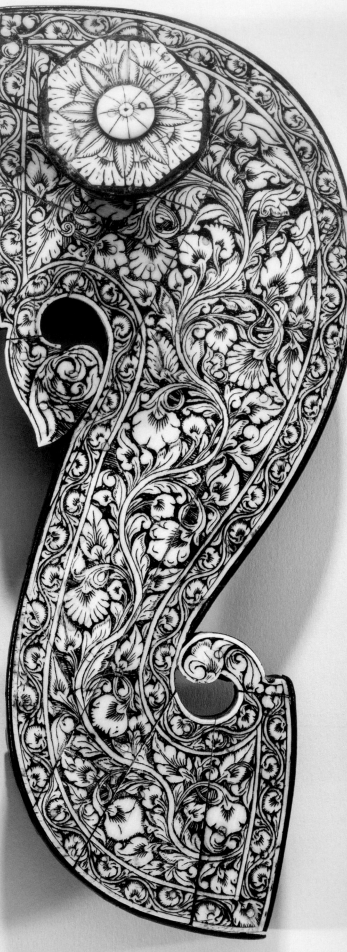

foreword

CHRISTINE BATA SCHMIDT, CHAIR

As Sonja Bata's daughter, I grew up in a home where the prized possessions, beautifully displayed on the shelves in our front hall, were shoes. No ordinary footwear, these were exquisite platform sandals from India with delightful jingling bells; intricately carved silver stirrups and spurs from Chile that fascinated us as children, as we could imagine the gauchos galloping across the pampas wearing them; accordion boots from Czechoslovakia that almost danced the polka by themselves; as well as a collection of whimsical shoe-shaped snuffboxes.

Why shoes? As my mother would simply respond, "I married a shoe man." When she was nineteen, she and my father, Thomas Bata, embarked on an extraordinary sixty-year partnership that took them around the world, expanding the Bata Shoe Organization. She was not an anthropologist, but her design background and innate curiosity led to a fascination with the uniqueness of each culture she encountered, its history, and how this was expressed through the footwear she began to collect.

Traveling with my mother on business trips was the most exciting thing in the world. She always found time in her hectic schedule to dive into the local markets. Talking to the stall owners would inevitably lead to someone who knew someone who had a fabulously interesting pair of shoes. More often than not, we would end up in their homes while they taught us about their treasures and their lives. For one of the museum's first exhibitions, *The Spirit of Siberia*, we spent an unforgettable week in Saint Petersburg shortly after the Soviet Union collapsed. We were visiting with professors Jill Oakes and Rick Riewe of the University of Manitoba, who had made field trips on behalf of the museum to study and collect footwear made by nomadic peoples across Siberia, from the Nenet to the Chukchi. We met with curators from the Russian Museum of Ethnography both to deepen our research knowledge and to persuade them to lend us artifacts that had never before left Russia. Undaunted by the complexities of post-Soviet bureaucracy, my mother succeeded.

Sonja Bata was an extraordinary, multifaceted person who never did anything halfway. Once she had decided to create a museum to share the stories of the collection, she hired the best team to assist with the research and conservation and set out to create the most exciting exhibitions in a jewel of a building designed by Raymond Moriyama. She reveled in superb craftsmanship and helped open our minds to an understanding and appreciation of cultural and historic differences. She rejoiced in these differences, regardless of whether they were found in a pair of minimalist sandals from ancient Egypt, exquisitely opulent eighteenth-century brocade mules, or sneakers made with cutting-edge technology. Her passion was contagious and her dedication to excellence was inspiring. This book, which features a carefully chosen selection of shoes, celebrates the outstanding collection she created and the twenty-fifth anniversary of the museum she founded.

OPPOSITE *Paduka, or toe-knob sandals, India, 1775–1825.*

introduction

*The mission of the museum
is to illuminate human
history and culture through shoes.*

—SONJA BATA

From a global obsession with sneakers to the complicated politics of the high heel, footwear has increasingly become the focus of significant cultural commentary. While this attention to shoes may seem like a recent development, footwear has been a key feature of dress around the world for millennia and has been used to express a wide range of social ideas, including those regarding gender and status. Since the inception of the Bata Shoe Museum in 1995, its mission has been to explore and illuminate these multifaceted histories of culture and society through footwear. Shoes bring us into startlingly close proximity with people from distant times and places and are a surprisingly effective entry point into an understanding of the economics, politics, and values of the societies in which they were made and worn, revealing sometimes elusive or overlooked characteristics of a culture.

FIRST STEPS

In 1946, at the age of nineteen, Swiss native Sonja Ingrid Wettstein married Czech-born Thomas J. Bata and joined him in Canada, where he had moved in 1939, just as the Second World War began, to re-establish his father's shoe manufacturing empire. The nationalization of Bata's Czechoslovakia holdings under Communist rule, after World War II, allowed the Batas to focus on the company's wide-ranging international manufacturing and distribution channels outside of Europe. As part of this undertaking, Sonja Bata traveled the world with her husband, which sparked a fascination with the incredible diversity of footwear she discovered in the cultures she was

exposed to. Her first collecting efforts consisted of acquiring examples of local footwear to serve as inspiration for Bata shoe designers, but as her collection grew, she became increasingly interested in footwear items as cultural objects. She was intrigued by their many facets, from how they were made to how they were worn. As a result, she decided to shift her focus. While she continued to collect contemporary footwear from diverse regions and cultures, she also began to collect historical examples seriously. By 1979 her holdings numbered in the thousands, and the Bata Shoe Museum Foundation was established as an independent entity committed to sponsoring field research and publishing findings.

BUILDING A MUSEUM

In the mid-1980s, Sonja Bata decided to build a museum in the heart of downtown Toronto dedicated to telling the stories of humanity through footwear. Her deep appreciation of architecture and her vision for the museum called for a bold approach, so she turned to acclaimed Canadian architect Raymond Moriyama and commissioned him to create a "small gem of a museum." Moriyama was intrigued by the idea of a museum dedicated to footwear, and he decided to model the new building on the shape of a shoebox. He continued the theme throughout the building, incorporating many subtle footwear-referencing details that spoke to the purpose of the building. The building is clad in a warm fine-textured

OPPOSITE *Sonja Bata, 1966. Photo by Roloff Beny: Library and Archive, Canada.*

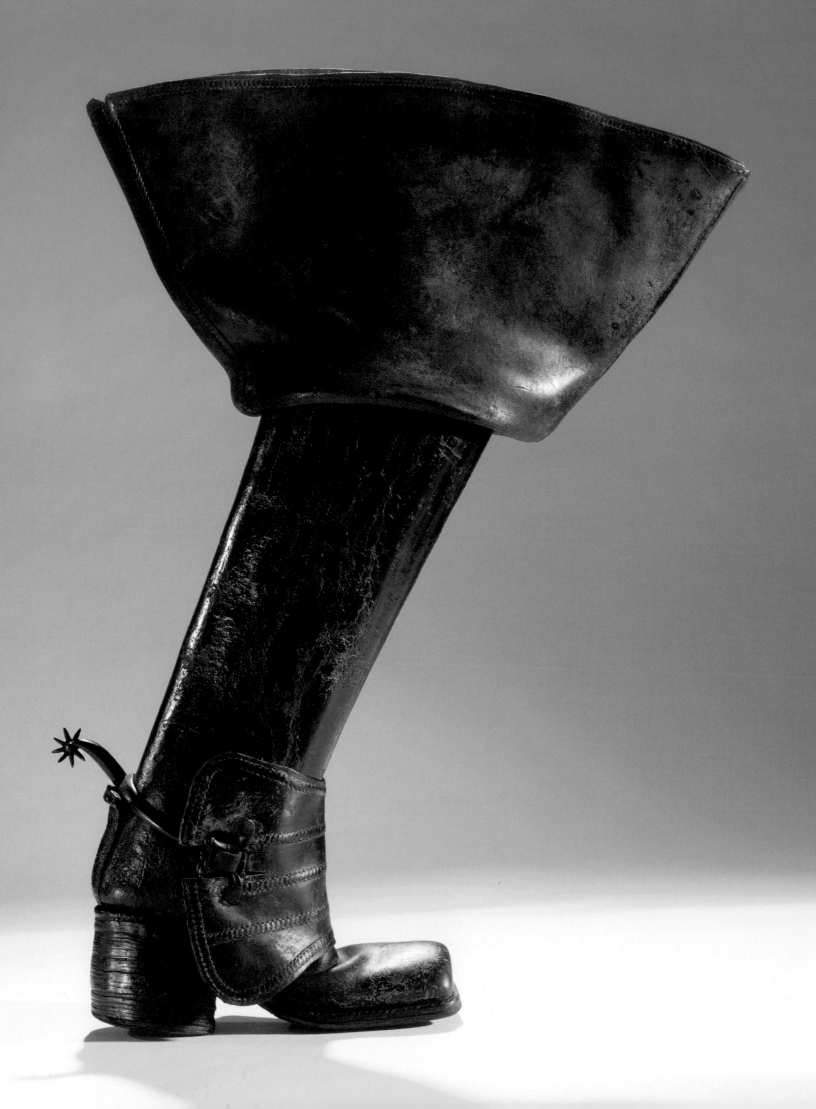

limestone that was chosen for its resemblance to leather, and the impressive floating staircase that cuts through the open atrium features holes punched into the risers, allowing visitors to see the shoes of those using the stairs.

When the museum opened on May 6, 1995, it attracted a great deal of curiosity, as it was the only shoe museum in North America and one of only a small number worldwide. At that time, there had been little formal research on the subject of footwear, but over the years, the museum's reputation as a center for scholarship and insight has grown, and it continues to expand today. In the years since the museum's opening the collection has also grown, and today it includes more than 14,000 shoes and footwear-related artifacts spanning 4,500 years of history. This extraordinary collection allows the museum to mount innovative and original exhibitions regularly, publish widely, and develop engaging educational programs.

THE SHOES

The shoes themselves have entered the collection in a variety of ways. Field research has permitted the museum to collect contemporary examples of footwear made by living designers and artisans as part of the study and documentation of shoemaking processes. Auction houses and dealers are another major source of rare historical artifacts, and generous private donations of footwear and footwear-related artifacts and documents are yet another extremely important means of growing the collection.

Field research was an especially great source of pride for Sonja Bata, who appreciated that it brought to the collection not only new artifacts, but also significant primary research and cultural context seldom attached to museum artifacts. By working directly with contemporary makers, she challenged the misconception that some cultures are "timeless" and isolated from both internal cycles of fashion and cross-cultural influences. Museum-sponsored research has included trips to all the circumpolar regions of the world, including Greenland, Canada, the United States, Russia, and Sápmi, the homeland of the Sámi people, which stretches across northern Scandinavia from Norway to Russia. With each field trip to the Arctic regions, the holdings have grown, and the museum now houses the largest collection of circumpolar footwear in the world.

OPPOSITE *English, c. 1700.*

Research funded by the foundation has also been conducted in Nepal to document traditional boot-making by the Tibetan diaspora; in India to study *jutti* and *chappal* making; and in Mongolia to study the making of *gutal.* Additional research has also been undertaken in Europe and the United States to study many areas, including the impact of the industrialization of shoe manufacturing on workers and consumers in the nineteenth century; the work of designer Roger Vivier in France; the introduction of the heel into Western fashion in Hungary and Austria; and contemporary sneaker culture in the United States and Europe. The museum collection itself is also the focus of constant study and research.

All objects that enter the museum collection are cared for assiduously. Their condition is assessed and they are conserved before being secured in specially designed artifact storage rooms. The museum is privileged to have a senior conservator who is arguably unrivaled in the conservation of historic footwear. It is the policy and practice of the Bata Shoe Museum to carefully and ethically conserve artifacts rather than to "restore" them, an activity that can remove evidence of use. The museum is interested in the information that can be gleaned from the traces left by the wearer along with evidence of the environment through which the person walked. These details can be as important to the historian and researcher as the materials and construction of the shoe itself. An unusual and popular feature of the museum's conservation lab is a set of long glass windows that permits visitors to watch as footwear is being conserved.

EXHIBITING FOOTWEAR

With less than 3 to 4 percent of the collection on view at any given time, changing exhibitions are an important way of showing the breadth of the collection, as well as a means of engaging the audience with new questions. Architect Moriyama designed three special exhibition galleries, each of which is a "blank box," allowing the gallery interiors to be reimagined and transformed for each new show. In just over two decades, the research and collecting on behalf of the museum have led to a schedule of ambitious original exhibitions, many of which have been the first in the world dedicated to specific types of shoes. Notable among these are *Our Boots: An Inuit Woman's Art* (1995), which focused on Canadian Inuit women's artistry and skill (pages 216–17); *Every Step a Lotus: Shoes in the Lives of Chinese Women from Late*

Imperial China (2001), which reconsidered the role of foot-binding in imperial China; *Heights of Fashion: A History of the Elevated Foot* (2001), the first exhibition on the history of the high heel; and *On a Pedestal: Renaissance Chopines to Baroque Heels* (2009), the first exhibition on the history of the Renaissance chopine (pages 60–61). Other innovative exhibitions include: *Out of the Box: The Rise of Sneaker Culture* (2013); *Fashion Victims: The Pleasures and Perils of Dress in the Nineteenth Century* (2014); *Standing Tall: The Curious History of Men in Heels* (2015); and *The Great Divide: Eighteenth-Century Footwear and the Enlightenment* (2019).

Over the years, these exhibitions and their companion publications have demonstrated that footwear offers a fascinating and often surprisingly illuminating means of stepping into cultures both past and present. Because shoes are designed to meet the cultural desires of the moment in which they are made, they not only capture the material and technological aspects of those times, but also document the tastes, aspirations, and assumptions held by a people in a given moment or place. Because visitors already have a direct and personal understanding of footwear, these insights into different periods and perspectives are relevant to them. They can also lead to revelations when long-standing assumptions are challenged. The museum is dedicated to expressly encouraging visitors to consider how their own footwear choices reflect the larger social structures in which they live.

THE FUTURE

What started as a small private collection has been transformed into an internationally celebrated museum with a spectacular collection of footwear and a twenty-five-year history of supporting wide-ranging original research. With her eye on the future, Sonja Bata ensured that the museum would continue to flourish after she passed away. Not only is the collection growing, but the museum's reach continues to expand through an ever-increasing number of publications and exhibitions, as well as engaging public programs and an online presence.

This book, published in honor of the Bata Shoe Museum's twenty-fifth anniversary, offers a glimpse into this remarkable collection. Sonja Bata's dedication to scholarship was matched only by her deep appreciation for the beauty of the footwear she collected. We share with you many of her (and our) favorites in the pages that follow.

OPPOSITE *The exhibition* On a Pedestal: Renaissance Chopines to Baroque Heels *at the Bata Shoe Museum, 2009.*

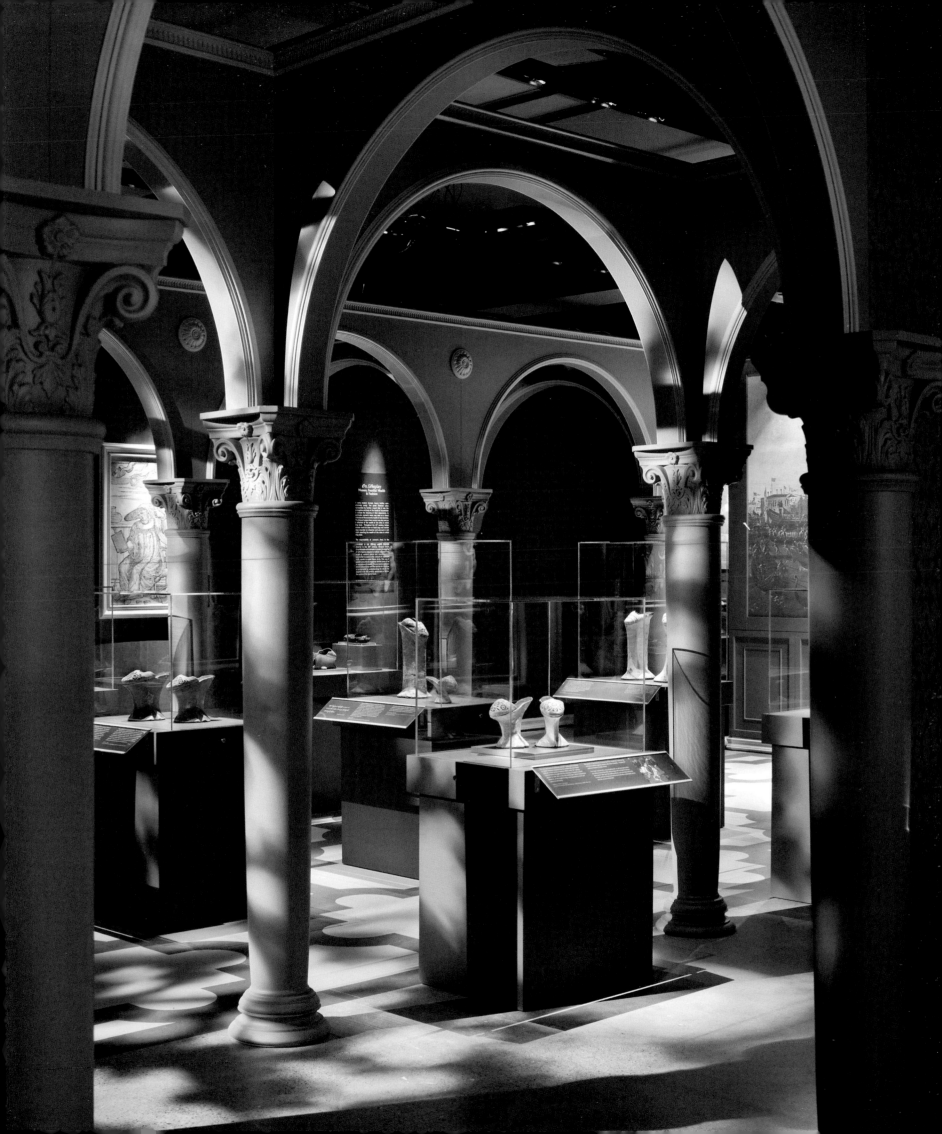

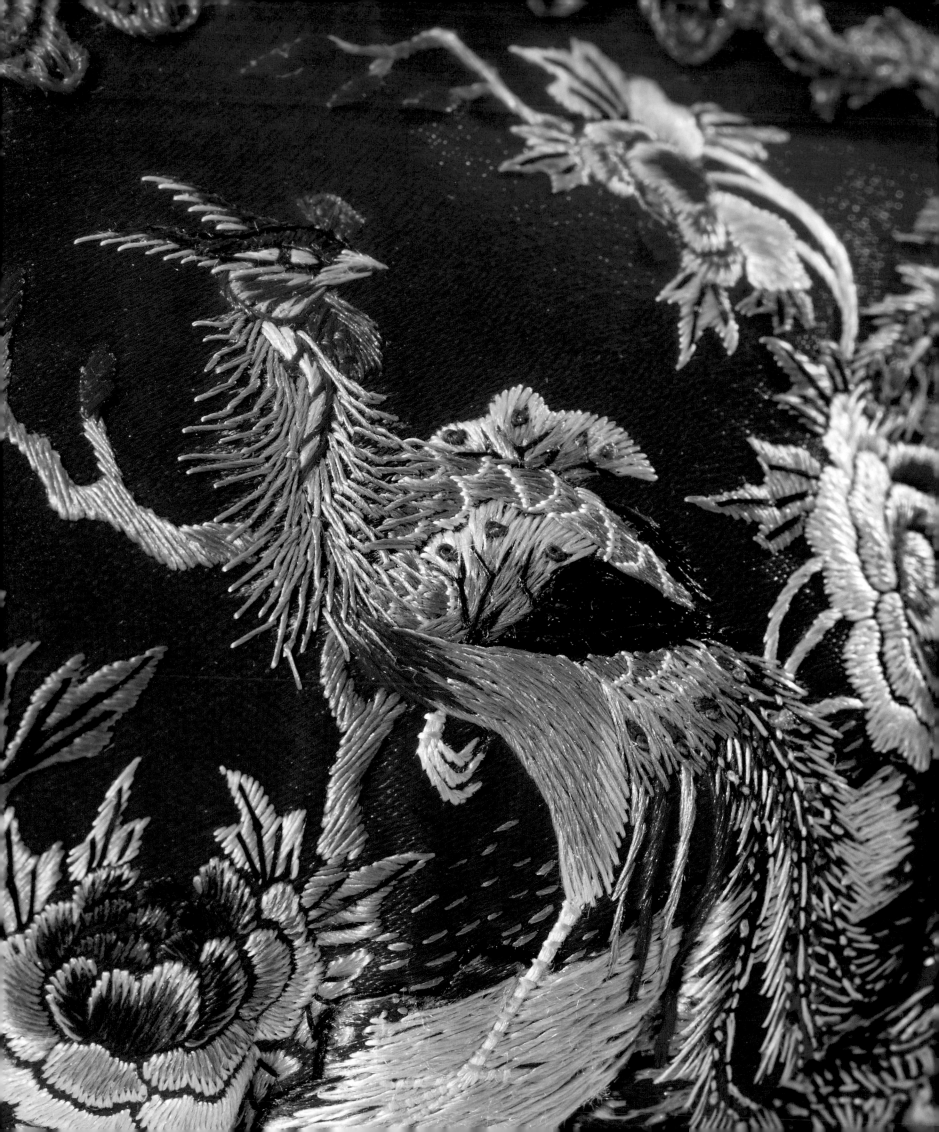

red

This pair of red suede ankle boots was made for the Canadian department store Eaton's in the late 1920s or early 1930s. Boots that closely hugged the contours of the lower leg were popular in women's fashion from the nineteenth century well into the twentieth, but after hemlines rose in the 1920s, leg-concealing boots fell out of favor. The designer of this pair seemed determined to make the boots conform to a new aesthetic by folding the boot shafts back on themselves to increase visibility of the lower leg and by using gilded kid to frame the leg. From the gilded heels to the Art Deco–inspired bow, this pair is a feast for the eyes.

CANADIAN · LATE 1920s

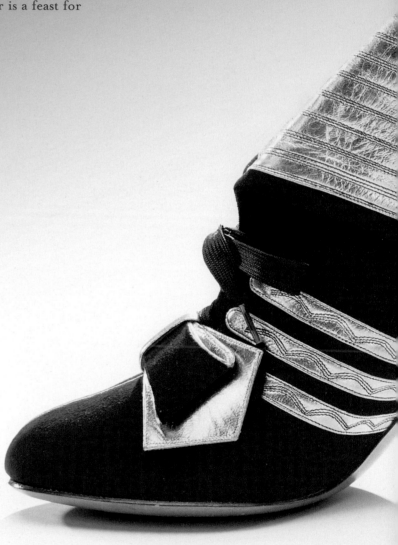

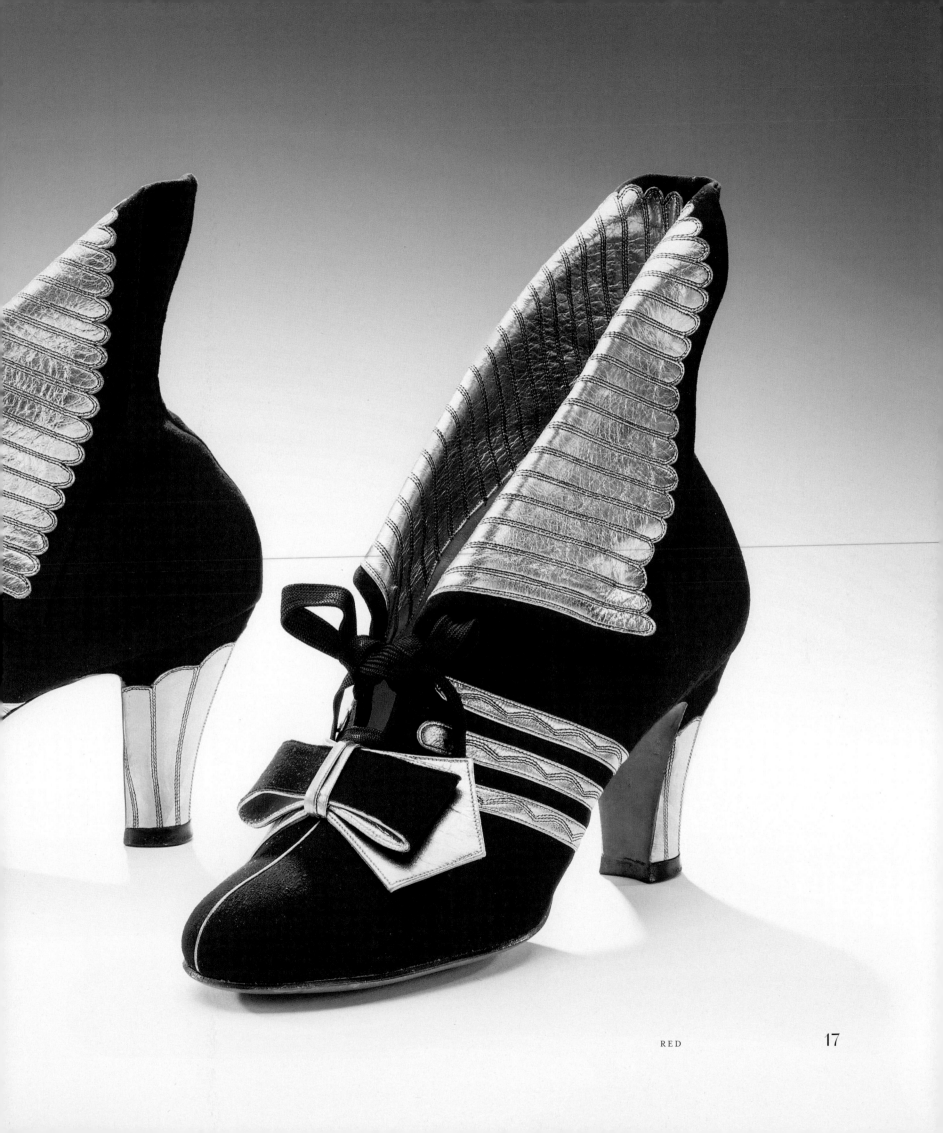

he use of bright red silk embellished with intricately embroidered symbols suggests that this pair of Manchu *mati* was associated with marriage. In China, red is an auspicious color and brides have worn the color on their wedding day for centuries. Likewise, the phoenix, a traditional symbol of empresses in China, was commonly used to decorate the bridal attire of Manchu brides, while the mandarin ducks depicted swimming among the lotus blossoms conveyed messages of fidelity and fertility. While the color and motifs of these high pedestal shoes reflected long-standing Chinese traditions, the structure of these shoes may have been inspired by "exotic" platform chopines (pages 60–61), which were introduced by Europeans in the sixteenth and seventeenth centuries.

MANCHU · LATE 19TH CENTURY

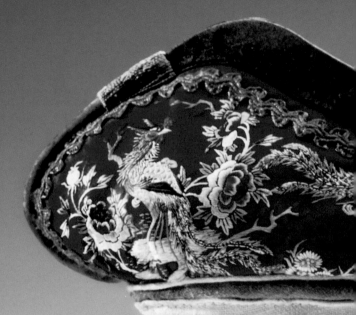

THE WORLD AT YOUR FEET

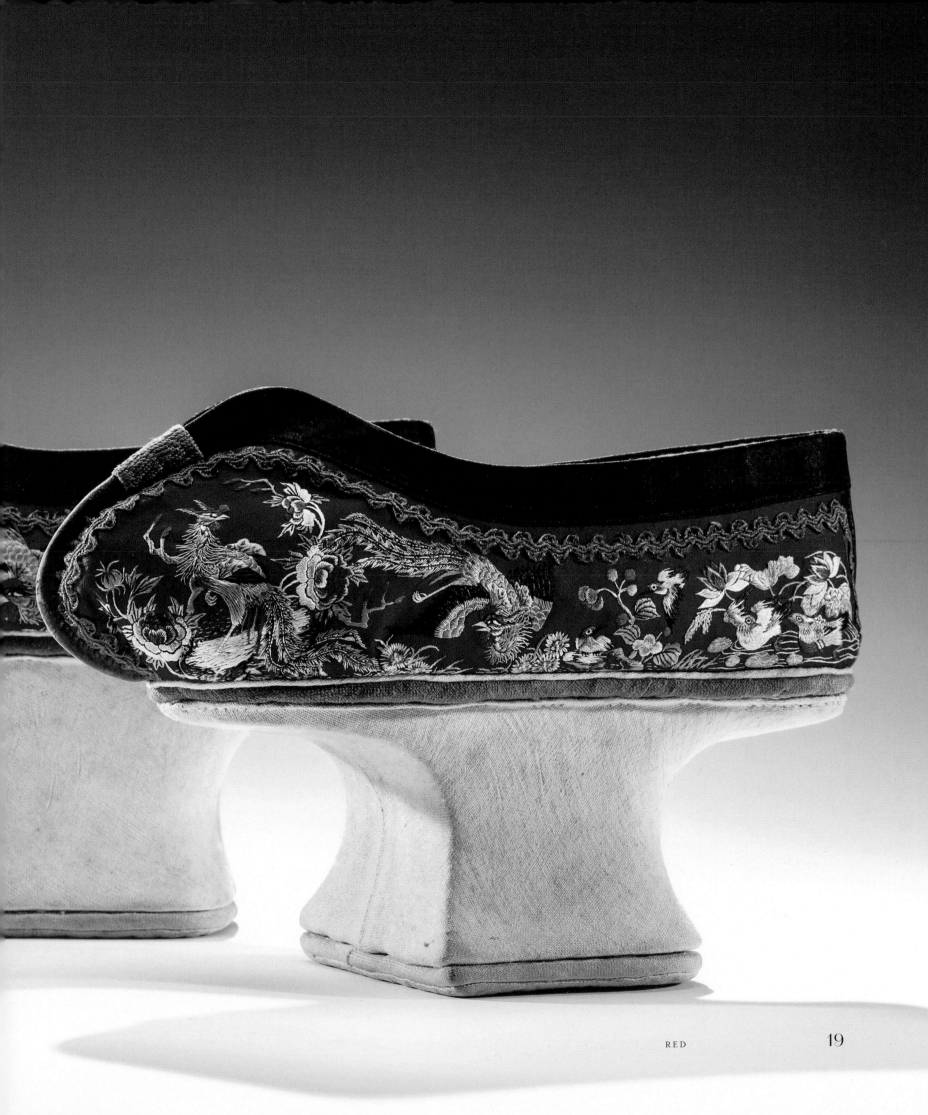

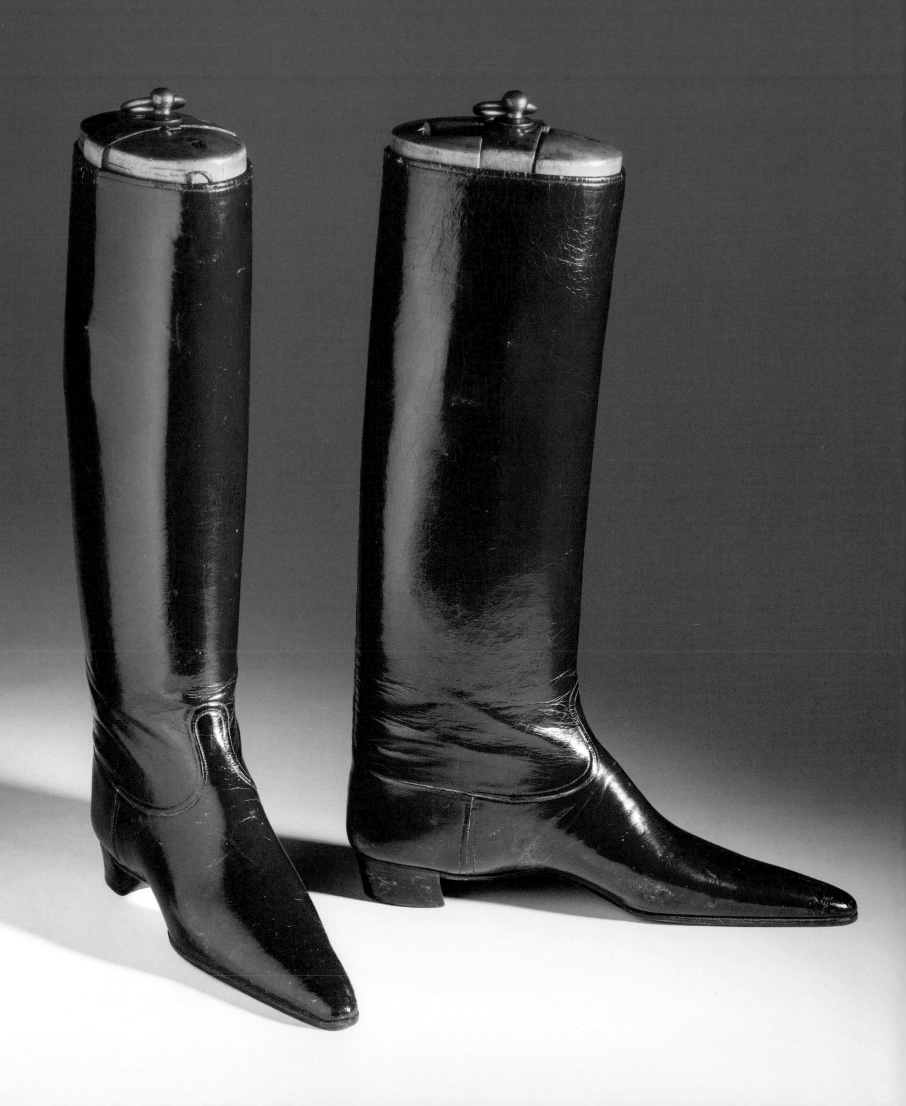

On his head he wore a tall black hat,
supernatural in its glossy shine, and his
large feet were encased in a pair of highly-
polished boots, so much too tight for him.

—LILLIE DEVEREUX BLAKE, *FETTERED FOR LIFE,*
OR, LORD AND MASTER: A STORY OF TODAY, 1874

Modern conceptions of nineteenth-century Western fashion often focus on images of women in tight corsets and hobbling heels, but much of men's clothing of the era was very restricting as well. Fashionable men's boots were especially notable for the tight cylinders of highly polished leather that encased the calf, not only suggesting male vanity but serving as a reminder that the nineteenth century was an age of military imperialism and conquest. This pair of boots is said to have belonged to the *grand écuyer* (the person in charge of the royal stables) under Napoleon III. Despite his high station, we can imagine he certainly experienced discomfort wearing these fashionably slender boots.

FRENCH · LATE 19TH CENTURY

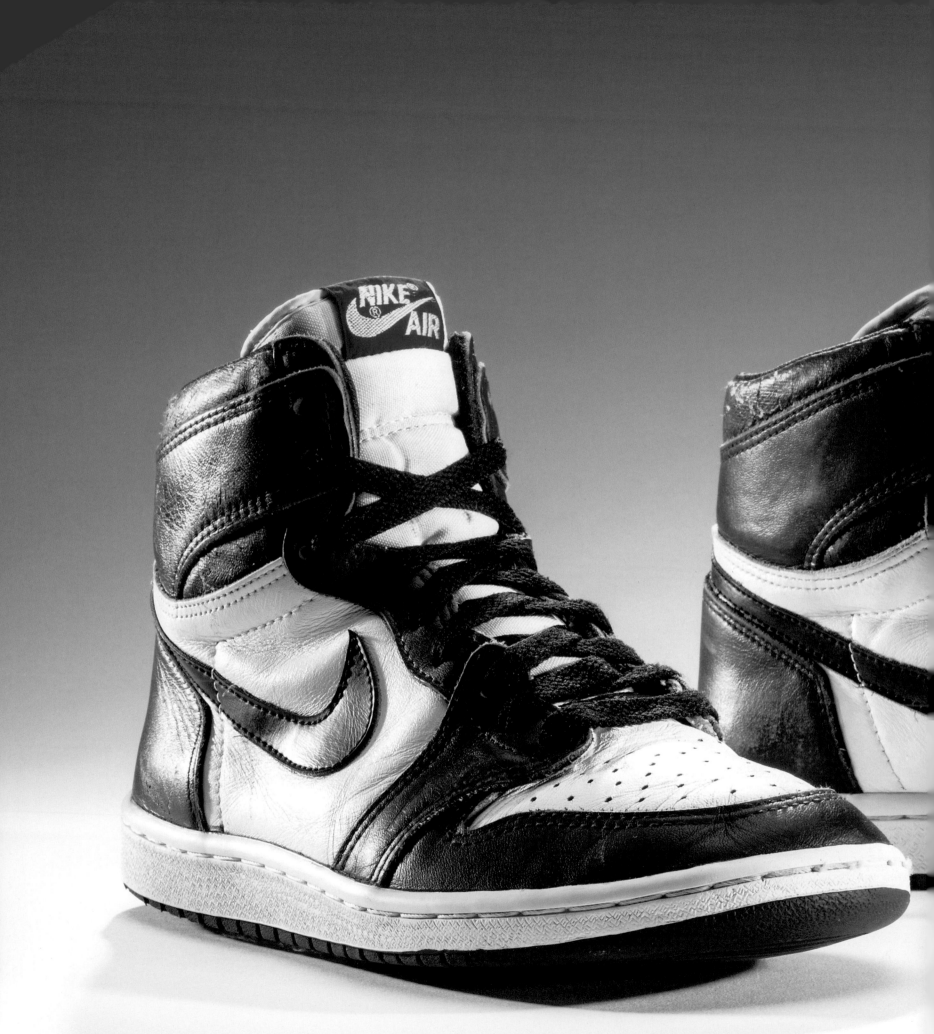

THE WORLD AT YOUR FEET

n 1984, young Chicago Bulls rookie Michael Jordan signed with Nike to create a line of signature sneakers. Jordan's first shoe, now known as the Air Jordan I, went on to become an icon of sneaker culture. Original examples from 1985 are extremely rare, and this treasured pair was donated to the Bata Shoe Museum in 2018. The original Air Jordan was designed by Peter Moore. A widely told story is that when Michael Jordan wore a prototype version of the sneaker at the start of the 1984 basketball season, he was reprimanded by the NBA and threatened with fines for not conforming to the "uniformity of uniforms rule." Nike saw an opportunity and ran commercials reminding customers that "On October 15, Nike created a revolutionary new basketball shoe. On October 18, the NBA threw them out of the game. Fortunately, the NBA can't keep you from wearing them." These associations with rebellion, determination, and phenomenal achievement remain central to the appeal of the sneaker decades after its debut.

AMERICAN · DESIGNED BY PETER MOORE FOR NIKE · 1985 · GIFT OF CHRIS COCKERHAM

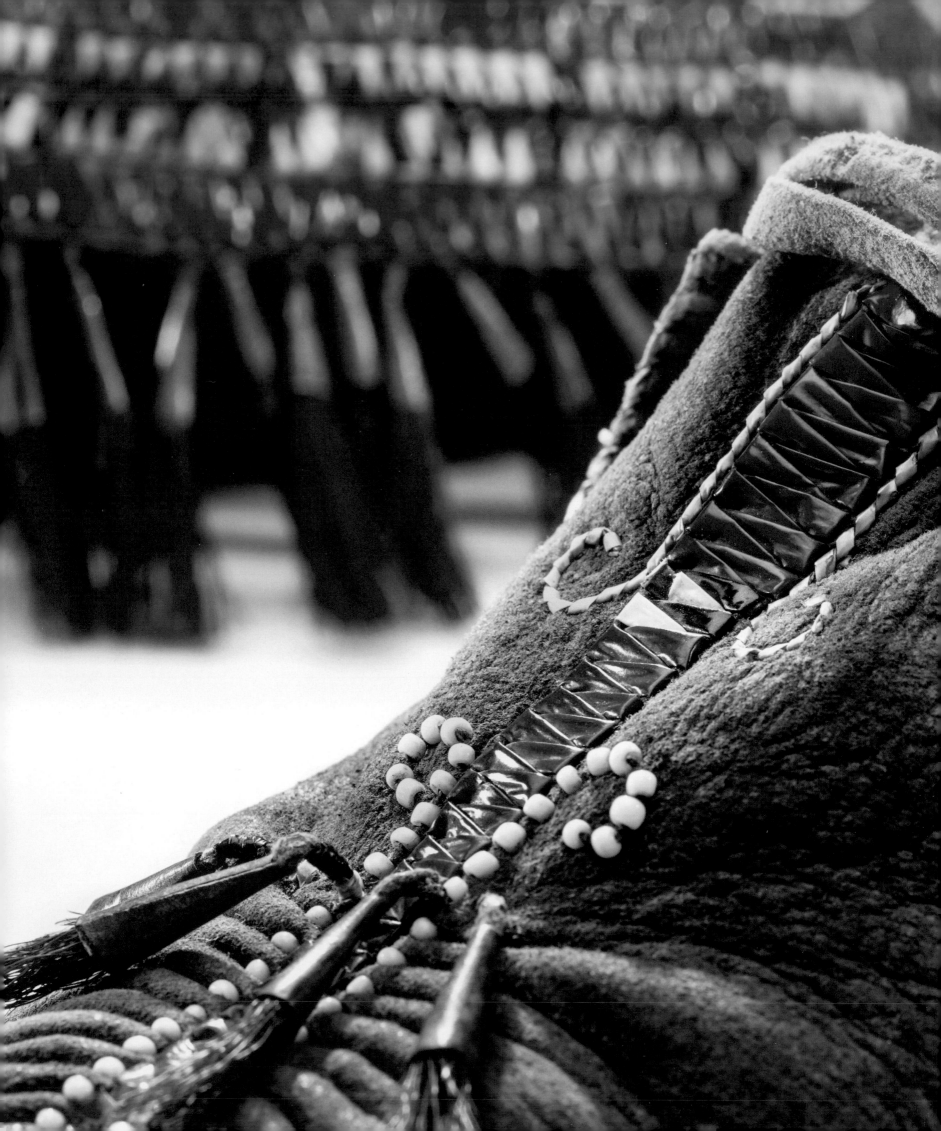

This rare pair of woodland moccasins dates to the eighteenth century and is believed to have been made by a Kanien'kehá:ka (Mohawk) woman. She made them using brain-tanned deerskin treated with smoke to impart a warm brown color and decorated them with dyed porcupine quills, tiny white beads, and small tin cones festooned with deer-hair tassels that would have made a gentle tinkling sound with each step. The identities of the moccasins' maker and their recipient remain hidden in the past, but the footprints still visible on the soles serve as a poignant reminder of the wearer.

PROBABLY KANIEN'KEHÁ:KA · 1770s

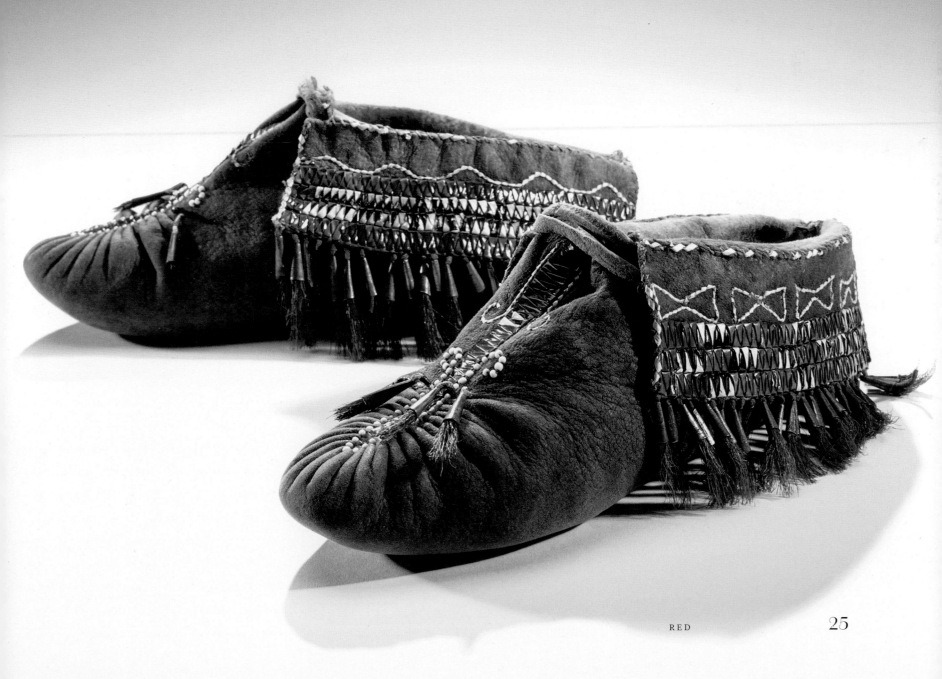

In celebration of the Bata Shoe Museum's tenth anniversary in 2005, it opened the exhibition *Icons of Elegance*, which highlighted Christian Louboutin's work and his famous red soles. Louboutin not only attended the opening, but spent a considerable amount of time studying materials and artifacts in the museum's archives. He was particularly drawn to its holdings of 1920s Western fashion and took inspiration for this shoe, the Cathedral Mary Jane, which appeared in his 2007 collection, from a wonderful pair of Art Deco shoes in the collection.

FRENCH · DESIGNED BY CHRISTIAN LOUBOUTIN · 2007 · GIFT OF CHRISTIAN LOUBOUTIN

THE WORLD AT YOUR FEET

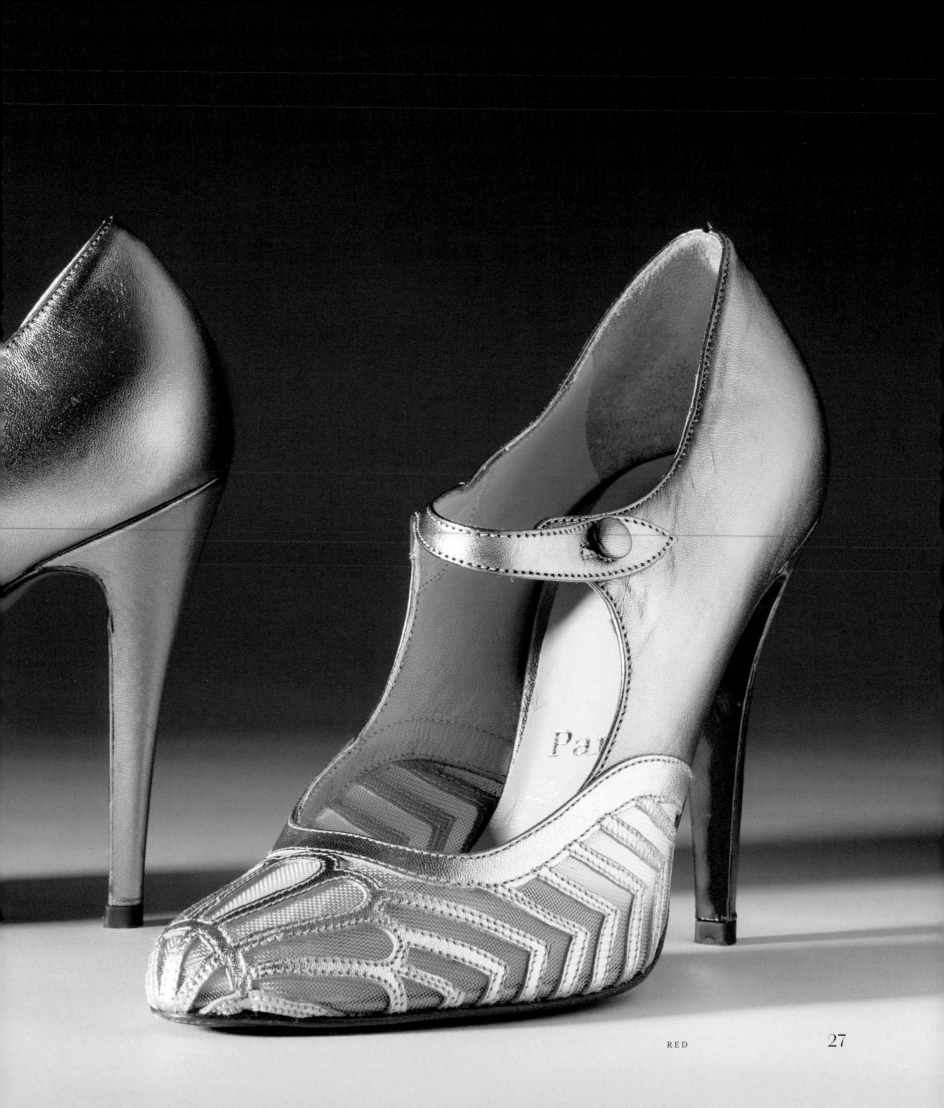

This pair of red leather Egyptian shoes dates to the post-pharaonic period of Byzantine rule, which lasted from 330 to 1453. Christianity was the official religion throughout the empire, and this pair of shoes may have been ecclesiastical. The motif of four heads surrounded by halos in gold leaf most likely depicts the Four Evangelists, the authors of the four gospels in the New Testament: Matthew, Mark, Luke, and John. By the Middle Byzantine period (843–1204), red footwear had become a central feature of imperial regalia, and when the Schism of 1054 divided the Christian church into East and West factions, red shoes, and their associations with power, were adopted by the Roman Catholic popes.

BYZANTINE · POSSIBLY FROM
AKHMIM, EGYPT · 330–641

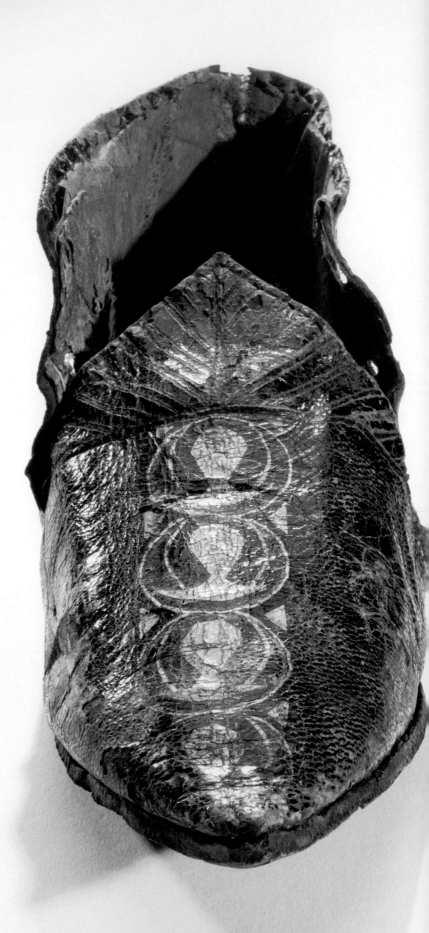

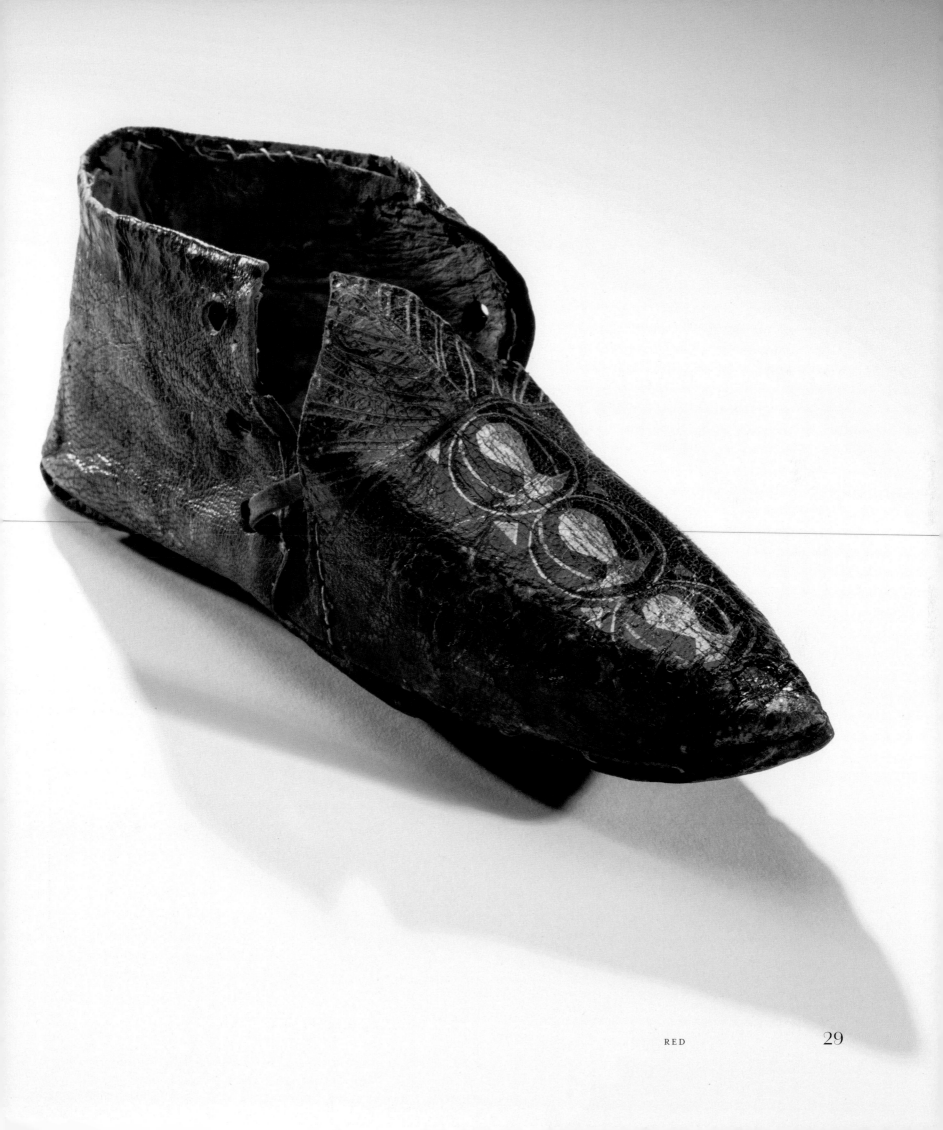

K alaallit Nunaat, or Greenland, is the world's largest island. Though it is blanketed with ice, its coastal areas have supported human populations for more than 4,500 years. Since the tenth century, Greenland has been connected to Europe by trade and settlement and, following a long history of Danish colonization, Greenland officially became an autonomous country within the kingdom of Denmark in 2009. Traditional Greenlandic dress reflects this complex history and displays a blend of Inuit and European influences, as seen in this beautiful pair of red kamiks made by Laurie Jeremiassen for her silver wedding anniversary in 1955. At first glance, the intricate embellishment appears to be needlepoint, but closer inspection reveals that the design was created using tiny squares and rectangles of dyed sealskin sewn into place.

KALAALLIT · CREATED BY
LAURIE JEREMIASSEN · 1955

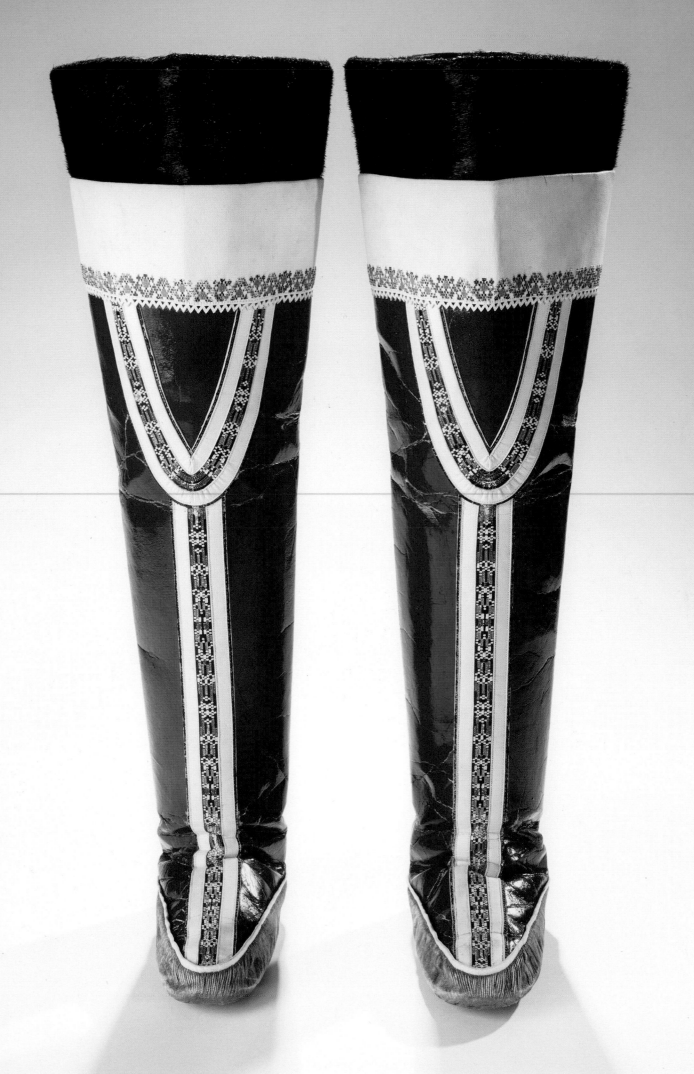

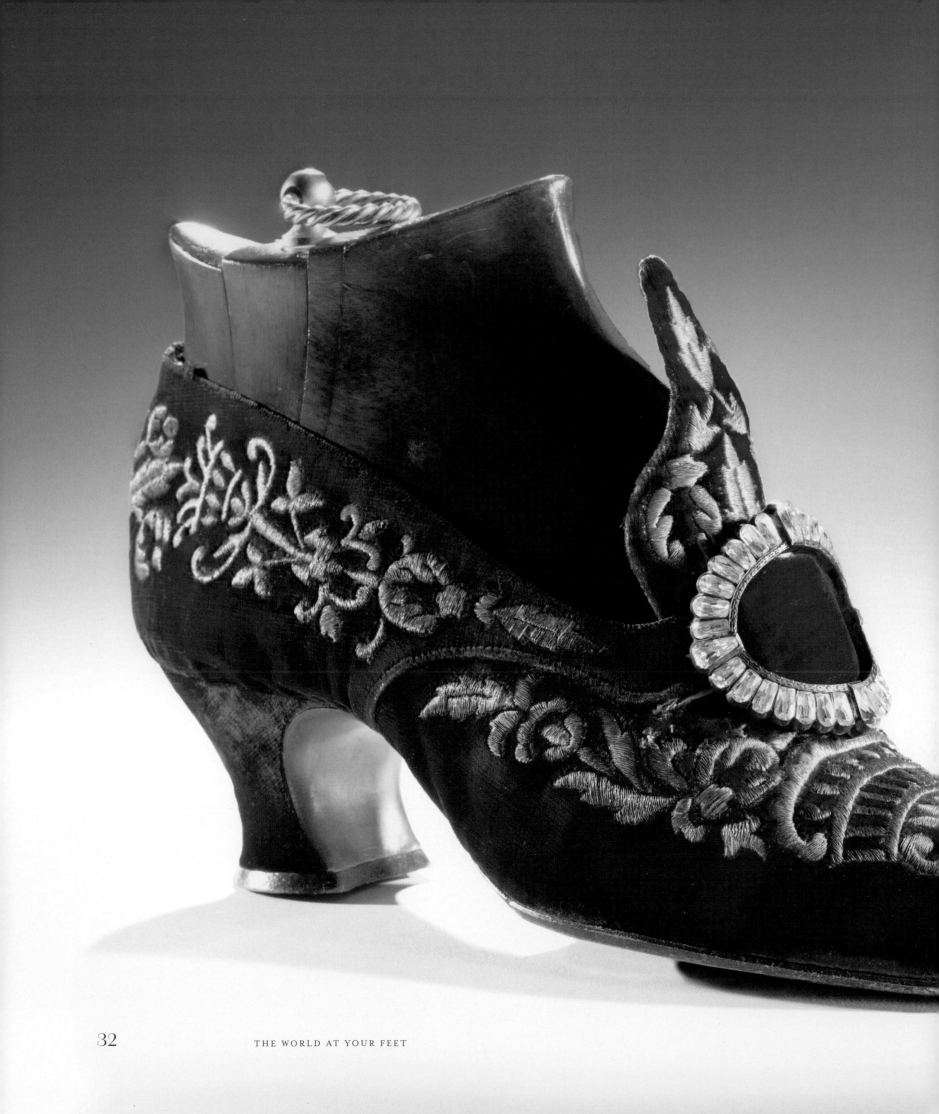

I n 1908 Pietro Yantorny set up shop at Place Vendôme in Paris and hung a sign in his window declaring himself the most expensive shoemaker in the world. He was a demanding craftsman who required a down payment of no less than the equivalent of one thousand dollars to initiate an order and sometimes took years to complete his commissions. Those who wished to be shod by Yantorny had to submit to his dictates, but the finished shoes were treasured objects. Lady Duff-Gordon, the famous Canadian fashion designer who took the professional name Lucile, wrote to her sister, after surviving the Titanic catastrophe, that although she had lost a valuable fur coat, she had fortunately been able to wear her Yantorny mules as she boarded the life-boat. This prized Yantorny belonged to the Countess André de Limur and was generously donated to the Bata Shoe Museum by her daughter in 2006.

**FRENCH · CREATED BY PIETRO YANTORNY ·
1920s · GIFT OF MARY WEINMANN**

The exceptionally fine beadwork decorating this pair of Persian shoes features tiny pearls and glass beads that form images of royal peacocks and the tree of life. The shoes were most likely made for a woman in the Persian court of the Qajar monarchy in the nineteenth century but her identity remains a mystery despite the tantalizing words embroidered on the red velvet insoles of her shoes. The right shoe reads: "Your grace puts even the brightest face of the sun to shame," while the left one translates to, "Let anyone who denies, prove otherwise. Praise the dust under your feet."

PERSIAN · MID-19TH CENTURY

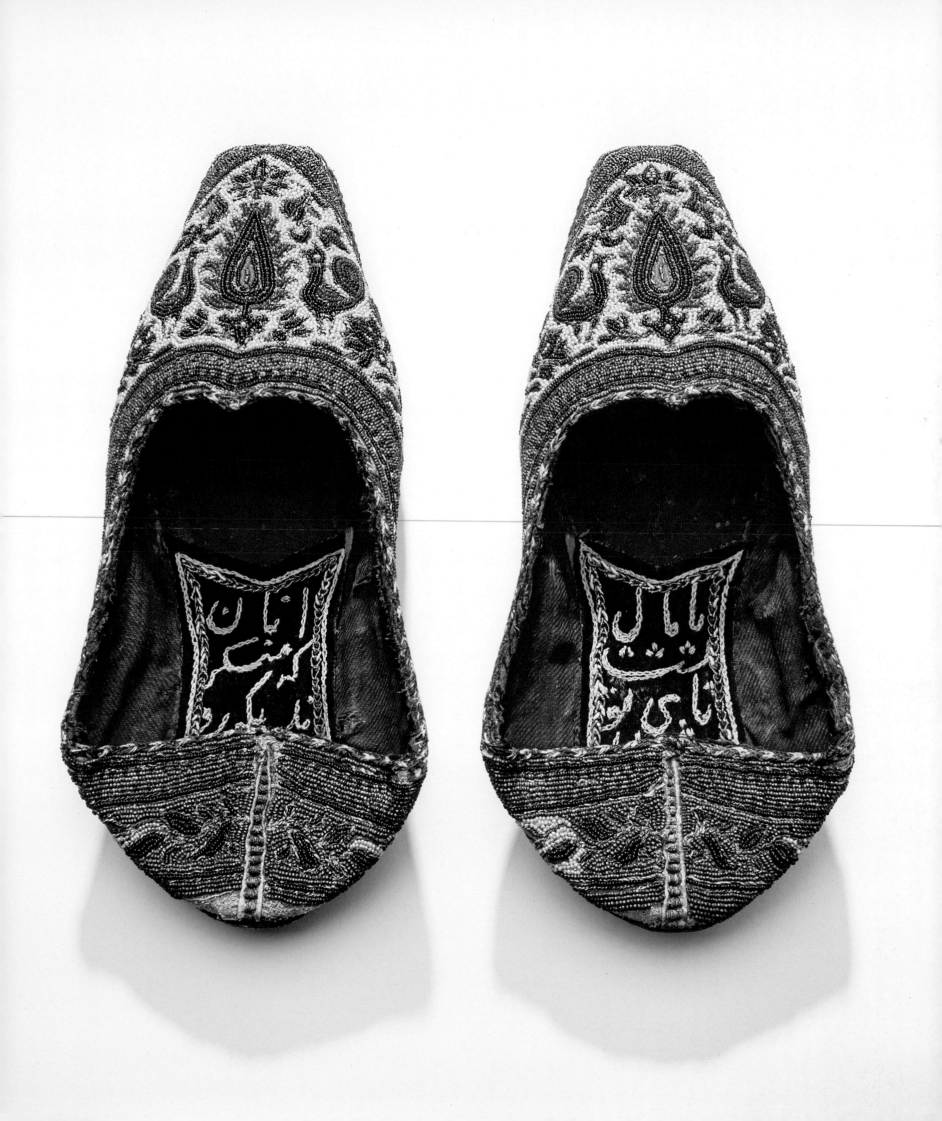

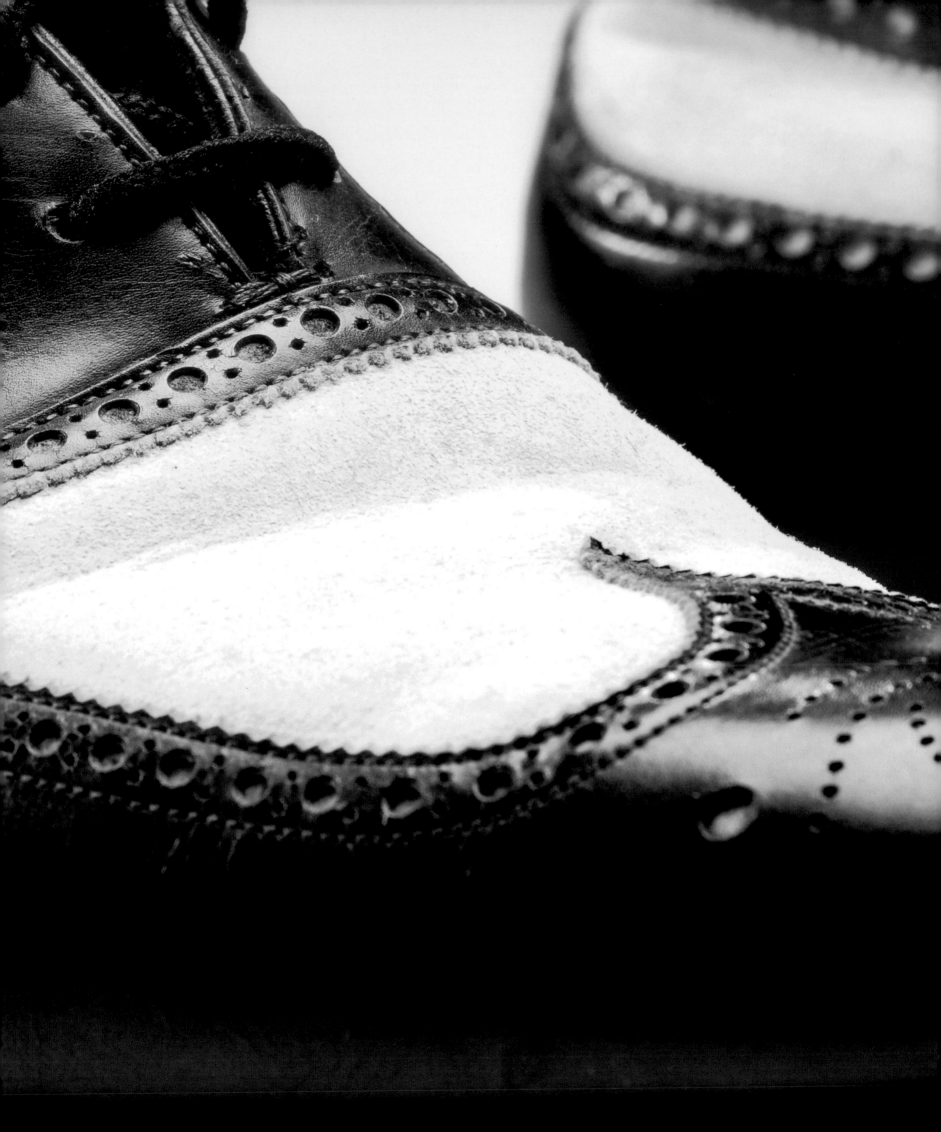

black

*O*iran, the highest ranked brothel workers in Edo (now Tokyo), Japan, captured the imaginations of both men and women during the eighteenth and into the nineteenth centuries. They were presented as paragons of luxury, and their lavish clothing stimulated desire and set fashion trends. *Oiran* paraded down Naka-no-cho, the main street in the walled brothel district, Yoshiwara, displaying their elaborate wardrobes. They wore high *mitsu-ashi geta* (three-toothed wooden sandals) like this one and slowly moved their feet in a highly stylized manner to create a figure eight with every step. Contemporary versions of *mitsu-ashi geta* are worn for annual re-enactments of these processions performed each April.

JAPANESE · 20TH CENTURY

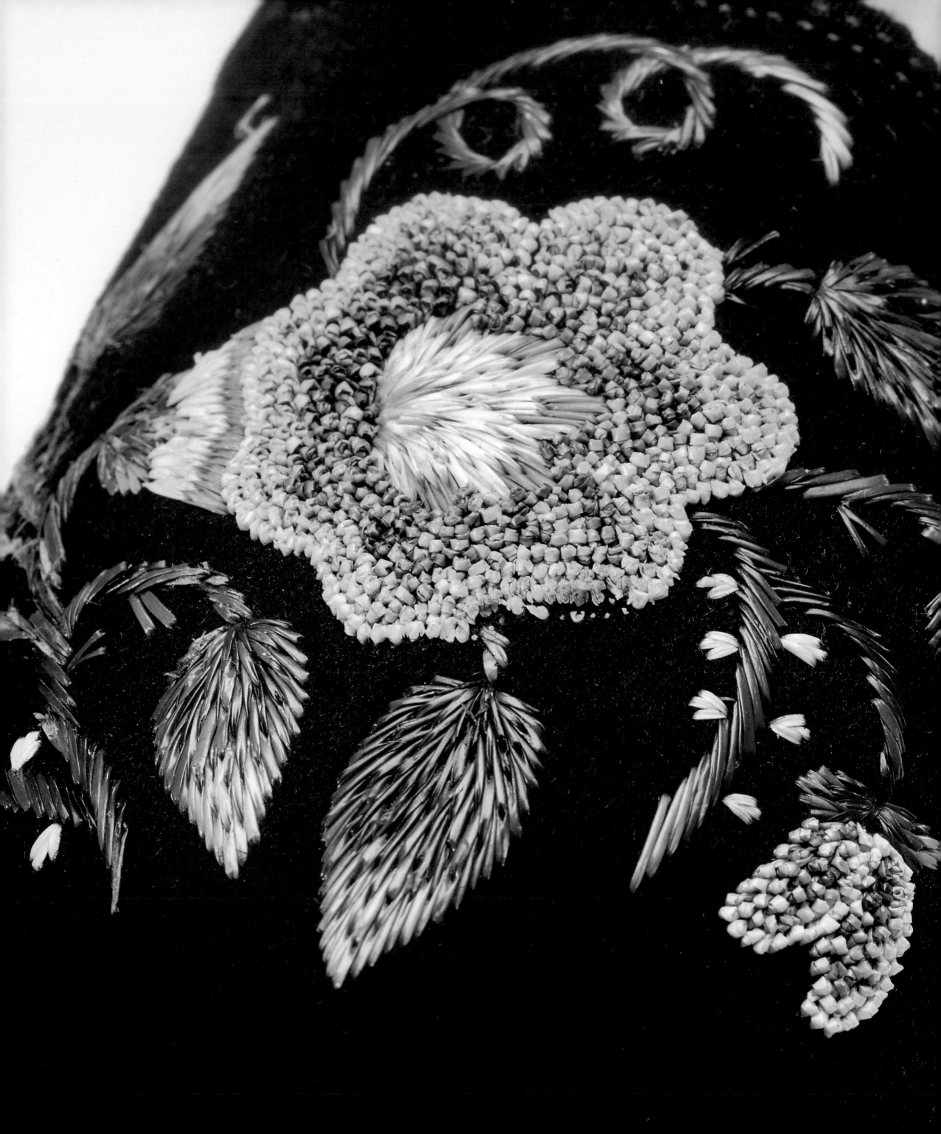

The uppers of this pair of shoes were most likely created by a Wyandot (Huron) woman in the first half of the nineteenth century for the Euro-Canadian market; once purchased they would have been taken to a local shoemaker to be made into Western-style women's footwear. The upper was made of a black woolen textile, but rather than embellishing it with the expected silk embroidery, the maker used exquisite moose-hair embroidery and delicate quillwork. The quillwork used to create the morning glories on the vamps is so finely done that only under magnification is it revealed that every single quill that forms the flower is actually knotted.

WYANDOT · MADE FOR THE EURO-CANADIAN MARKET · 1840–60

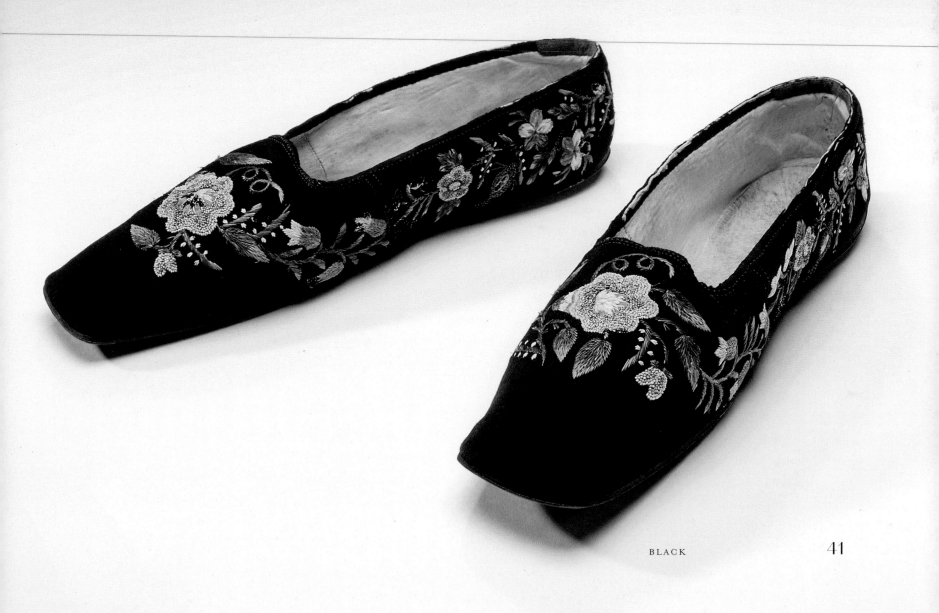

For centuries the latex sap of the "weeping wood" tree was used by the indigenous peoples of Central and South America to make rubber balls, waterproof cloth, and waterproof footwear. By the nineteenth century, stretchy waterproof rubber overshoes began to be made in Brazil for export to America and Europe, setting off a "rubber craze." However, the craze was short-lived, as rubber proved to be highly unstable in both hot and cold temperatures. It was not until Charles Goodyear discovered the process of vulcanization—the treatment of natural latex with heat and sulfur—that rubber was transformed into a durable material, paving the way for mass commercialization of rubber overshoes and sneakers in the 1840s. This pair of pre-vulcanized Brazilian rubber overshoes was made for the high-end American luxury market. The incised floral decoration was pressed into the rubber by young girls using their fingernails. The rarity of rubber at the time made early overshoes like these significantly more expensive than leather footwear.

BRAZILIAN · MADE FOR EXPORT · 1830–50

THE WORLD AT YOUR FEET

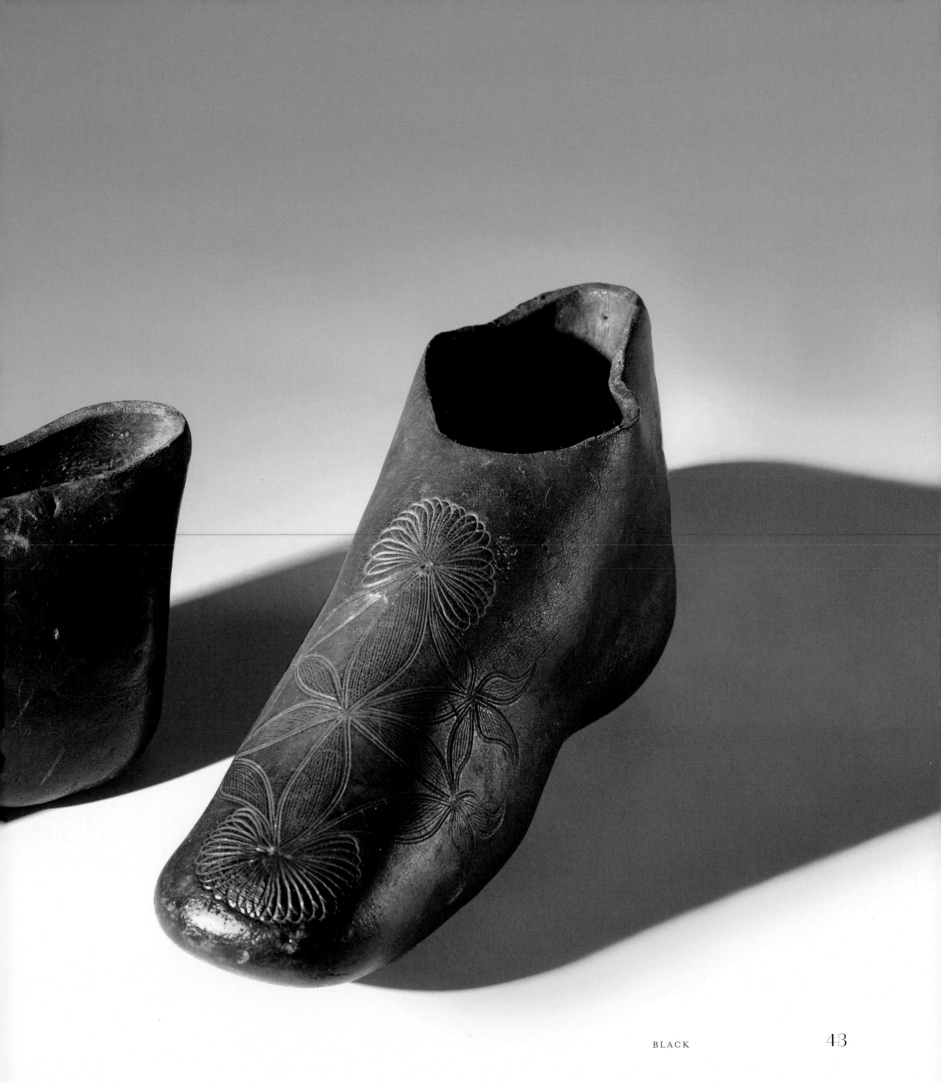

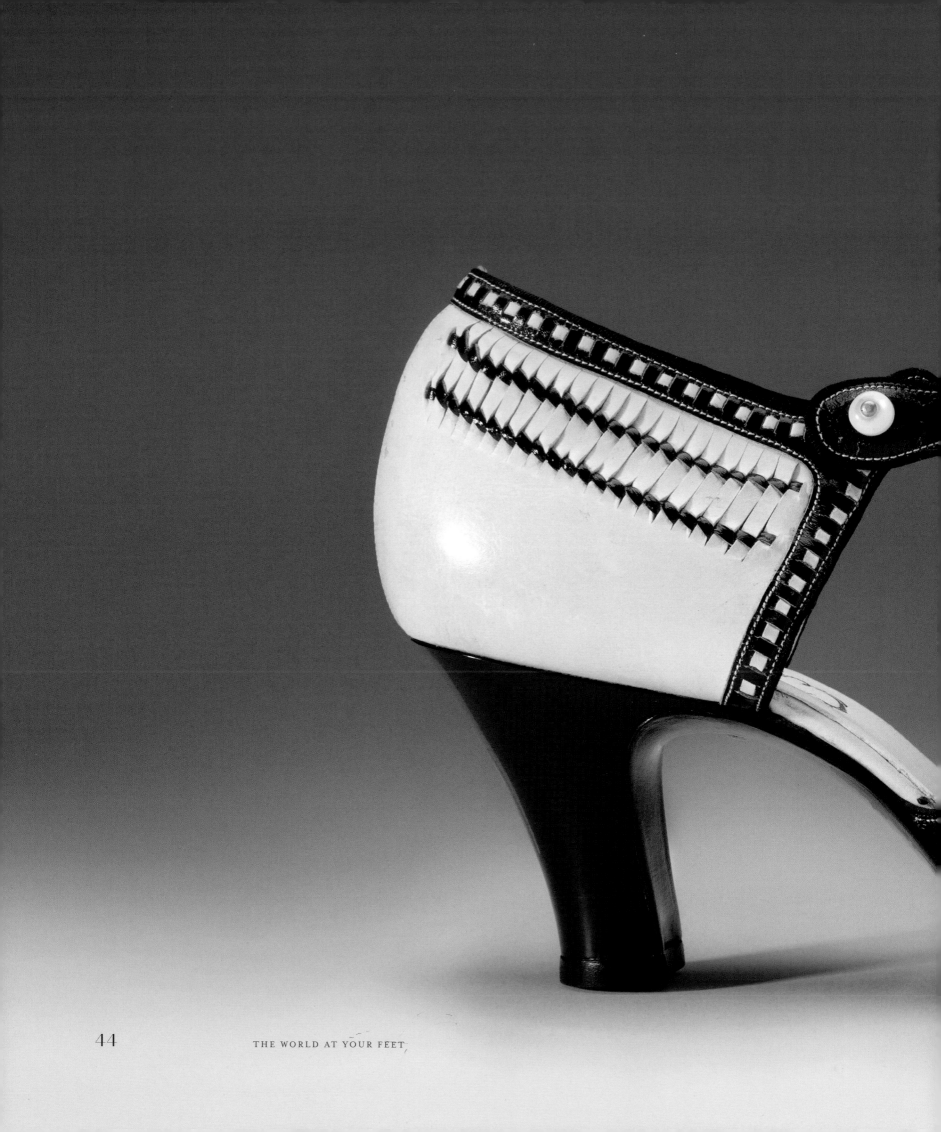

THE WORLD AT YOUR FEET

In the 1920s women did not wear strappy sandals during the summer—the open-toed sandal would not gain popularity until the 1930s. Instead, shoes with woven uppers were considered appropriate summer wear from Palm Beach to the French Riviera. This style was inspired by the traditional woven leather footwear of the Balkan region of Europe, but in the hands of 1920s shoe designers interwoven leather was transformed into Art Deco objets, such as this example by the Swiss brand Bally.

SWISS · DESIGNED BY BALLY · 1926–30

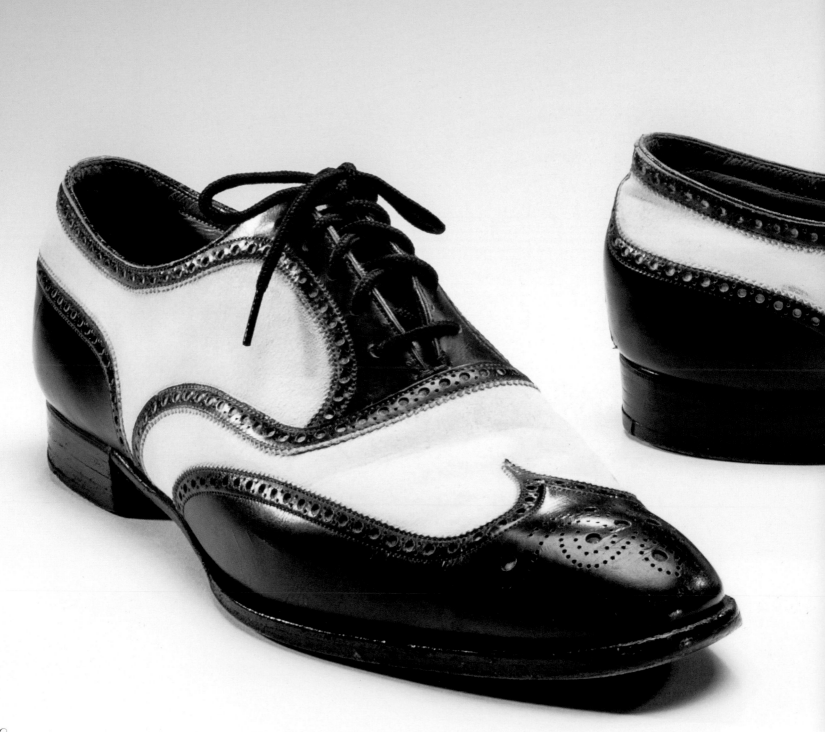

THE WORLD AT YOUR FEET

Two-toned spectators first became fashionable for men of leisure in the nineteenth century, but in the 1930s, the style attained a new level of popularity. The shoes were seen by most as flashy, and the men who wore spectators were often perceived as players. This new meaning was clearly expressed in England, where spectators also came to be called "co-respondents." In British divorce cases, people implicated in marital infidelity are called "co-respondents," so the word lent a whiff of the illicit to the style. This pair of spectators was worn by the elegant Hollywood actor Bela Lugosi, who perfectly embodied the player image. Lugosi's third marriage—he was married five times—lasted only a few months, and the co-respondent in that divorce was the movie star Clara Bow.

ENGLISH · DESIGNED BY ALAN MCAFEE LTD. · 1930s

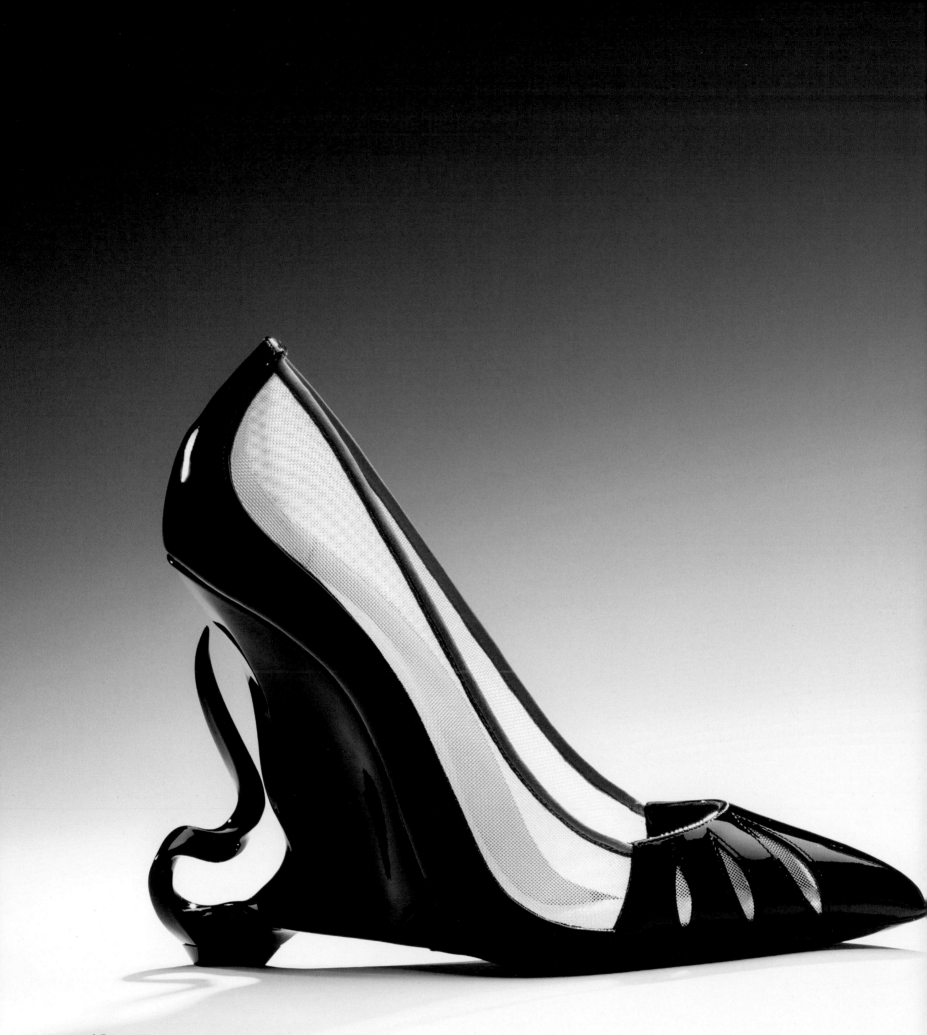

isney released the film *Maleficent*, starring Angelina Jolie, in 2014. To promote the film, Jolie wore bespoke shoes by Christian Louboutin that were inspired by her title character, the misunderstood fairy Maleficent from Charles Perrault's famous story *The Sleeping Beauty in the Wood*, now known simply as *Sleeping Beauty*. The shiny black patent-leather and nude-mesh shoes feature sculptural heels patterned after Maleficent's dramatic horned headdress. A limited edition of this design called Malangeli was made available to the public after the film opened, with the proceeds going to SOS Children's Villages, an international non-profit supported by Jolie that provides humanitarian aid to children in need around the world. Only ninety-six pairs were made, including this one, now in the collection of the Bata Shoe Museum.

FRENCH · DESIGNED BY CHRISTIAN LOUBOUTIN ·
2014 · GIFT OF CHRISTIAN LOUBOUTIN

J ean-Louis François Pinet was the most famous shoemaker in France by the end of the nineteenth century. His beautifully constructed and elaborately embellished footwear complemented the dresses created by emerging haute couture designers such as Charles Frederick Worth and was worn by the best-dressed women of the era. Pinet was intrigued by the possibilities afforded by the industrialization of shoemaking, and he established his own shoemaking factory in 1855. This venture grew quickly, and by the 1870s Pinet employed more than eight hundred workers. Of that number, seven hundred were women who worked at home, embroidering the uppers of his finest footwear. In stark contrast to the wealthy women who wore Pinet footwear, these embroiderers doing piecework labored long, arduous hours for nominal pay. The botanical accuracy and fine stitching of the floral embroidery set against the deep black silk of these Pinet boots are a testament to the remarkable skill of these women.

FRENCH · DESIGNED BY JEAN-LOUIS
FRANÇOIS PINET · 1880s

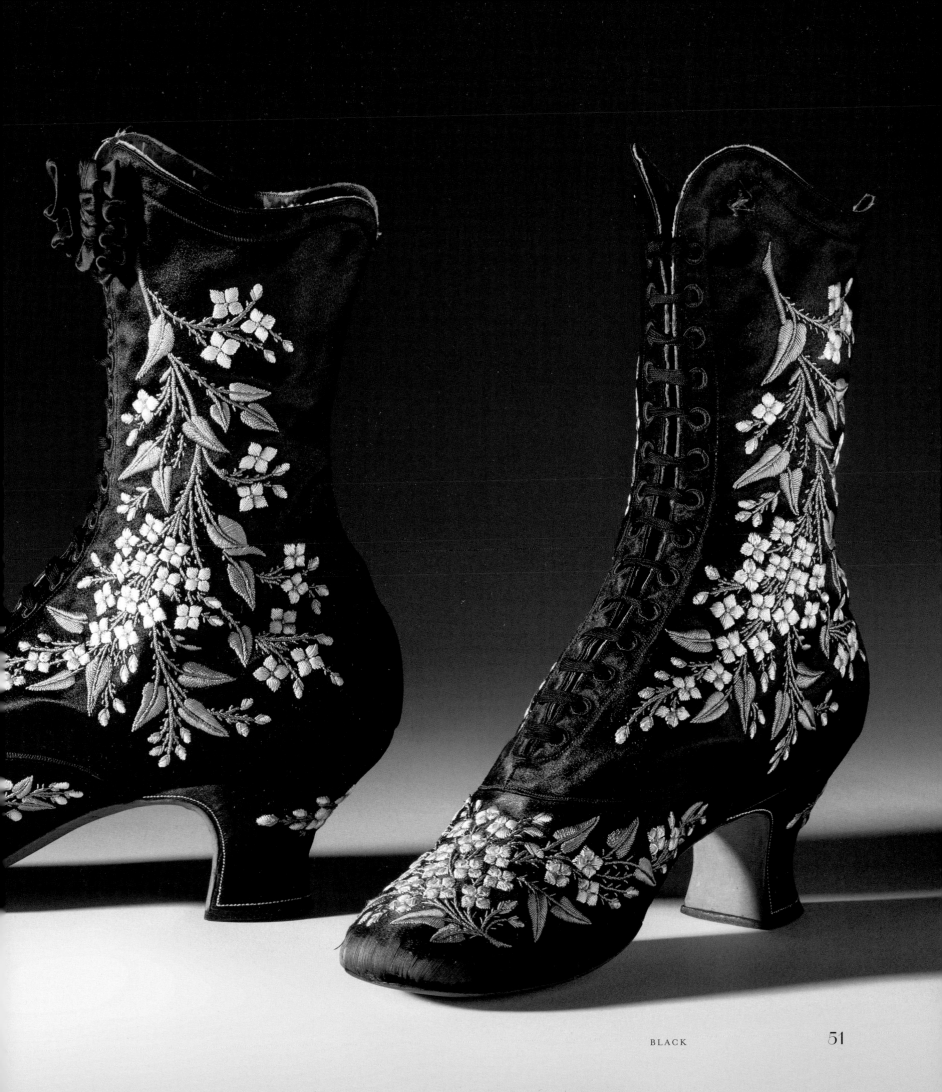

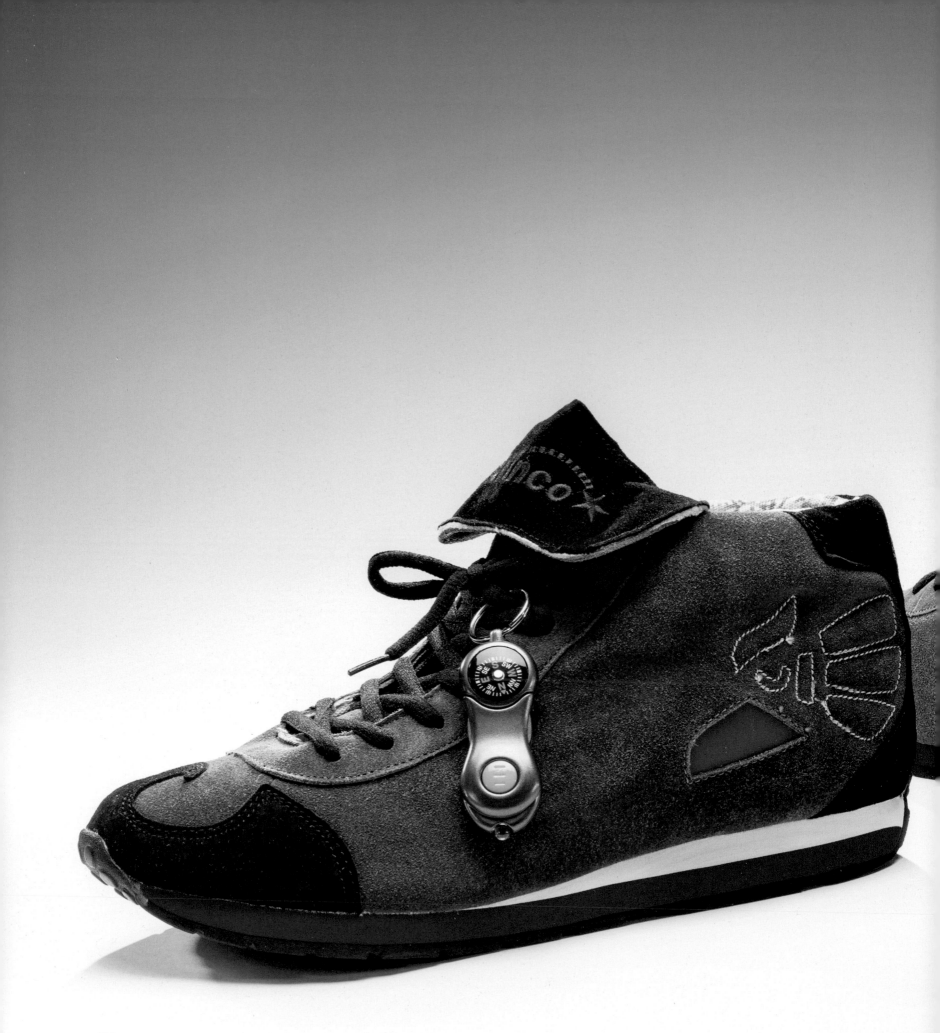

THE WORLD AT YOUR FEET

onceptual artist Judi Werthein chose the Spanish word *brinco*, meaning "jump," as the name for these cross-trainers. *Brinco* is also a word migrants use to describe the crossing from Mexico into the United States via San Diego. Drawing attention to the danger and difficulties faced by the migrants, Werthein designed these sneakers with details that would assist with "the crossing." Each pair is equipped with a compass, a light, and painkillers, in case of injury. The shoes were also designed to protect the wearer's ankles from snake and tarantula bites, and they have removable insoles printed with maps of the most popular routes from Tijuana to San Diego. In addition, they are decorated with the Aztec and American eagles, as well as small images of Saint Toribio Romo González, the patron saint of immigrants. Werthein handed out Brincos at the United States–Mexico border in 2005.

AMERICAN · CREATED BY JUDI WERTHEIN · 2005 · GIFT OF DALE HENDERSON AND MARIE POON

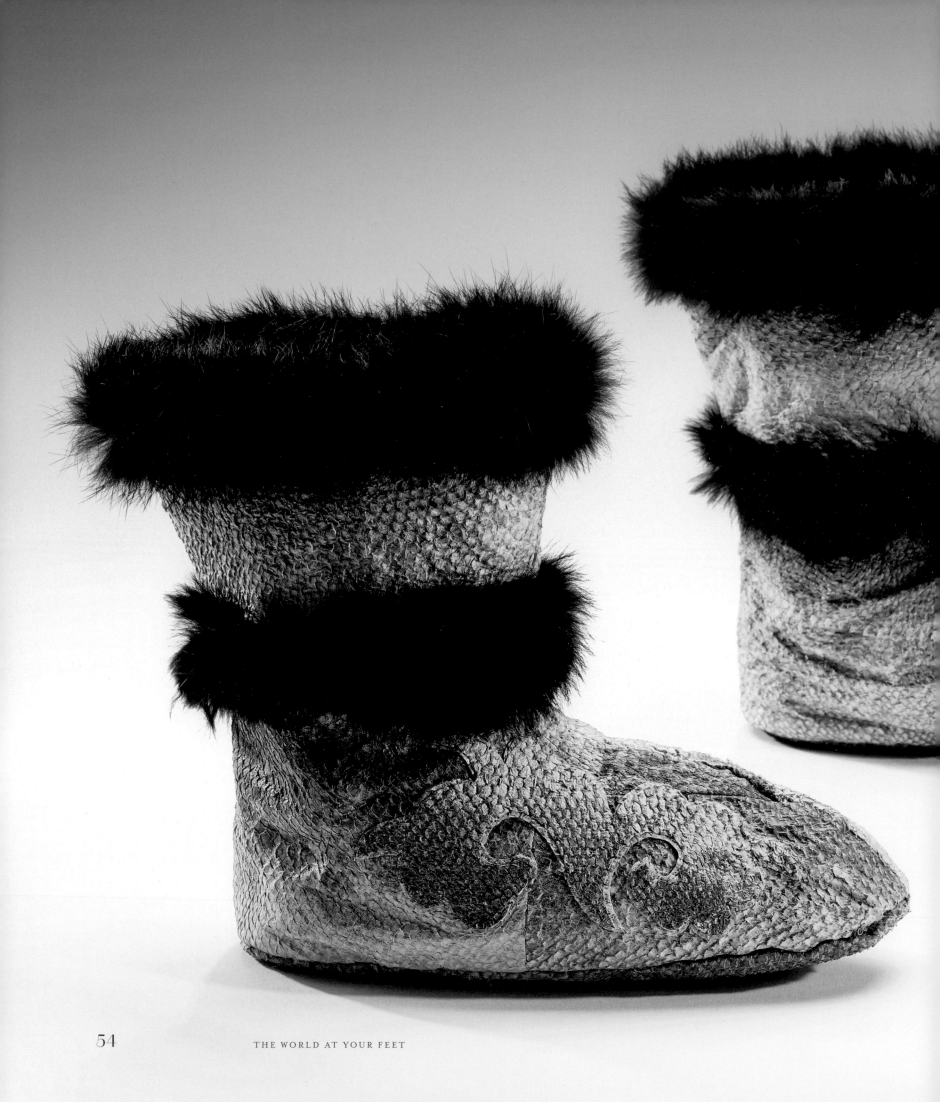

THE WORLD AT YOUR FEET

The Hezhe are one of the smallest ethnic groups in China. They live in the northeastern corner of China and in early autumn each year they catch salmon for both food and fashion in the large nets they set up in the Heilongjiang River. This pair of women's boots was made by You Wenfeng out of salmon skin. According to You, it takes eight pieces of salmon belly skin to make one pair. Salmon skin intended for clothing is cut from the fish in large sections and then dried, descaled, sprinkled with corn flour, and manipulated by hand until it is extremely soft and pliable. You decorated these subtle boots with a curvilinear piece of appliquéd salmon skin symbolizing waves. The soft black fur is marten.

HEZHE · CREATED BY YOU WENFENG · 2006

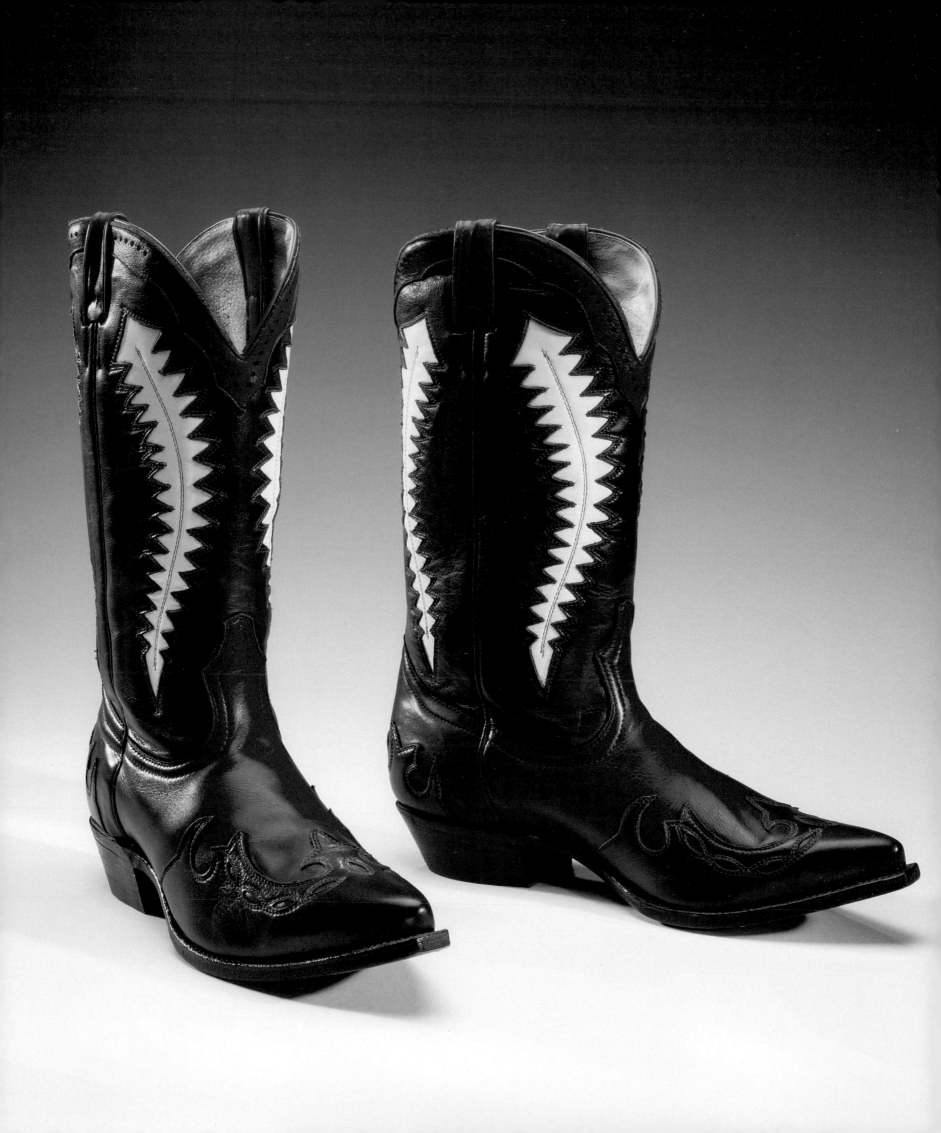

North American cowboys in the middle of the nineteenth century were a heterogeneous group made up of former US soldiers, new immigrants from Europe, recently emancipated slaves, Indigenous Americans, and Mexican vaqueros. This diverse group was united by hard work, long hours, and a heavy reliance on boots to make their living. Early photographs show cowboys wearing a wide range of boot styles; however, by the 1920s cowboy boots began to feature the now iconic pointed toes, decorative stitching, and bold colors. This pair, by Canadian maker Boulet, was owned by Stephen Pitch, an avid collector of both bespoke and ready-to-wear cowboy boots. His family generously donated close to seventy pairs of boots from his personal collection to the Bata Shoe Museum in 2017.

CANADIAN · CREATED BY BOULET BOOTS · 2017 · GIFT OF ANNA SAVOY

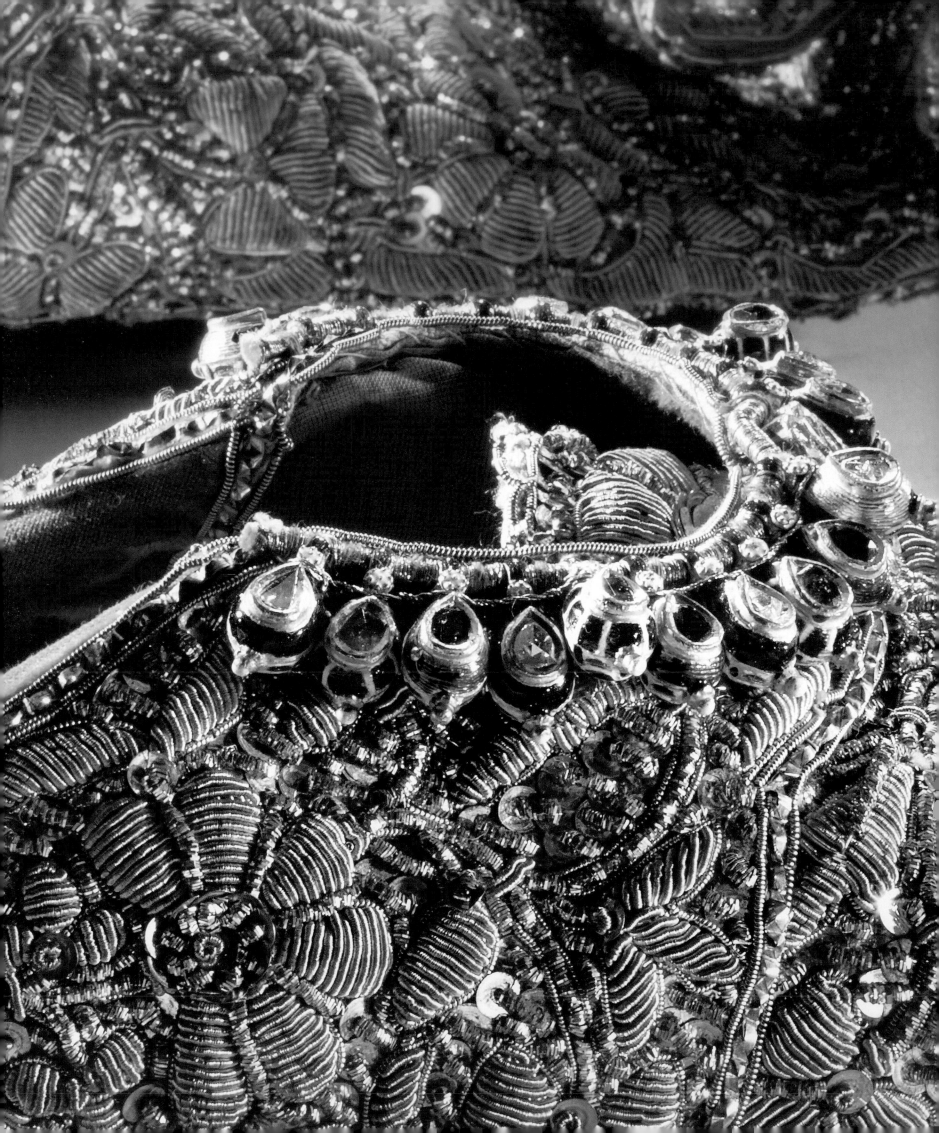

metallic

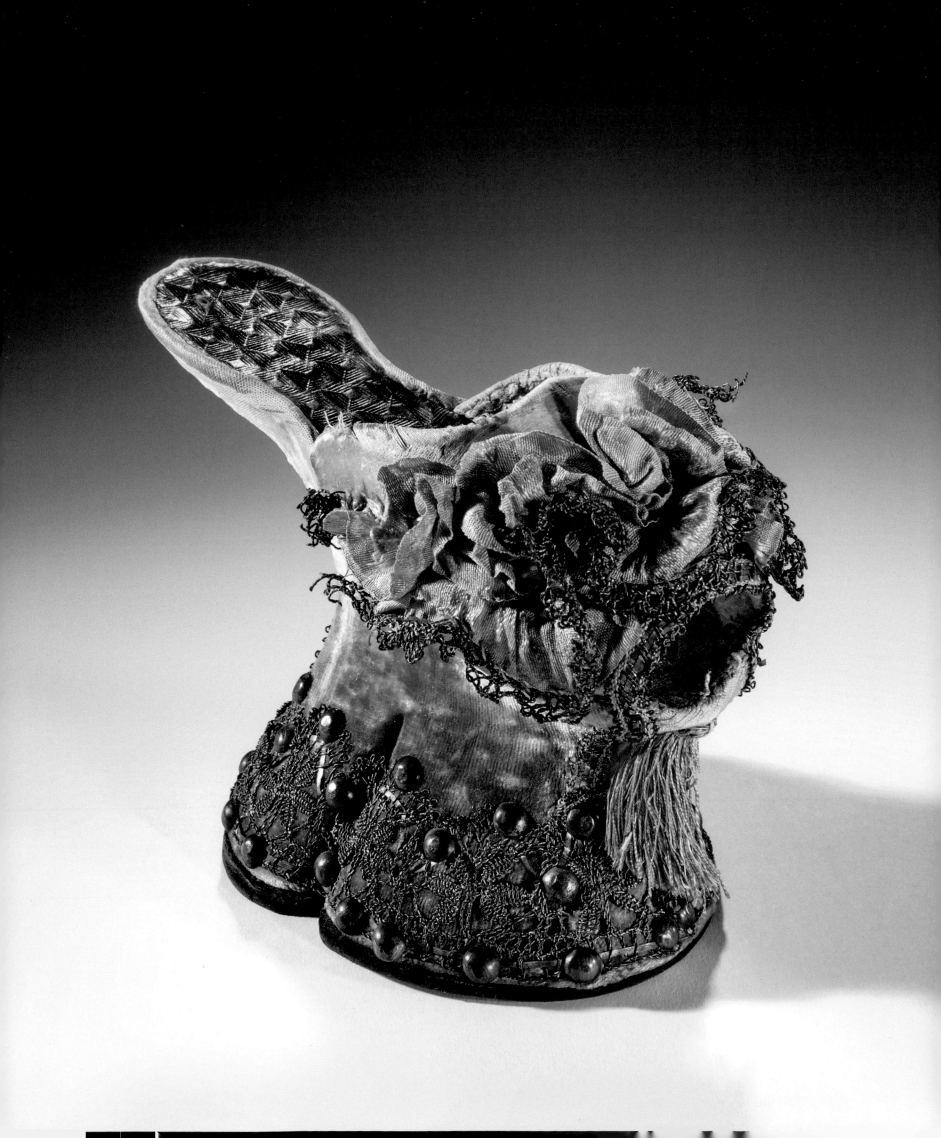

In Renaissance Italy, high-platform footwear was a central feature of upper-class women's dress. Chopines, as they were called in English, were worn concealed under women's skirts, and their purpose was directly related to the value of textiles. Since chopines had to remain hidden under women's skirts, the higher the chopines were, the more cloth was required to make the skirts. The value of cloth was so significant that any increase in skirt length became a conspicuous display of wealth. In Venice, some chopines even reached twenty-two inches in height. Despite criticism of the wasteful extravagance, women's dress was actually central to the expression of family wealth, and neither sumptuary laws nor moralizing deterred wealthy families from mounting their women in chopines and clothing them in costly garments. This rare chopine dates to the late sixteenth century. Its wooden platform is covered in expensive gold-colored velvet and embellished with silver bobbin lace and silver tacks set around the base, and the upper is lavishly decorated with lace and tassels of golden silk. Yet all of this adornment would have been hidden from view under the even more sumptuous skirts of the woman who wore chopines.

ITALIAN · LATE 16TH CENTURY

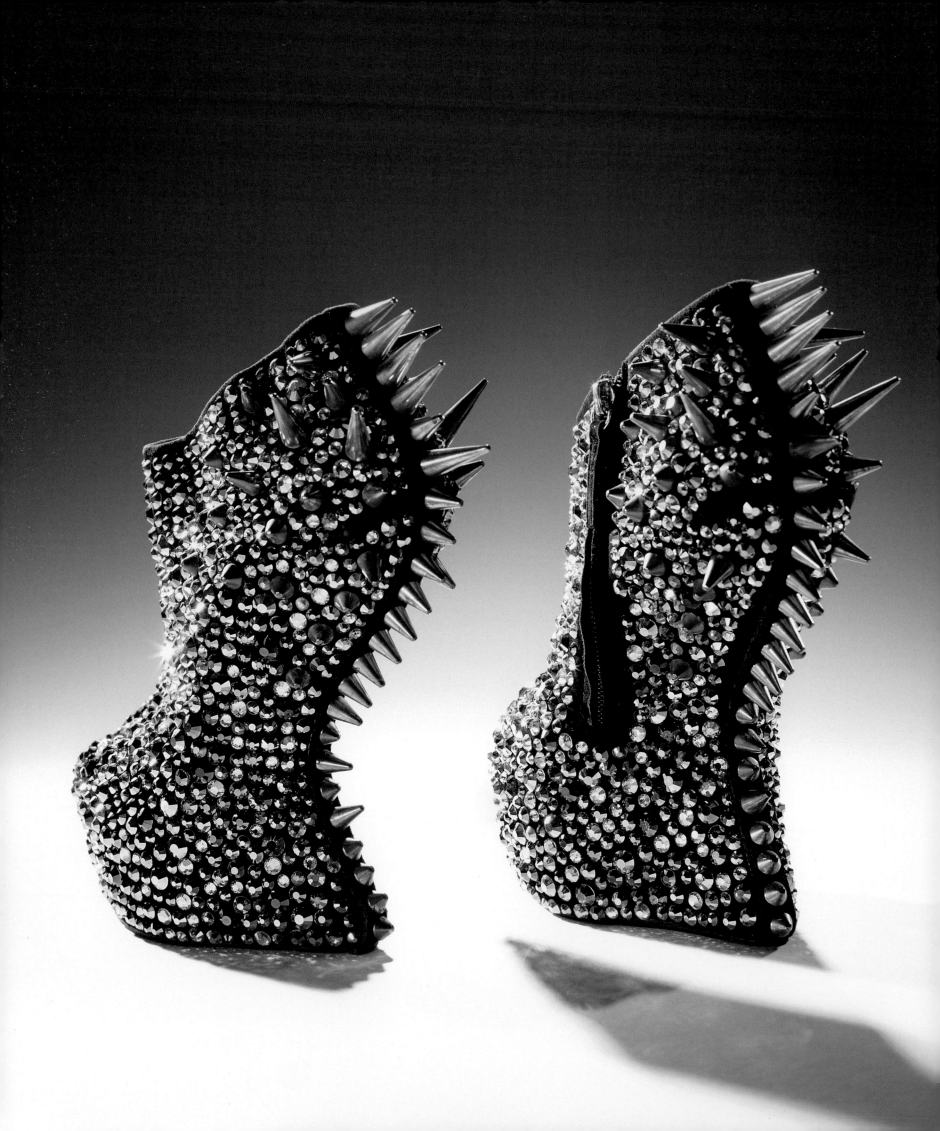

talian shoe designer Giuseppe Zanotti designed this pair of platform shoes in 2012. The unusual shape harks back to the Renaissance era in Italy and Spain, when upper-class women wore tall platform chopines as a means of displaying familial wealth and status. This pair of shoes likewise proclaims status but also connotes the world of fetish. The shape is reminiscent of "pony girl" horse-hoof fetish footwear, and the gold and silver spikes add an aggressive edginess to the design.

ITALIAN · DESIGNED BY
GIUSEPPE ZANOTTI · 2012

By the end of the nineteenth century, mass production had radically democratized Western fashion, and the enfranchisement of the lower classes into the culture of privileged fashion dismayed much of the upper class. In response, the wealthy began to reject aspects of mass-produced clothing and to demand expensive dress and accessories decorated with detailing such as beading and embroidery that could only be done by hand. A select few also sought out bespoke footwear, like these boots. This pair was designed to look like stockinged legs with feet slipped into golden shoes and reflects the infusion of erotically charged references into women's dress at the end of the nineteenth century. Although the majority of the calf-hugging shaft and elaborate gold-kid appliqué would have been hidden under the wearer's skirts, a glimpse of these boots, offered by lifting the skirt, would have tantalized onlookers.

SWISS OR GERMAN · 1890s

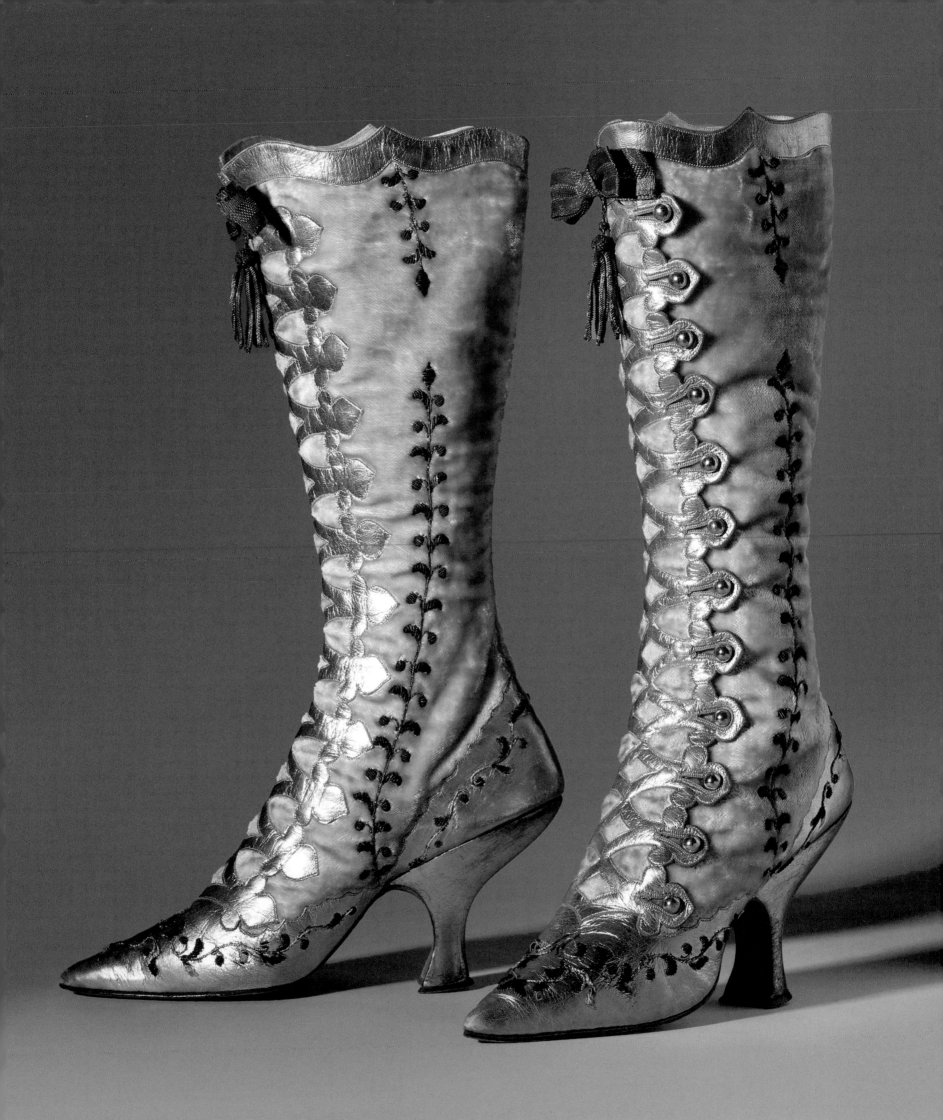

These gold *mojari* are thought to have been worn by Sikandar Jah. He was the Nizam of Hyderabad from 1803 to 1829, but the shoes may date to a time later in the century. The sartorial splendor of Hyderabad's rulers was closely linked to Mughal traditions; gold was used as a means of proclaiming power. This pair of shoes features *zardozi* (gold work) embroidery, which includes the use of *sunehri kasab* (gold-metal thread) and *sitara* (gold sequins). The throats of the *mojari* are bejeweled with rubies, diamonds, and emeralds set in enameled gold.

HYDERABADI · 19TH CENTURY

THE WORLD AT YOUR FEET

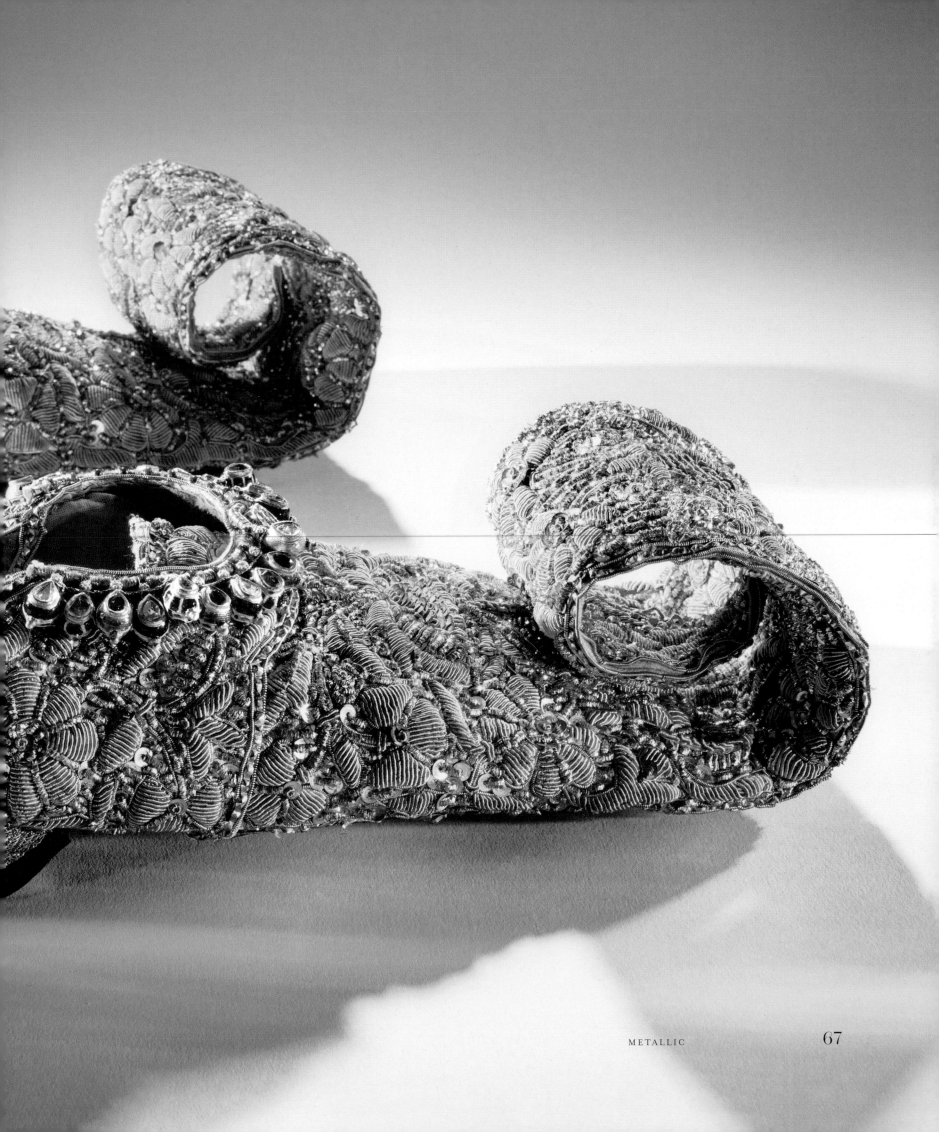

In ancient Egypt, mummy cases called cartonnage were frequently decorated with gold. By the Ptolemaic period of 305–30 BCE, an increasing number of people sought to be mummified after death, and less expensive use of cartonnage to encase only the head and feet became popular. "Mask cartonnage" covered the head and depicted an idealized version of the deceased, including golden skin to signal readiness to be among the gods; foot-cases typically depicted the deceased wearing gilded sandals with representations of enemies of Egypt, such as the Nubians and Libyans, painted on the soles, which symbolically helped them keep danger and sinister forces at bay.

EGYPTIAN · 1ST CENTURY CE

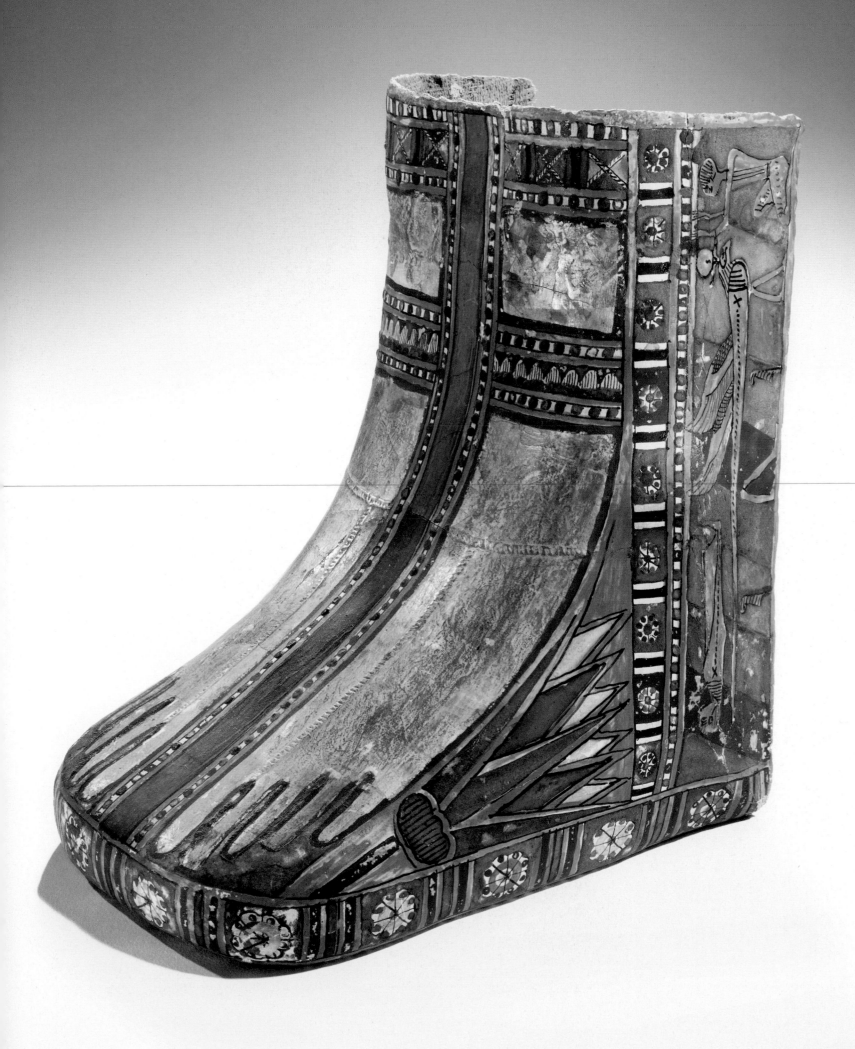

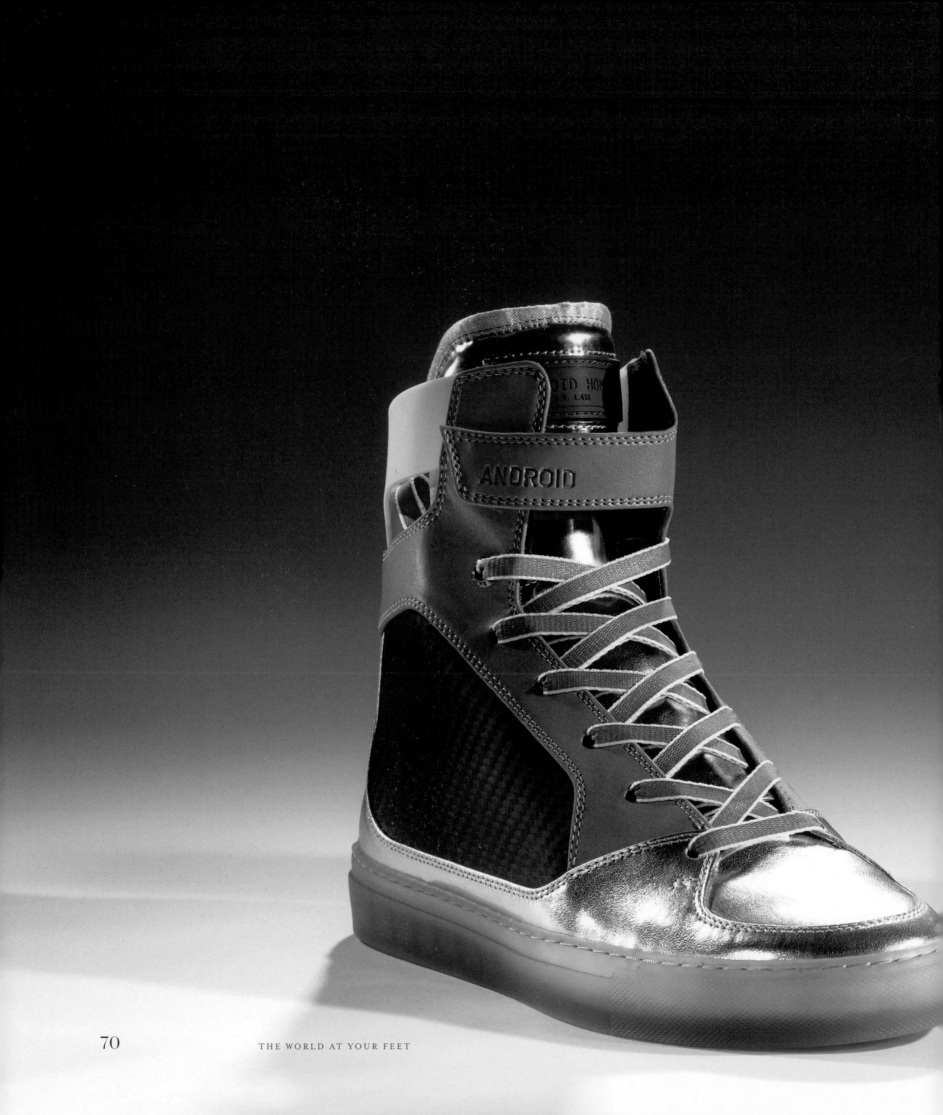

THE WORLD AT YOUR FEET

In 2014 General Electric (GE) celebrated the forty-fifth anniversary of the first moon landing by collaborating with luxury sneaker brand Android Homme to make one hundred pairs of lunar boot—inspired sneakers using the most innovative GE materials. GE had worked closely with NASA in the 1960s to develop new materials to be used in space missions, and Android Homme paid homage to this history by employing a number of those revolutionary GE materials in the making of these sneakers. These included stabilized carbon fiber, 3M Scotchlite reflective material, thermoplastic rubber, and a hydrophobic coating typically used to prevent ice from forming on wind-turbine blades. The sneaker was released by the online retailer JackThreads on July 20 at 4:18 p.m. on the East Coast, the exact time of the landing of the lunar module in 1969. The sneakers were priced at $196.90 to honor the date of the historic Apollo 11 moon landing.

AMERICAN · DESIGNED BY ANDROID HOMME
FOR GE · 2014 · GIFT OF GE

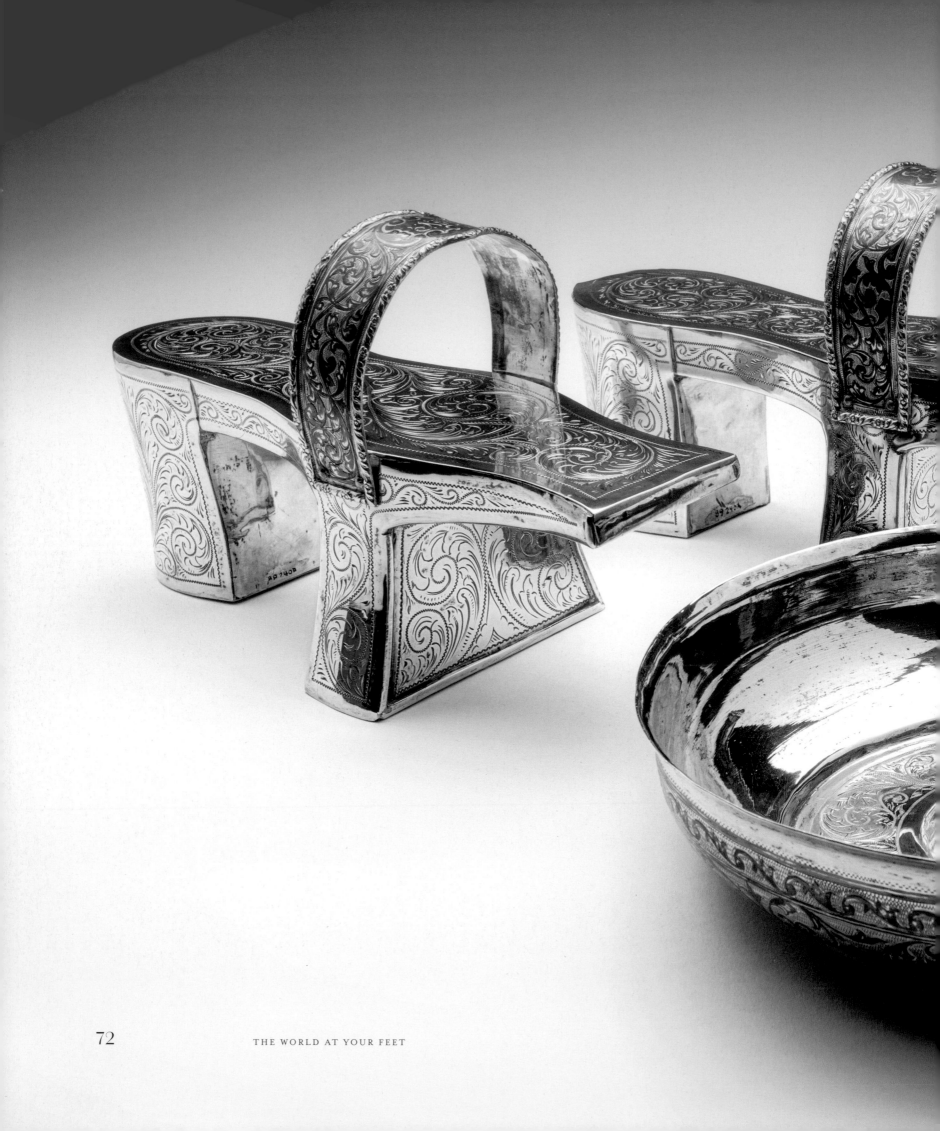

THE WORLD AT YOUR FEET

In a tradition that dates back centuries, a Turkish bride often bathes in a hammam, or Turkish bath, before her wedding. In earlier times, the accoutrements required for the hammam included Turkish towels, a bowl for pouring water, and a pair of tall sandals called *nalin*. These stilted bathhouse clogs were descendants of the wooden *sculponea* worn to bathhouses in ancient Rome. Under Roman rule, their use spread across the Maghreb and Near East where they became part of the female wardrobe. During the Ottoman Empire (1298–1922), wealthy brides were frequently gifted silver *nalin,* often accompanied by matching bowls. This set was given to a bride in Istanbul more than one hundred years ago.

OTTOMAN · c. 1900

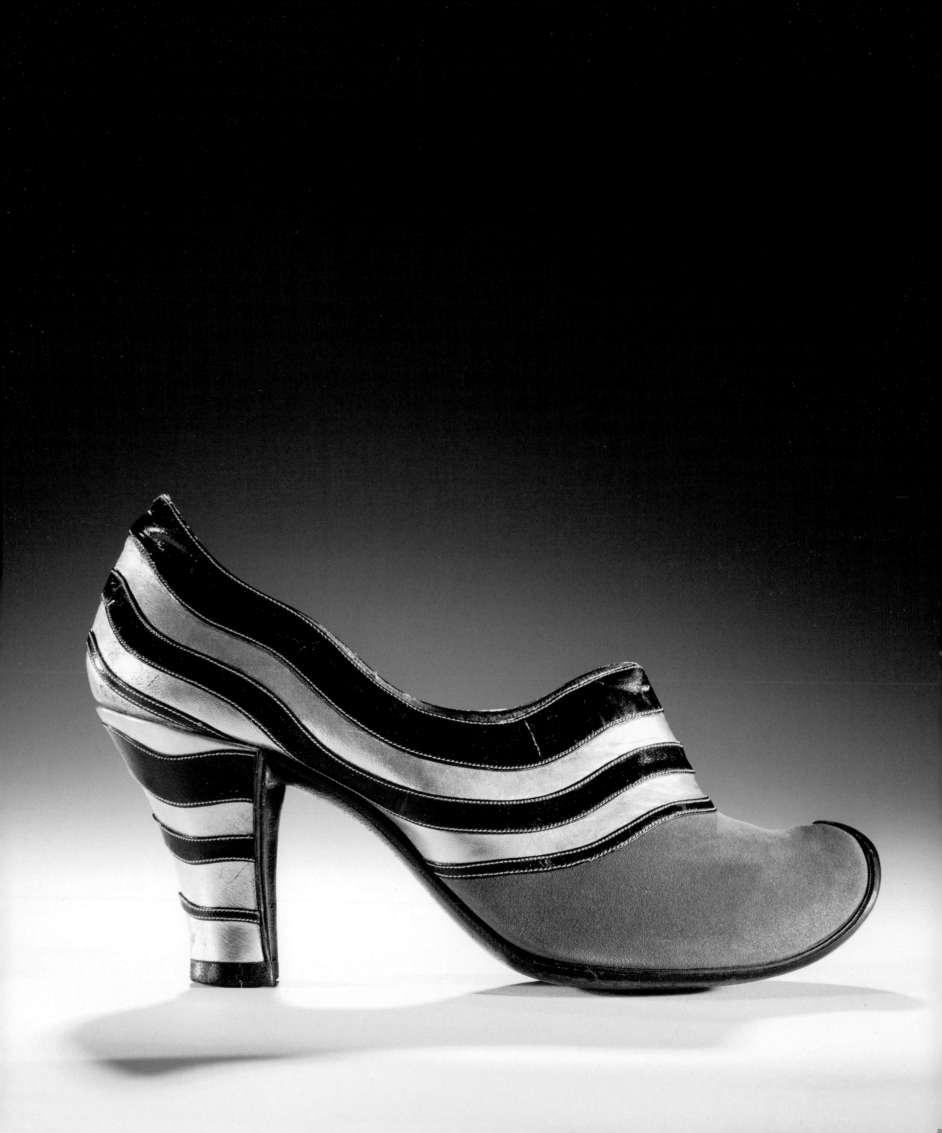

I n the 1920s, the suggested splendor of faraway places and cultures was found in everything from film to fashion. Intrinsic to these problematic fantasies were ideas of excess and luxury that were often linked to a lavish use of ornamentation in fashion. Certain structural conceits were also revisited again and again, including the repeated use of the upturned "Aladdin" toe in footwear design. Renowned French shoe designer André Perugia designed this exoticizing example for the silent-film star La Spinelly.

FRENCH · DESIGNED BY
ANDRÉ PERUGIA · 1925–27

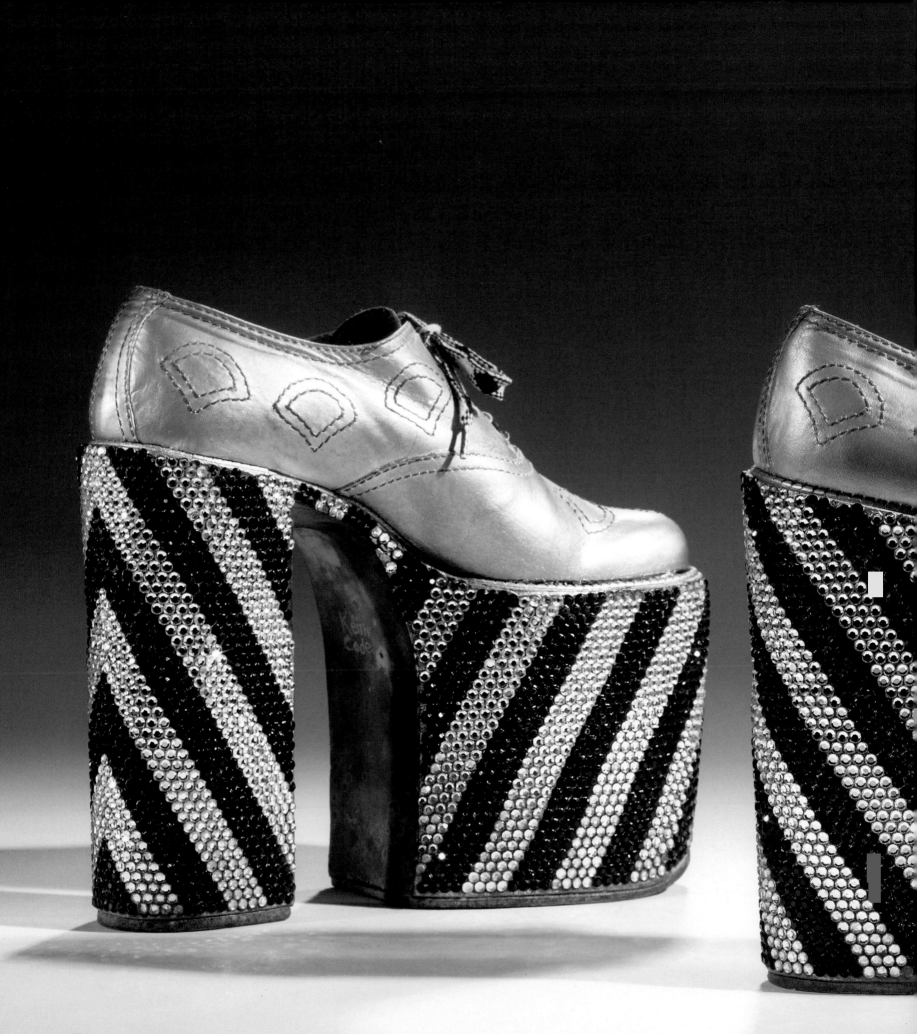

THE WORLD AT YOUR FEET

In the 1970s, heels for men reached unprecedented heights. On the street and in the disco, young men began sporting three-inch heels; even traditionally conservative businessmen began to wear slightly higher heeled shoes with their suits. Some of the highest were worn by glam rock musicians whose outrageous stage outfits often included high-heeled platform shoes. This pair was worn by renowned musician Elton John, famous for his flashy, over-the-top costumes and glittering high heels. This fashion is often described as gender bending, but the heels men wore in the 1970s were not borrowed from the female wardrobe; they were reclamations of heels that men such as Louis XIV had worn in the past.

ITALIAN · DESIGNED BY FERRADINI · 1972–75

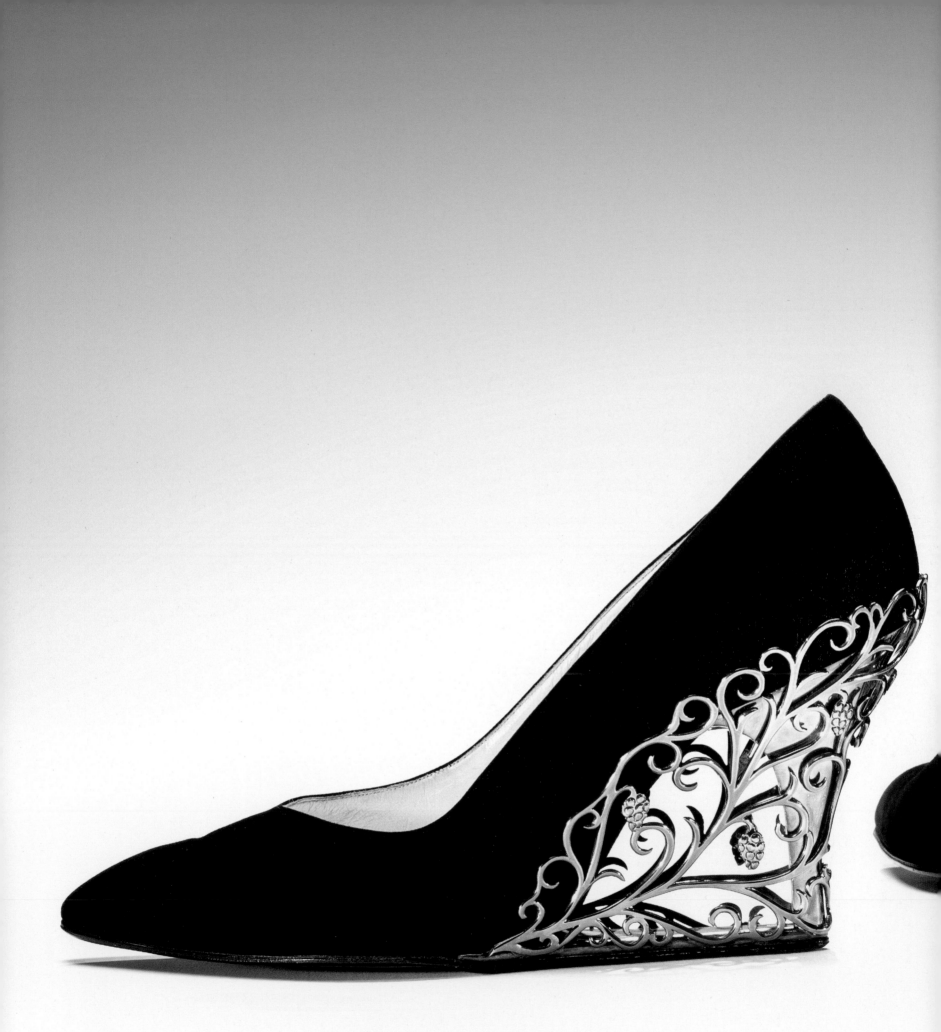

THE WORLD AT YOUR FEET

The invention of the narrow stiletto heel in the early 1950s relied on postwar technology to produce slender steel rods strong enough to support the wearer's weight. This new form of high heel was quickly embraced in Western fashion and displaced the wedges and platforms that had been popular during the 1940s. The design of these evening shoes, however, plays with the older fashion for wedges by shrouding the shoes' stilettos in a sterling-silver filigree curtain that offers only a glimpse of the hidden metal heel. The filigree is so open and delicate that when juxtaposed against the velvety black suede of the upper it almost disappears from view under the foot.

ENGLISH · DESIGNED BY HOLMES
OF NORWICH · 1957–59

blue

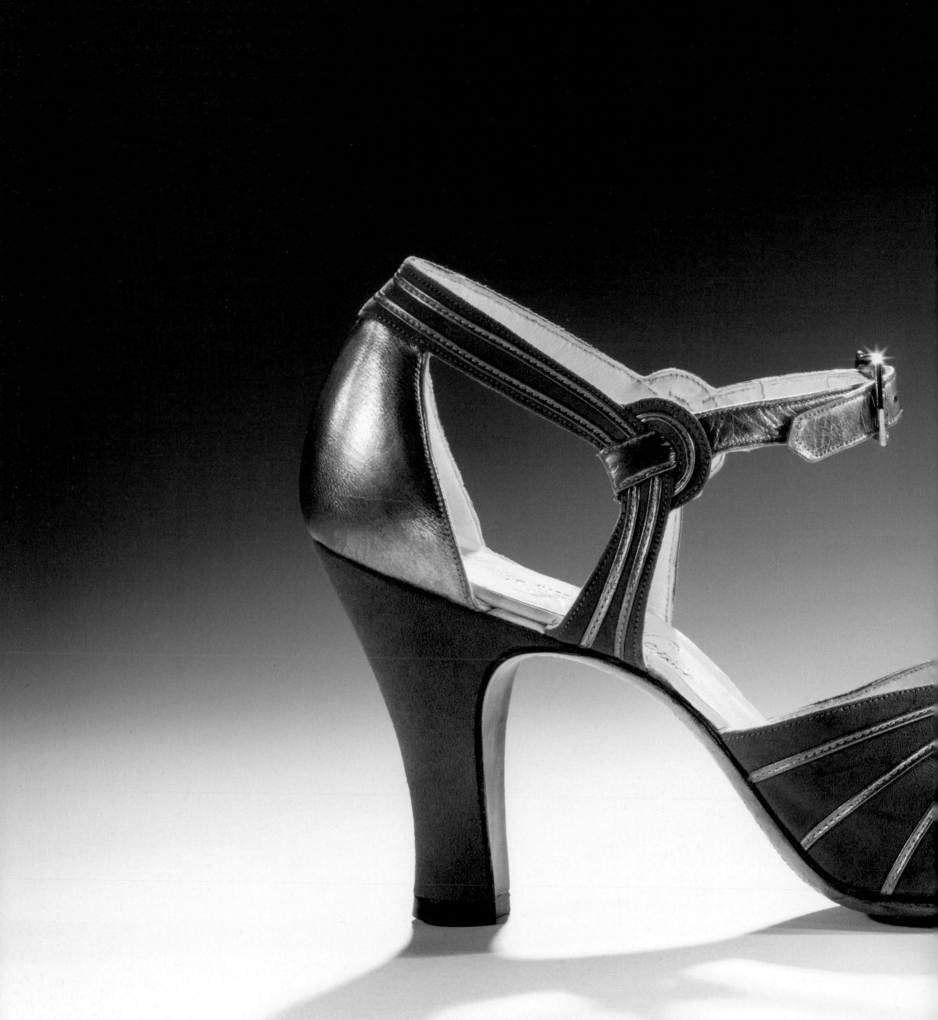

n the 1930s, fashion flourished despite the dire economic impact of the Great Depression. Those who could afford to purchased complete ensembles, while consumers on tighter budgets turned to accessories such as shoes to update their wardrobes. Just as 1920s fashion exposed women's legs, 1930s fashion exposed women's feet, and sandals became a means of instantly refreshing one's look. Evening shoes often featured complex cut-outs and strapping, as seen here, while some designers went so far as to create true sandals for formalwear that all but revealed the entire foot. This elegant blue evening shoe was made by the luxury Swiss shoe brand Bally.

SWISS · DESIGNED BY BALLY · 1935–36

With their sporty stripes and rich "Adidas blue" hue, these glittering high-heeled boots cleverly reflect both the disco and the fitness trends that were so popular in the late 1970s. Although sneakers were becoming increasingly important leisurewear, fashion struggled to reconcile female athleticism with alluring femininity. Designs like this one by British shoe designer Terry de Havilland reflected this tension by tempering the sportiness with overt signifiers of femininity, such as the towering heel and lavish use of glitter.

ENGLISH · DESIGNED BY
TERRY DE HAVILLAND · 1979–81

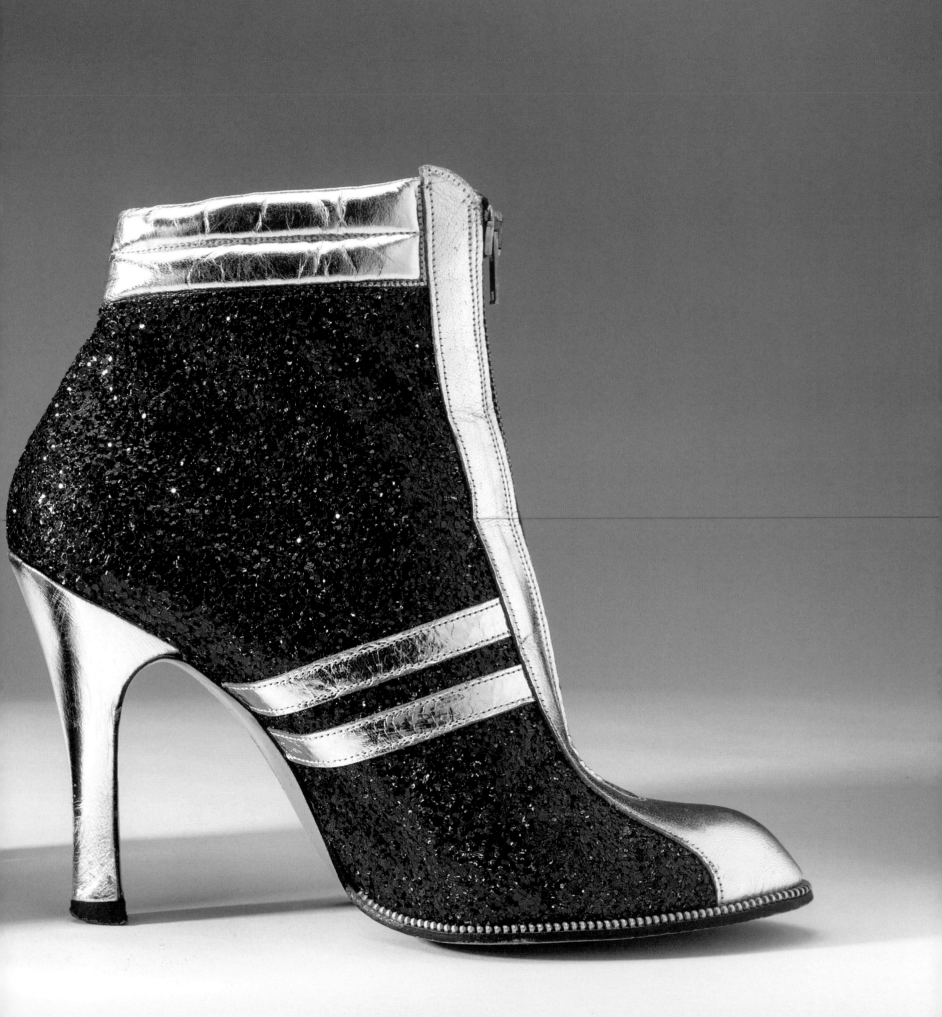

In Shishmaref, a village on Sarichef Island off the coast of Alaska, Inupiat women historically decorated strips of stained caribou skin or sealskin with tightly beaded designs that were used to decorate the tops of boot legs. These boot bands were often sold or traded to women on the mainland in exchange for materials such as caribou skin. This pair of winter boots was made by Ester Obruk in 1983. She used caribou skin for the uppers and sealskin for the soles. Her color scheme was blue, and in addition to using blue beads, she incorporated a blue textile and yarn into her design.

INUPIAT · CREATED BY ESTER OBRUK · 1983

THE WORLD AT YOUR FEET

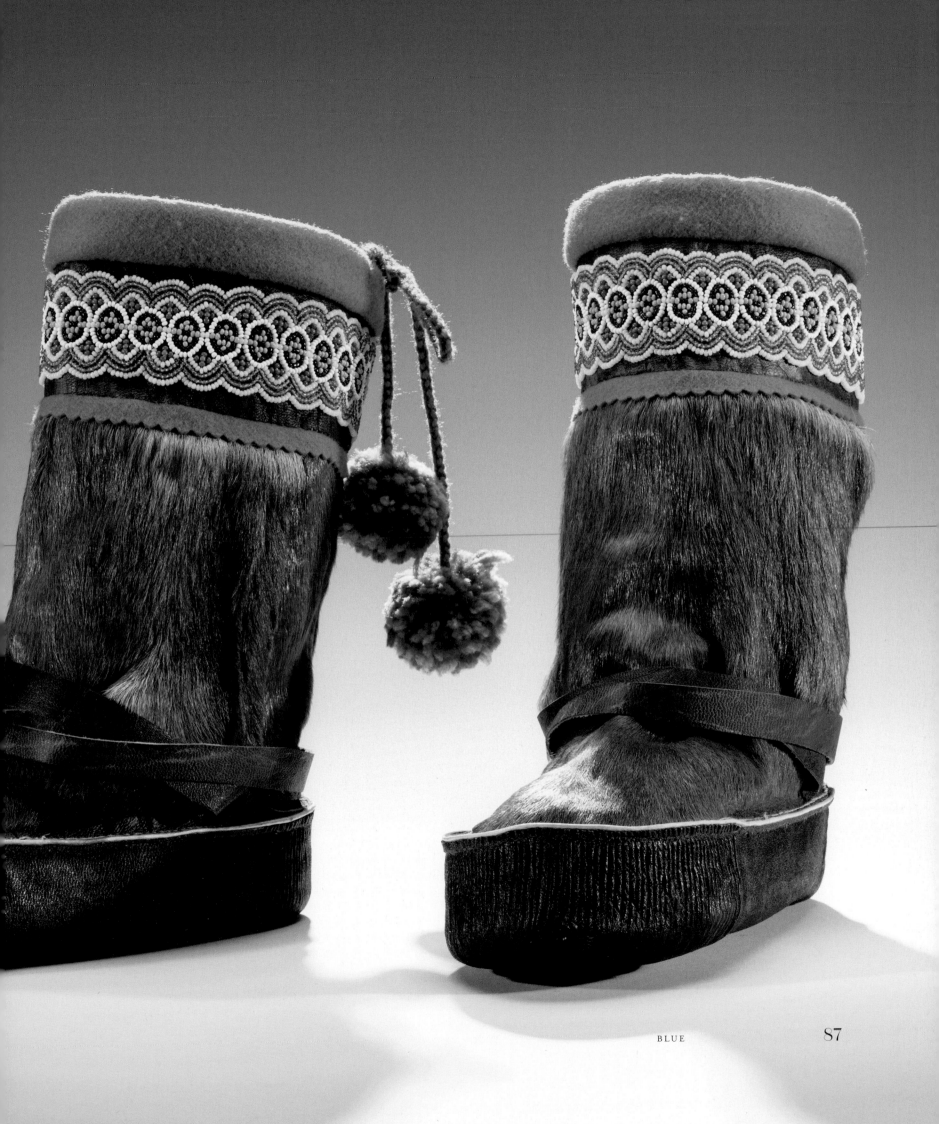

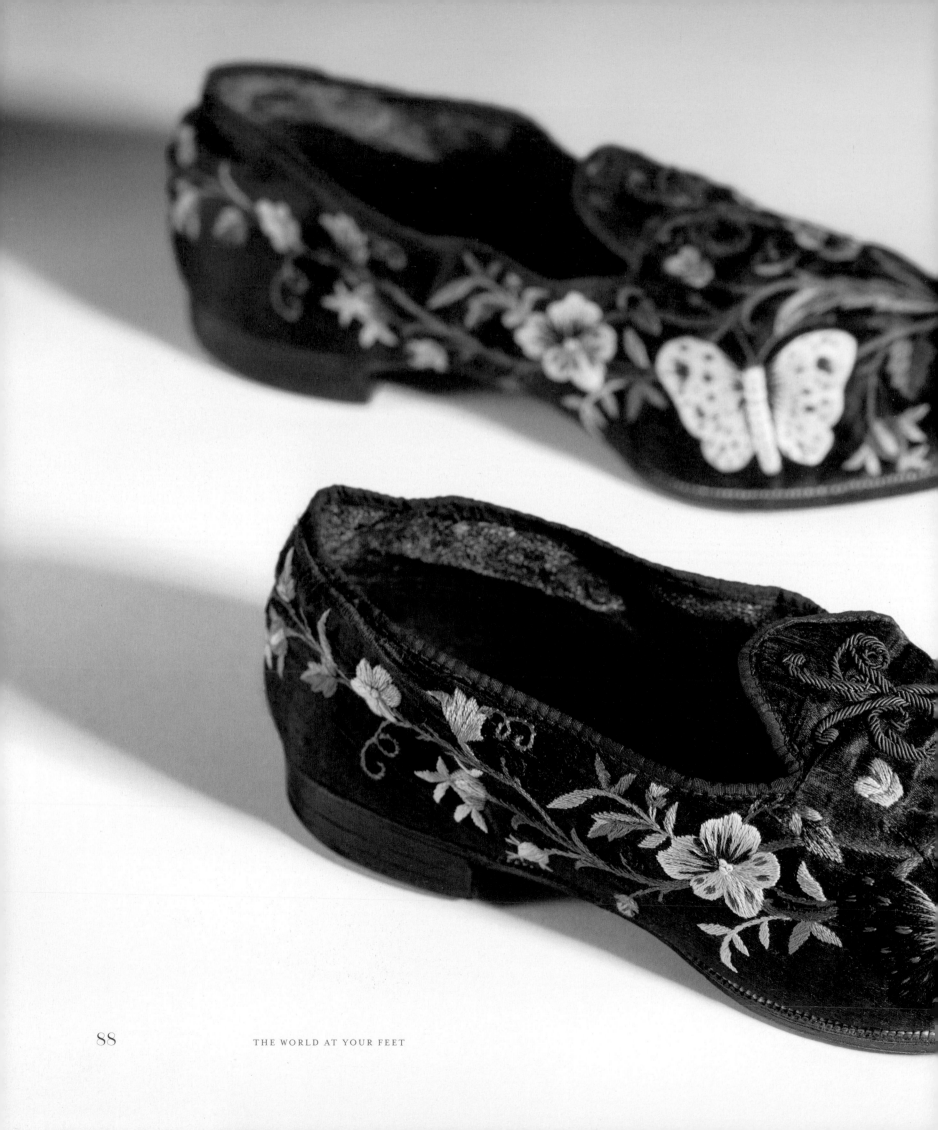

THE WORLD AT YOUR FEET

Floral motifs were popular in Western fashion throughout the nineteenth century. Women's attire made ample use of florals for all occasions, while men's fashion tended to limit flowers to clothing worn at home. These men's silk house slippers were hand-embroidered with flowers and butterflies and other nature motifs. *Pensées,* or "pansies" in English (it can also mean "thoughts"), were probably used on this pair to suggest the thoughtfulness of their French maker. Many women of means in the nineteenth century crafted finely embellished shoe uppers to be made into house slippers that were presented as gifts.

FRENCH · 1860s

oot-binding was practiced by the Han Chinese for more than a thousand years. By the end of the Qing dynasty (1636–1912), *jin lian*, or "golden lotus" feet, had become complex signifiers of feminine beauty, modesty, and status. They were also signifiers of ethnicity, as the Manchus, who ruled China at that time, did not practice this form of body modification. In addition to having their feet bound, a process that typically started around the age of six, Han women were often responsible for making their own footwear, including embroidering the uppers of their shoes. The woman who made this pair of shoes embroidered symbols such as peonies and double coins to convey wishes for financial wellbeing.

HAN · LATE 19TH CENTURY

THE WORLD AT YOUR FEET

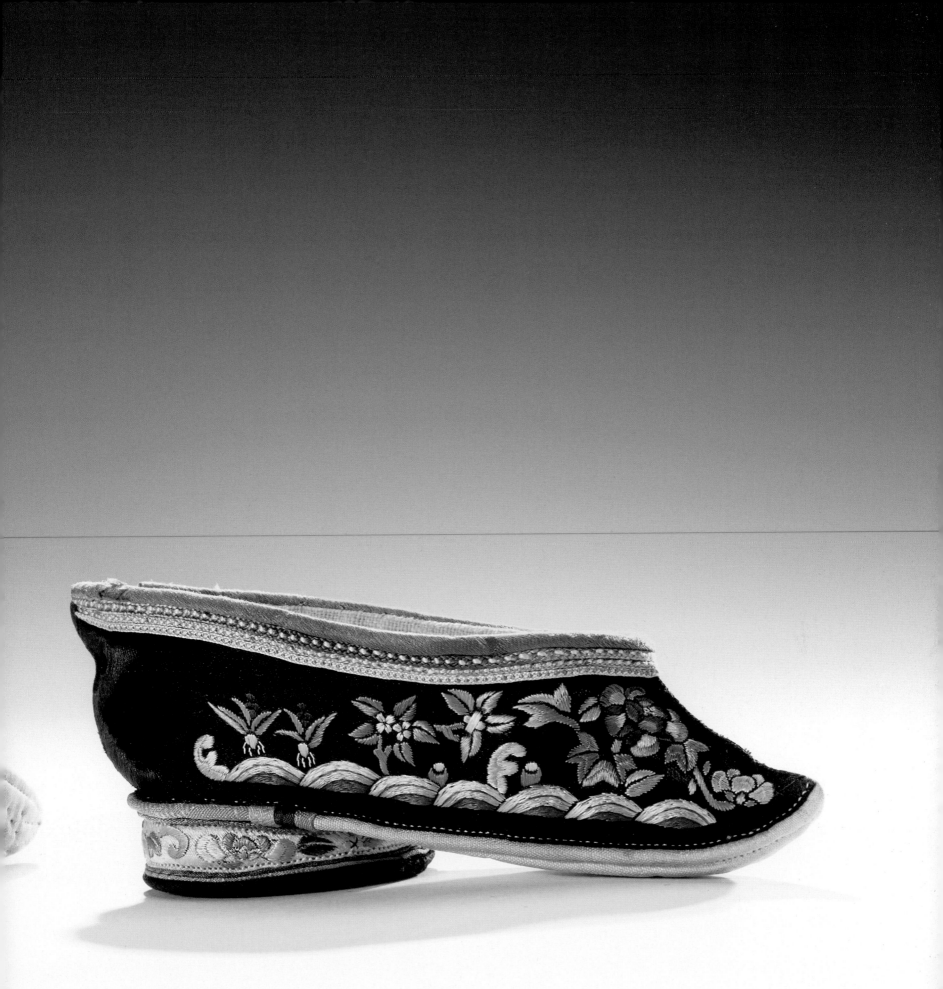

These shoes were designed by American shoe designer Beth Levine in the late 1960s. They are unadorned except for the beautiful rhinestone butterflies that rise up the heel and spread their wings across the back quarters of the shoes. Although Levine never received formal training in shoemaking, she created many groundbreaking designs, including the stretch boot, the spring-o-lator mule, and the topless shoe, which was nothing more than a sole held to the wearer's foot with adhesive pads. Beth Levine and her husband, Herbert Levine, stopped producing footwear in 1979, but the designer remained engaged with the fashion world. She was a staunch supporter and friend to the Bata Shoe Museum until her passing in 2006.

AMERICAN · DESIGNED BY
BETH LEVINE · 1967–69

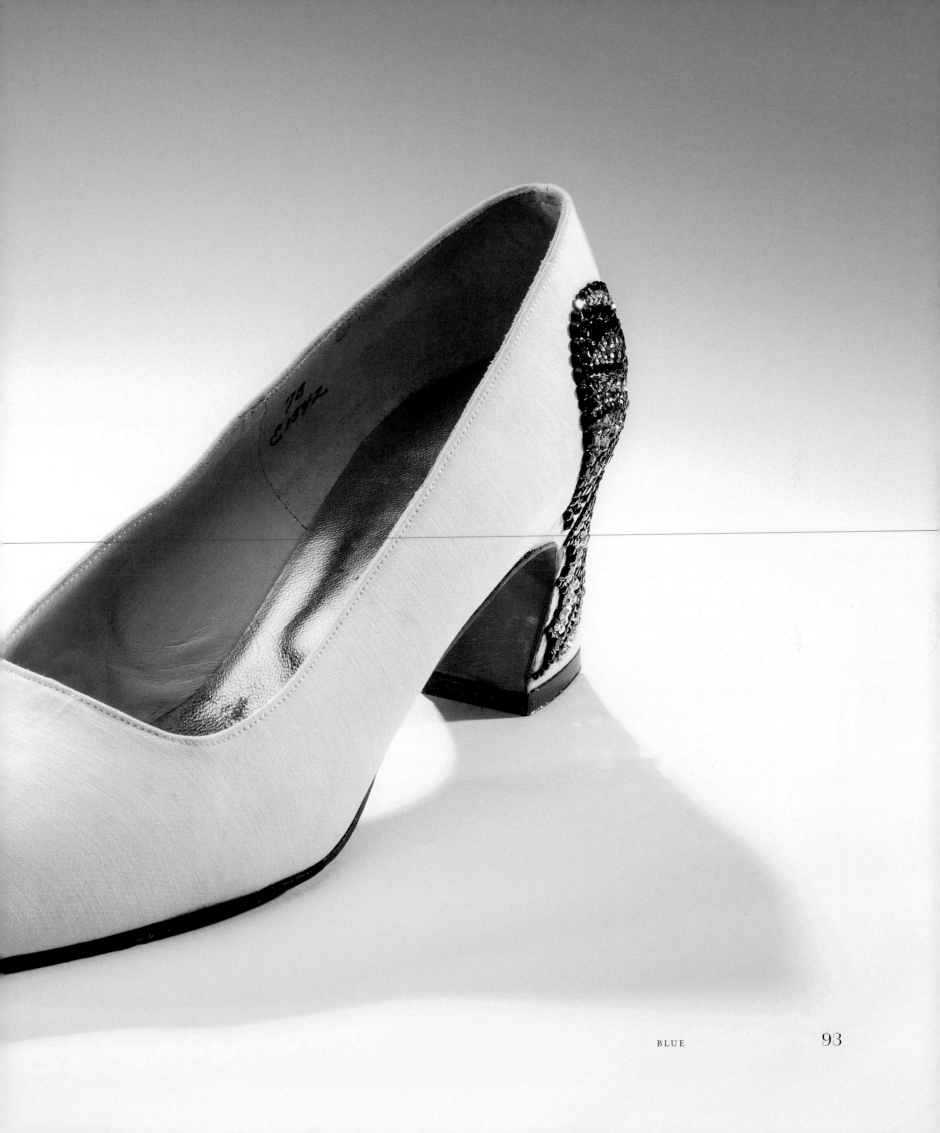

By the end of the eighteenth century, Europe had seen a rise of neoclassical restraint in design and fashion, perhaps in response to the increase in social unrest that led to the French Revolution. Shifting toward more modest fashion statements, the privileged in Europe eschewed rich brocade textiles in favor of a subdued palette of plain silks and printed leathers that were embellished with fine hand-applied decorations, such as sequins, embroidery, and bows. This pair dates to this period of restrained elegance, but the gold sequins, set off against blue silk and highlighted by bright white silk embroidery, ensured that these shoes made a statement.

ITALIAN · 1790s

THE WORLD AT YOUR FEET

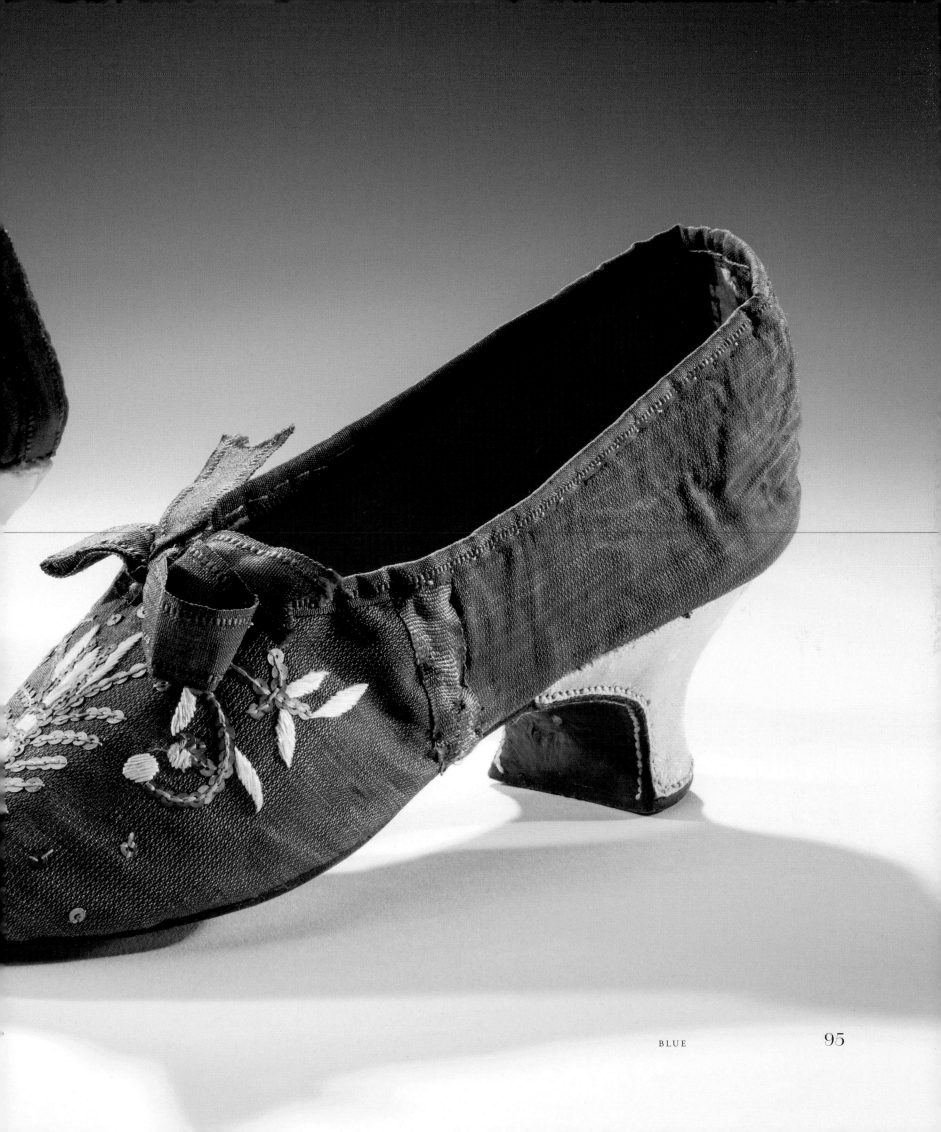

These monochromatic shoes designed by Roger Vivier for the house of Dior are streamlined in their simplicity, yet the small rosettes that hover above the instep by means of thin transparent plastic tabs still have a touch of romance about them. Of all the designers who worked for Dior, Vivier alone had his own name added to the Dior label for the items he designed. This exceptional honor reflected the close professional relationship between Christian Dior and Vivier, who was eminently sympathetic to Dior and his commitment to the architecture of fashion.

FRENCH · DESIGNED BY ROGER VIVIER
FOR CHRISTIAN DIOR · 1961

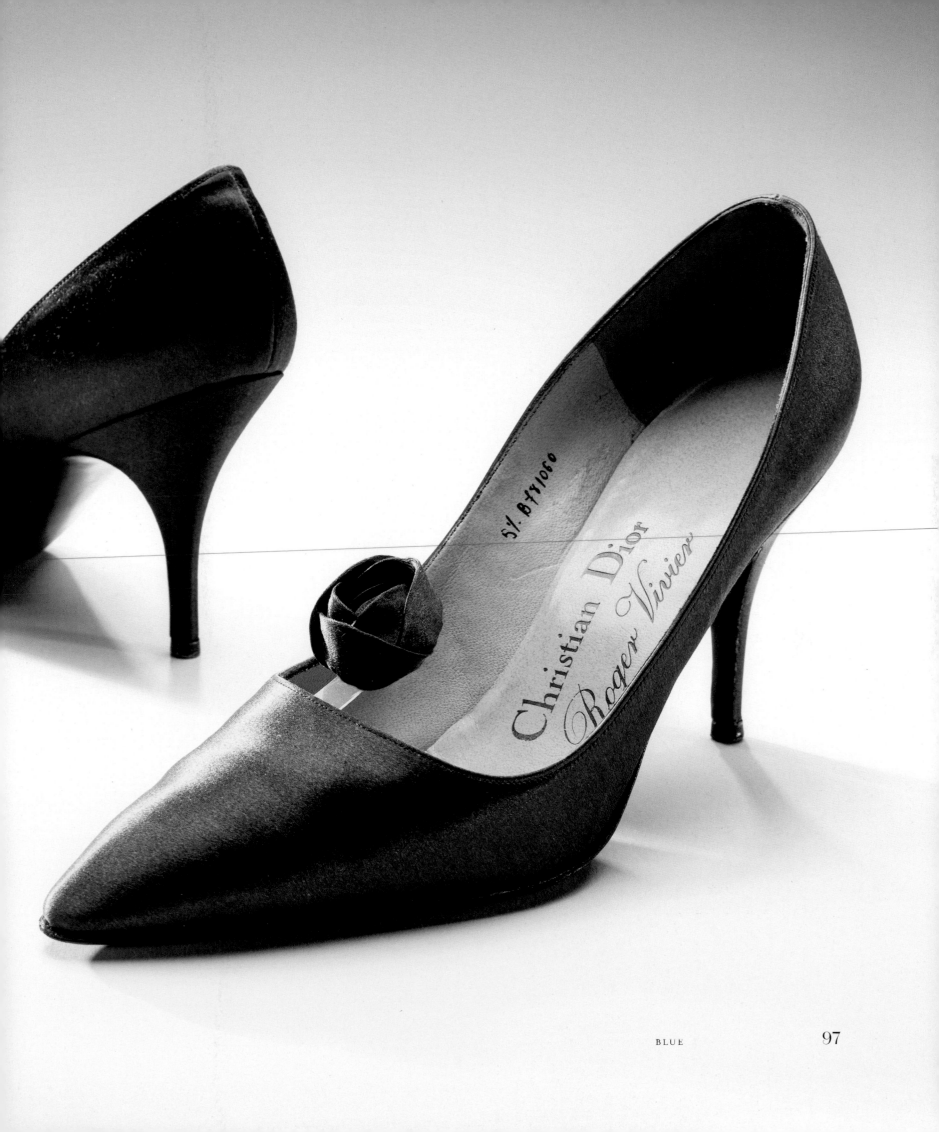

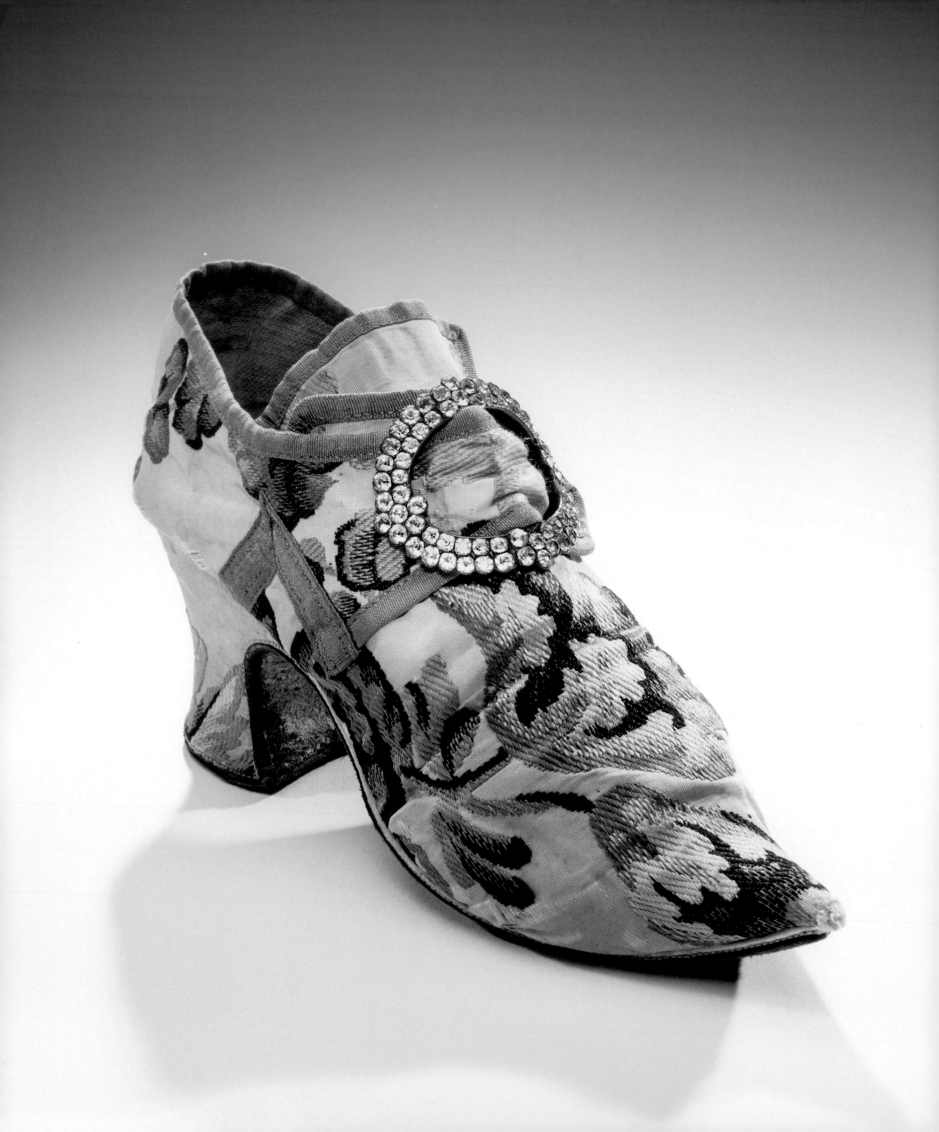

This English eighteenth-century women's shoe was made with Spitalfields silk brocade fabric depicting flowers in blue. Some of the most spectacular textiles in the eighteenth century were made in Spitalfields in the East End of London. Silk brocade was a luxury material, and even the remnants left over from dressmaking would be put to good use. Many women brought such small pieces of material to their shoemakers to have bespoke shoes made. This shoe features many English details, such as the silk; a thick, sturdy heel; a needlepoint toe; and, like other shoes of the period, requires a buckle. Like jewelry, rhinestone-embellished buckles added a bit of sparkle to the wearer's ensemble. The most expensive buckles were made of silver, and many English examples in the Bata Shoe Museum still retain the maker's marks stamped into the metal.

ENGLISH · 1730–50

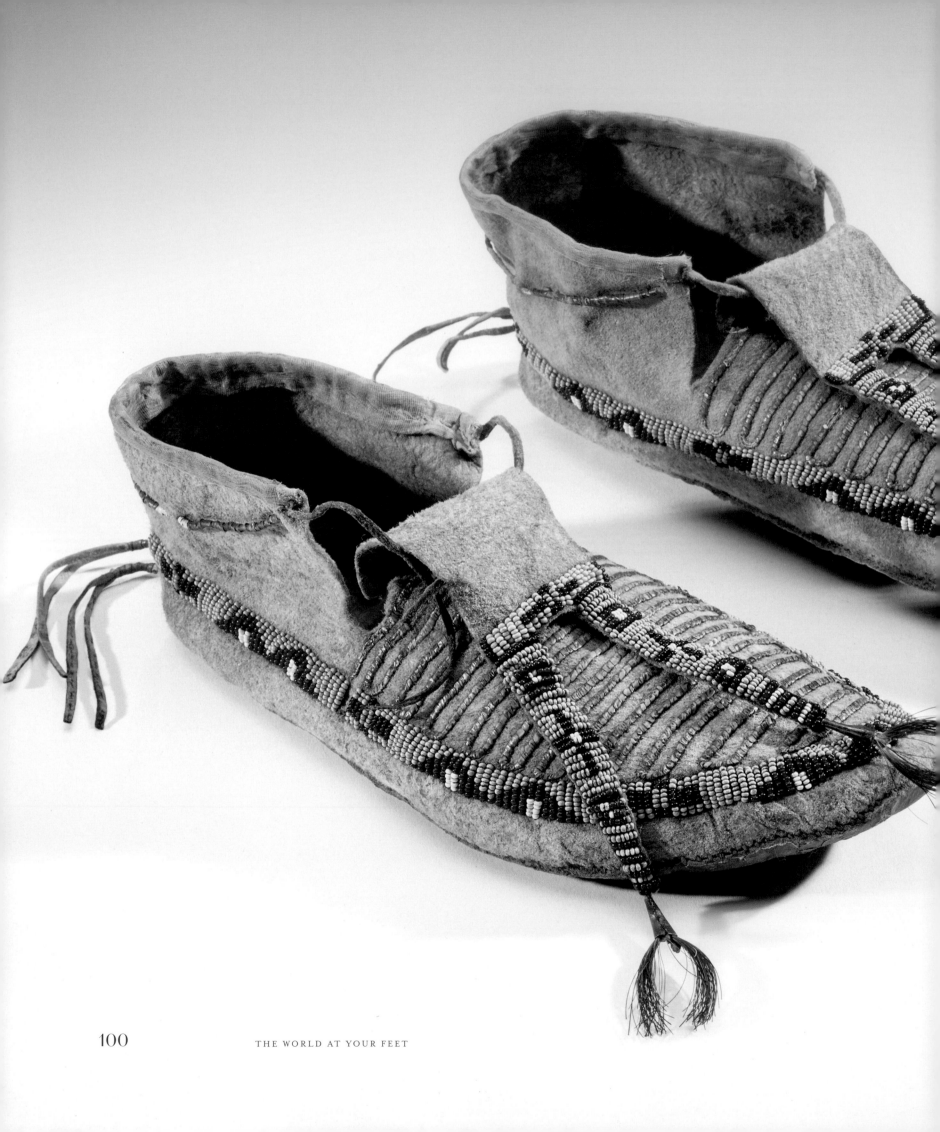

THE WORLD AT YOUR FEET

This pair of Lakota (Sioux) women's moccasins dates to the nineteenth century and features both fine beadwork and exceptional quillwork. The woman who made this pair used three different shades of blue beads, as well as smaller numbers of red, pink, and white beads to create a band around the uppers. She also beaded the forked tongues. The vamps, however, feature rows of red quillwork. These unbroken lines of quillwork are said to express the desire for a long life and healthy children. Porcupine quills were used as embellishment across North America for centuries; colorful European-made glass beads were introduced through trade starting in the seventeenth century.

LAKOTA · 1880–90

orange

THE WORLD AT YOUR FEET

igers have long been symbols of protection, strength, and bravery in Chinese culture. Warriors historically dressed in tiger skins or painted tiger patterns on their armor to ward off danger, and mothers traditionally embroidered tiger symbolism on their children's clothing as a means of protection. This pair of tiger booties was for a small boy and features long silk-tassel whiskers at the toes and frolicking tigers on the sides. The intense shade of orange on the silk further enhances the tiger theme.

HAN · 20TH CENTURY

The demure bows anchored by diminutive rhinestones do little to tame the boldness of this pair of orange silk evening shoes designed by Roger Vivier. In the early 1960s, when new synthetic hydrocarbon-based dyes were being developed, vivid, saturated colors were growing in popularity. Vivier's use of eye-catching color kept his classic stilettos edgy. This pair was once in the collection of Mary Robertson, a personal friend of Roger Vivier.

FRENCH · DESIGNED BY ROGER VIVIER
FOR CHRISTIAN DIOR · 1962

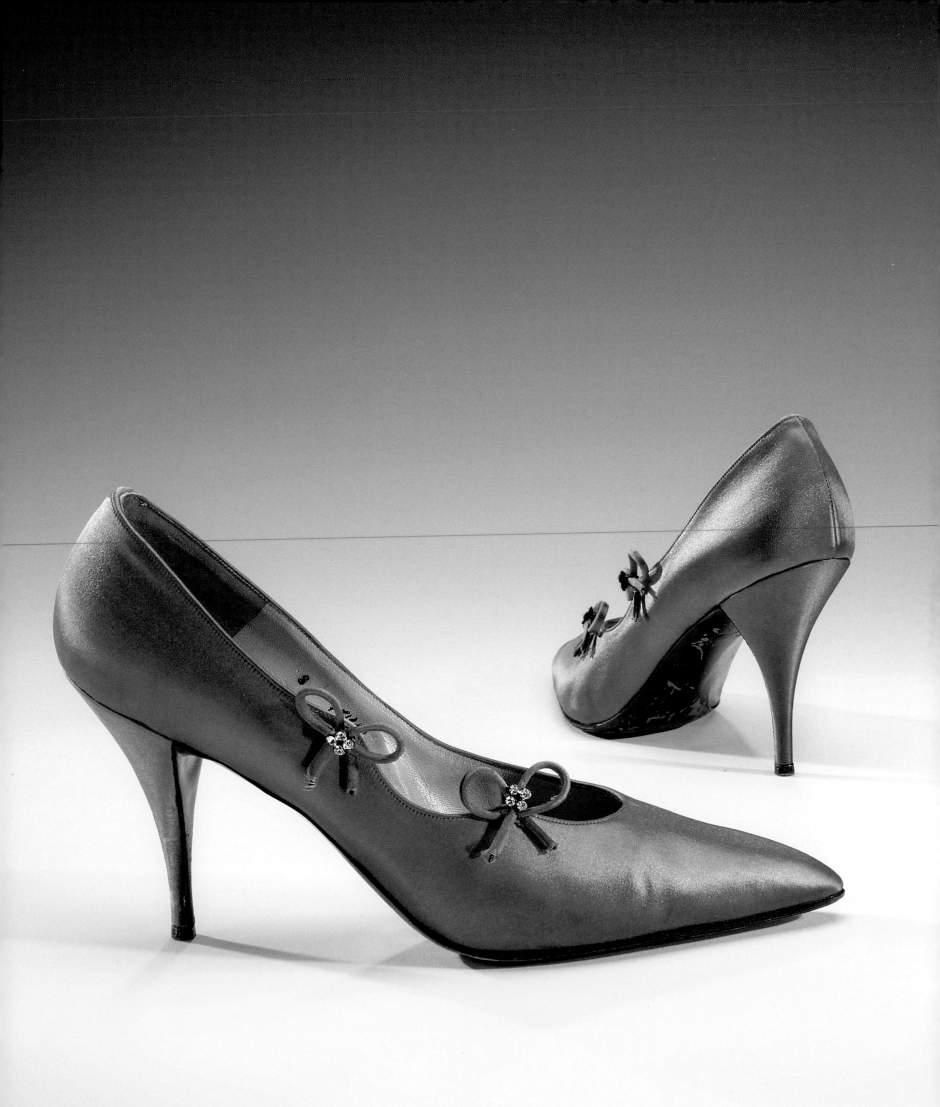

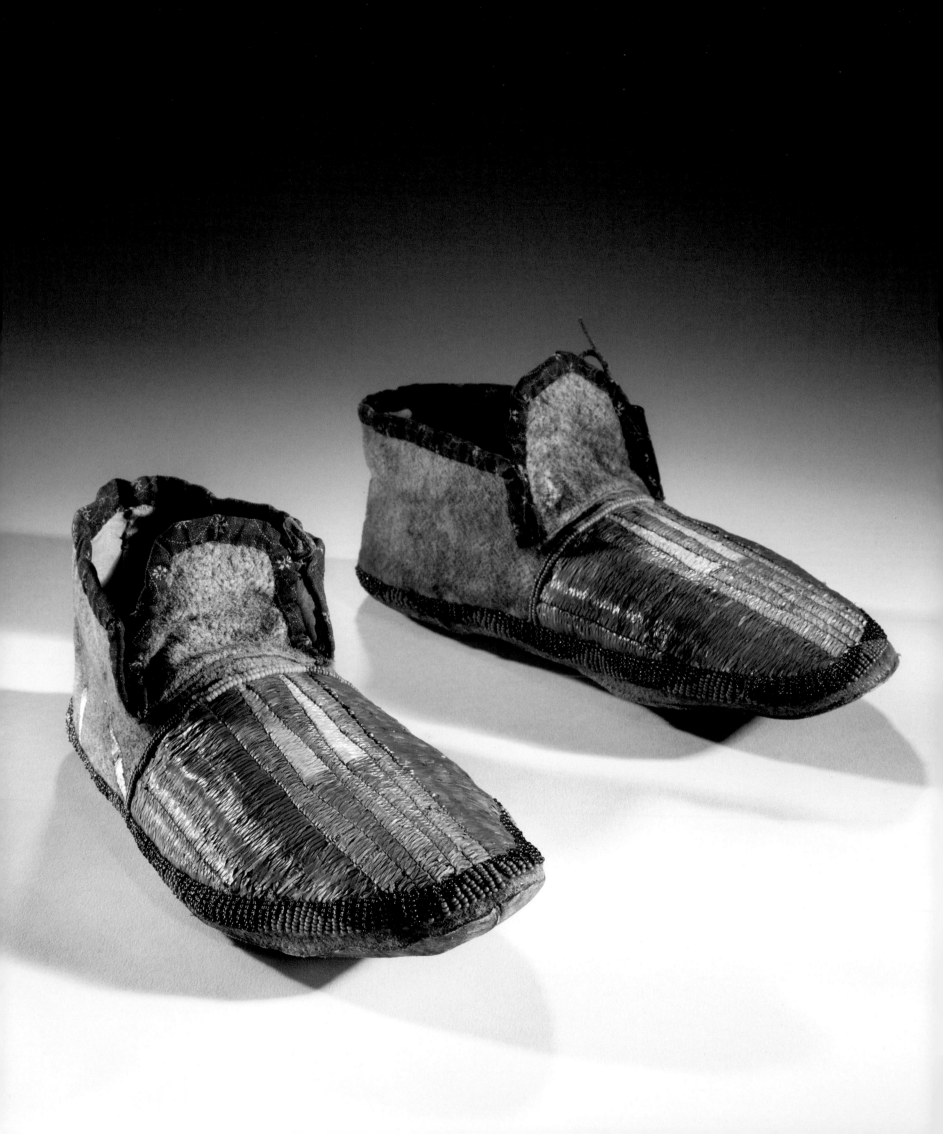

In the nineteenth century, Hidatsa women were famous across the Great Plains for their especially fine quillwork. Porcupines have a range of quills on their bodies, but those preferred for quilling come from the abdomen. Typically white, these quills can be dyed, and before the invention and widespread availability of aniline dyes they were colored using natural dyes. Quilling can be done in a variety of ways. The woman who did the quillwork on this pair was exceptionally skilled, and she painstakingly interwove each flattened quill while also couching it in place using sinew thread.

HIDATSA · c. 1890

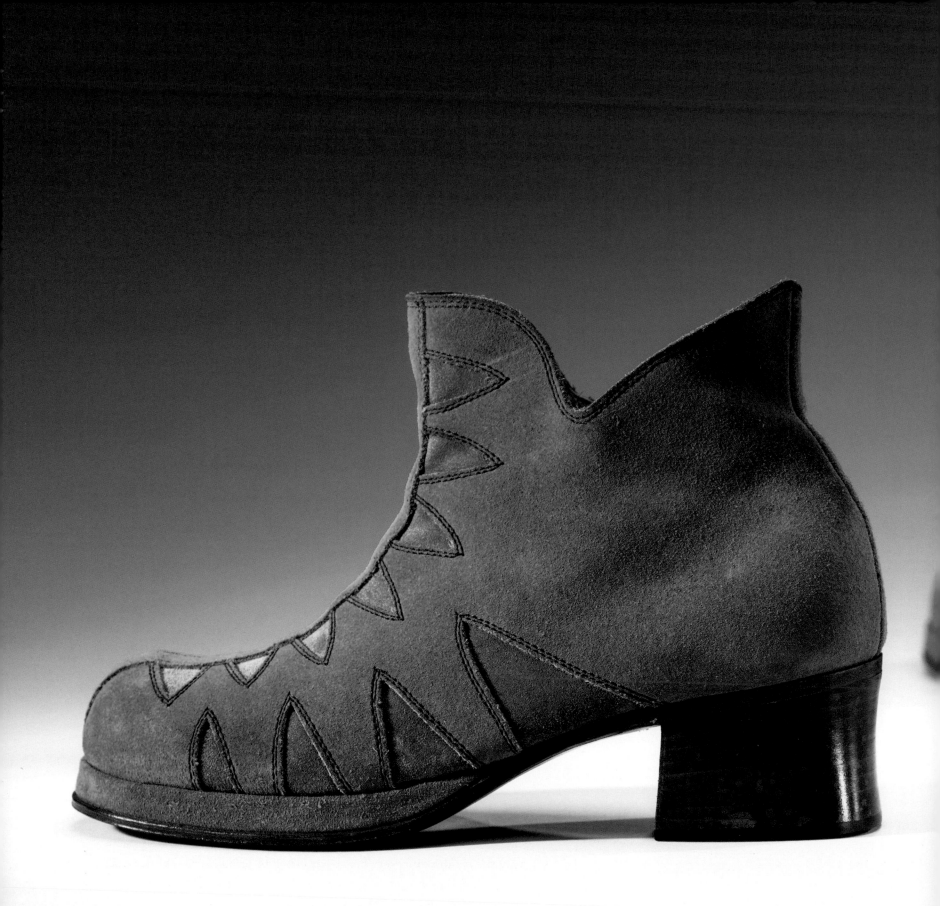

THE WORLD AT YOUR FEET

n the 1960s, many people in the West were interested in challenging the rigid social constructions of gender. Proponents of the self-styled Peacock Revolution encouraged men to be more adventurous in their dress and to reclaim what they argued was the male privilege of display demonstrated in other animal species, from lions to peacocks. This push for more daring sartorial choices, however, was not an attempt to disrupt the gender binary; rather, it was meant to revitalize masculine gender expression by aligning it along more "natural" lines. This pair of men's boots, with tiger-orange suede uppers cut in a jagged pattern to reveal blue suede insets that are suggestive of sharp teeth, is perfect for projecting a more assertive, even animalistic masculinity.

PROBABLY ENGLISH · LATE 1960S–EARLY 1970s

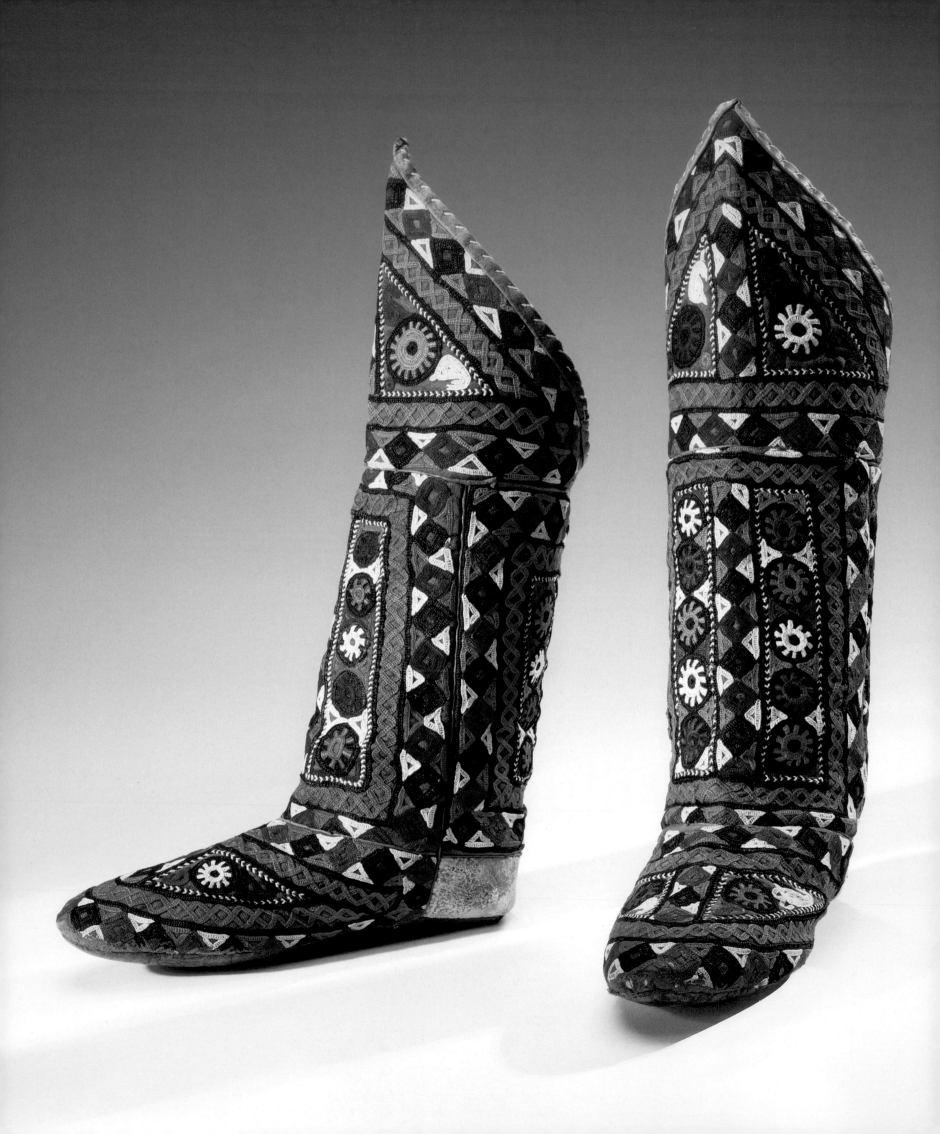

In northern Afghanistan, highly decorated leather socks were designed to be worn indoors without shoes, while out-of-doors they were worn with overshoes. Together, the knee-high socks and overshoes functioned like a boot and would be worn for horseback riding, as well as other activities. This pair features traditional Uzbek embroidery. Hallmarks of this work include the use of bright colored embroidery thread worked in dense geometric designs.

POSSIBLY UZBEK · LATE 19TH CENTURY

In the early 2000s, researcher and travel writer Ruth Malloy visited Mongolia to acquire artifacts for the Bata Shoe Museum. She supplemented her acquisitions with documentary photographs and recorded interviews with Mongolian bootmakers, providing invaluable insights into traditional methods of boot-making. While the majority of artifacts she acquired were contemporary, one pair of boots was historic: they had been worn by Tsendiin Dondogdulam, the first consort of Bogd Khan, the eighth Jebtsundamba Khutuktu and the last monarch of Mongolia, who was responsible for declaring independence from China in 1911 and then ruled Mongolia until 1924, when the monarchy was abolished. This elaborately embroidered boot features numerous designs, among them the Buddhist swastika, a long-standing auspicious symbol throughout Asia.

MONGOLIAN · EARLY 20TH CENTURY

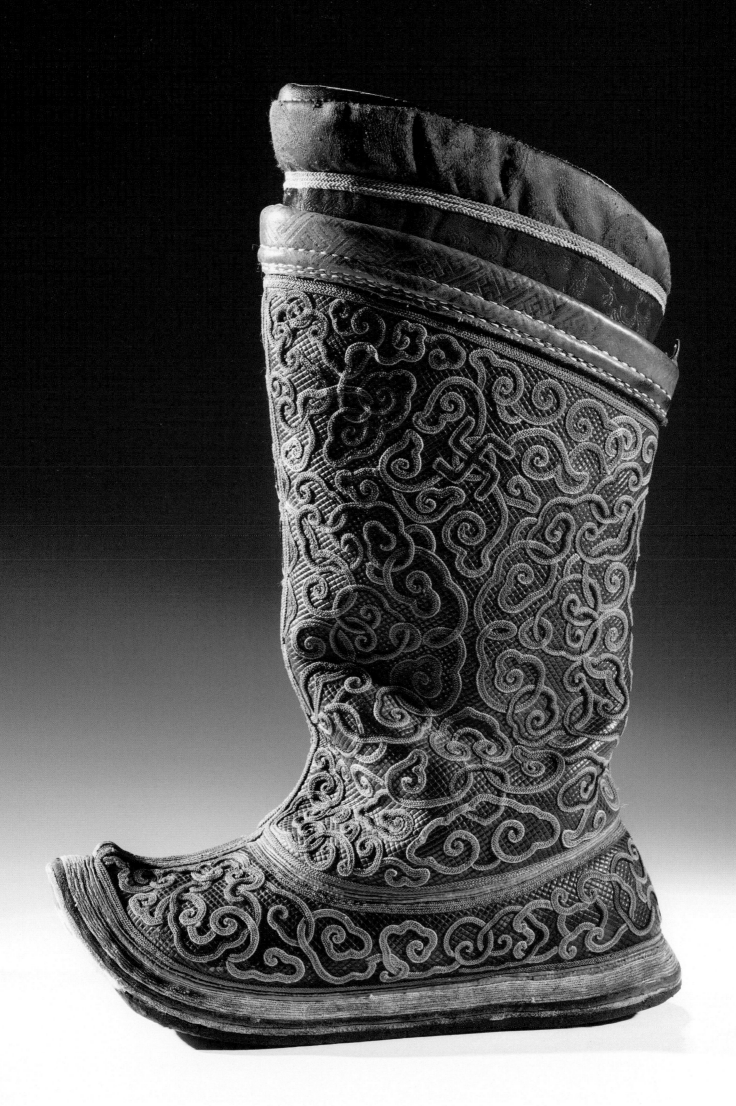

hese heavy sequined platform shoes might have seemed utterly contemporary in the 1970s, but the multicolored pattern is suggestive of the costume worn by Harlequin, a central character in the centuries-old Italian commedia dell'arte. Harlequin's costume is typically composed of brightly colored patchwork, often in a diamond pattern, and his character is lighthearted and good natured, associations well suited for a night at the disco.

ITALIAN · DESIGNED BY LORIS AZZARO · 1970s

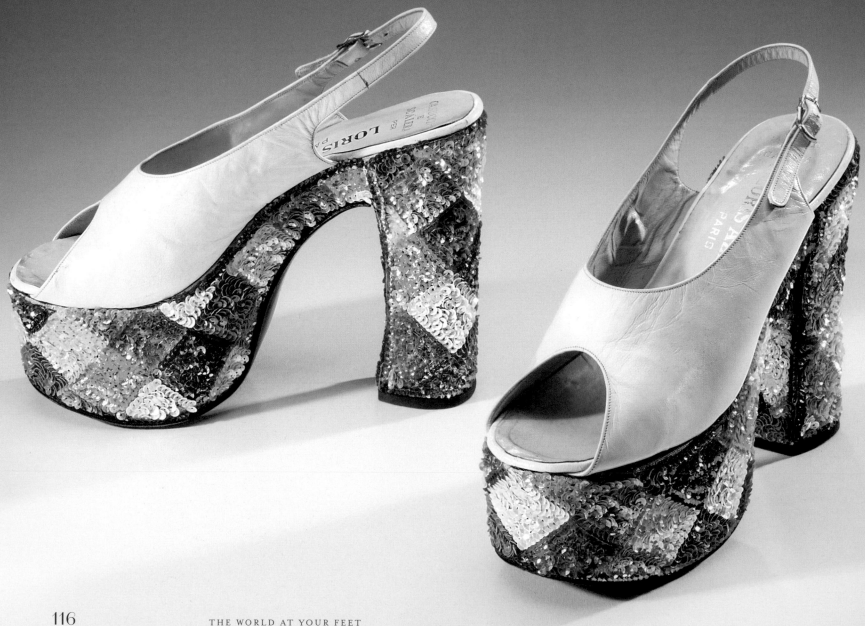

　THE WORLD AT YOUR FEET

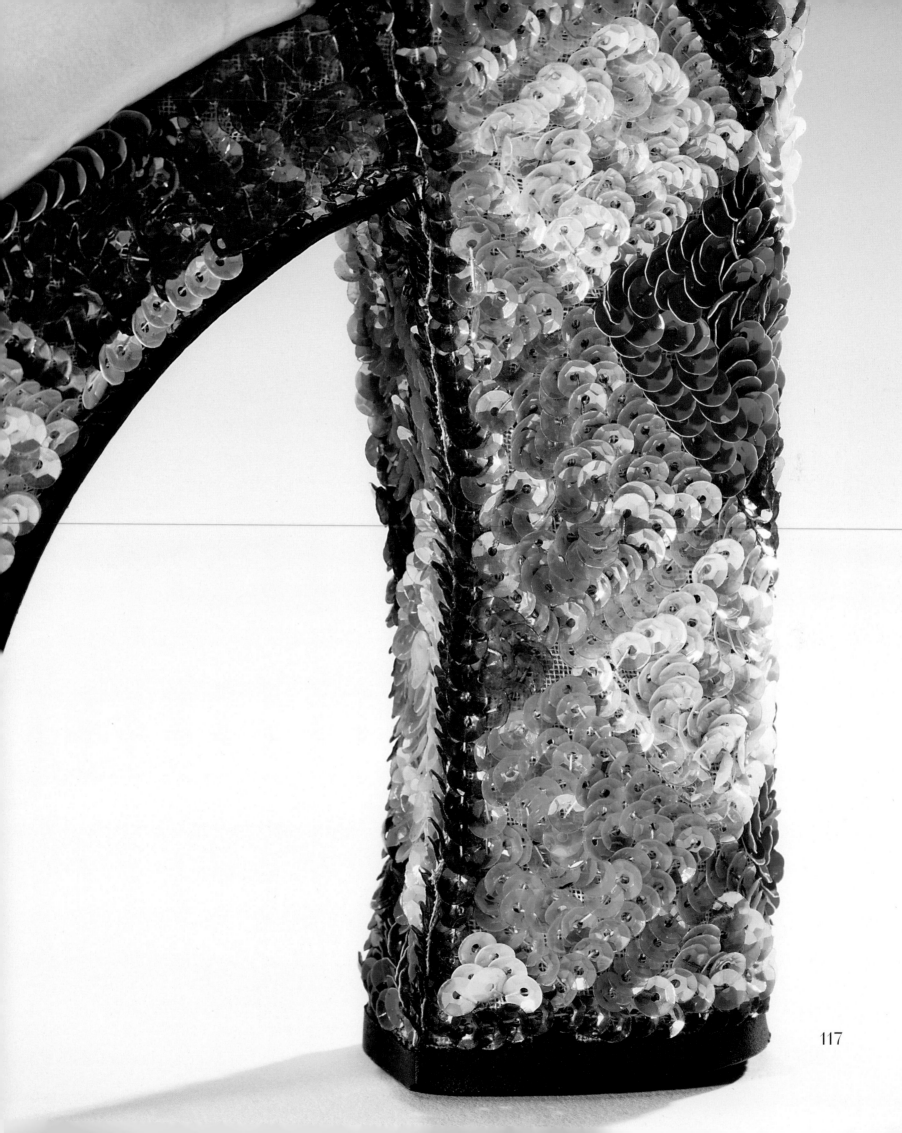

Bison and horses were of central importance to many of the nations who lived on the Great Plains in the nineteenth century, and symbols related to them found expression in women's artistry, as displayed in this pair of Tsitsistas/Suhtai (Cheyenne) shoes. The distinctive "keyhole" shape on the vamps of this pair is thought to represent a "buffalo pound," which was an enclosed space, either engineered or part of the natural landscape, used to encircle a herd of bison so that they could be killed more easily. Horses were integral to the success of bison hunts, and the maker built on that theme by depicting six horses on each moccasin encircling the wearer's feet.

TSITSISTAS / SUHTAI · LATE 19TH CENTURY

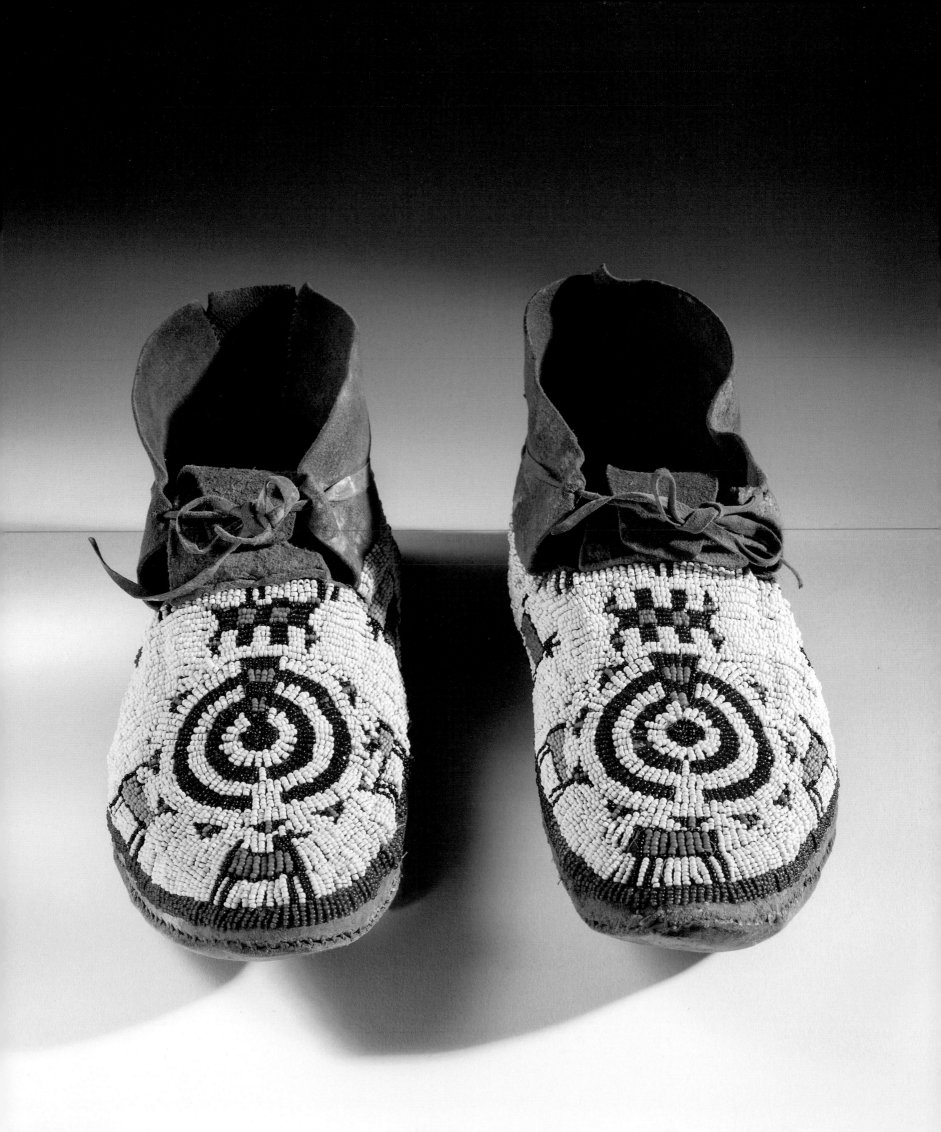

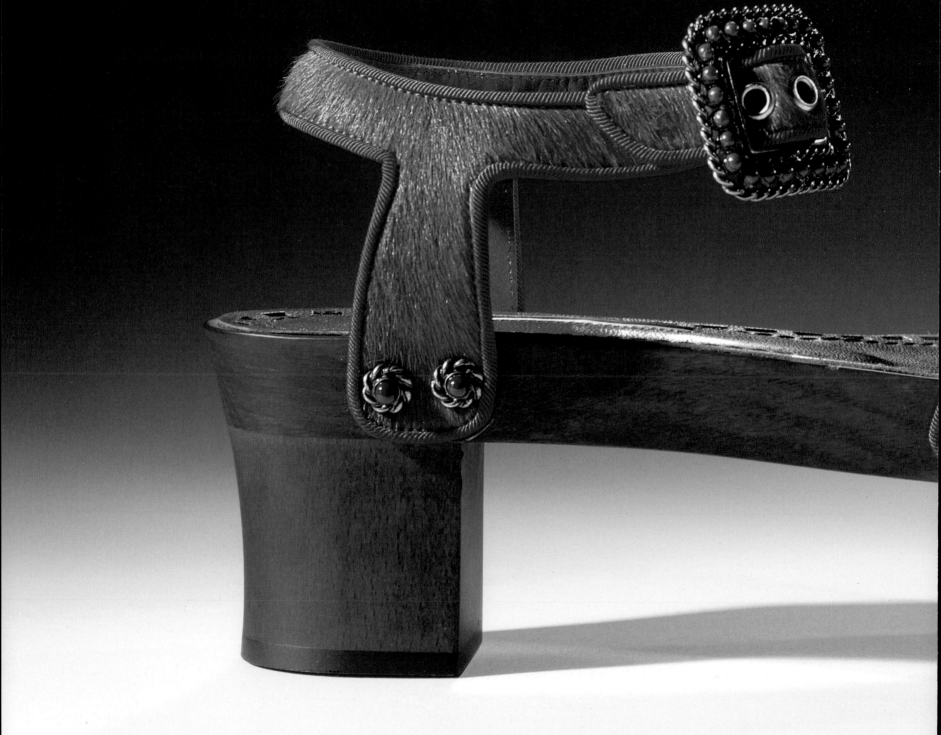

THE WORLD AT YOUR FEET

anolo Blahnik, a world-renowned shoe designer, finds inspiration at every turn. This bright orange wooden sandal from his Spring/Summer 2016 collection was inspired by traditional Turkish *nalin* bathhouse clogs, but the broad, heavy strapping and the faux coral-encrusted buckle are pure Blahnik. This model, called Milenotus, is one of Blahnik's favorite designs. In 2018 the Bata Shoe Museum hosted *Manolo Blahnik: The Art of Shoes,* a traveling retrospective of Blahnik's work. In addition to attending the opening of the show, he spent an afternoon in storage studying the footwear in the museum's collection. Perhaps one of the artifacts he saw there will inspire one of his future designs.

ENGLISH · DESIGNED BY MANOLO BLAHNIK ·
2016 · GIFT OF MANOLO BLAHNIK

he Buddhist kings in what is now Myanmar used to wear golden footwear in the shape of the sacred *hintha*, or *hamsa* (in India), bird as part of their royal garments. These birds, which usually refer to a goose, a duck, or a swan, are important Hindu and Buddhist symbols that signify purity, harmony, and good character. In Myanmar they are also symbols of serene authority, making them perfect for royal regalia. These royal shoes are believed to date to the Konbaung dynasty, the last Burmese dynasty, which ruled between 1752 and 1885. The maker of this pair recreated the hintha bird's golden feathers in traditional *shew-chi-hto* embroidery, which incorporates gold thread, gold sequins, beads, and cut glass into its lavish designs.

MYANMARESE · 19TH CENTURY

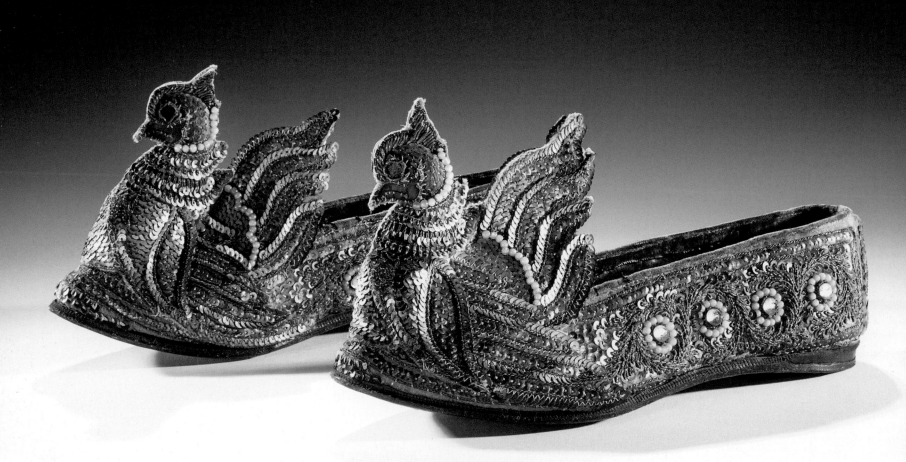

THE WORLD AT YOUR FEET

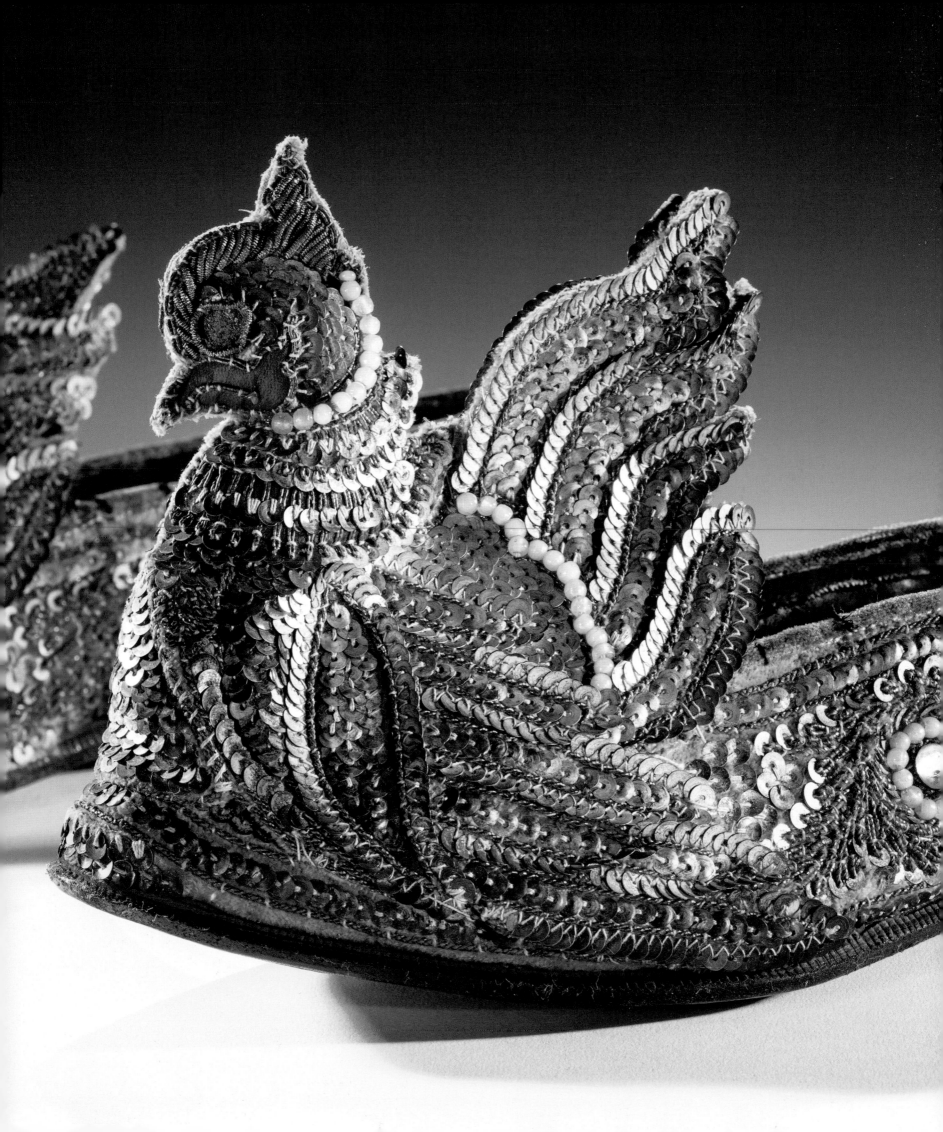

yellow

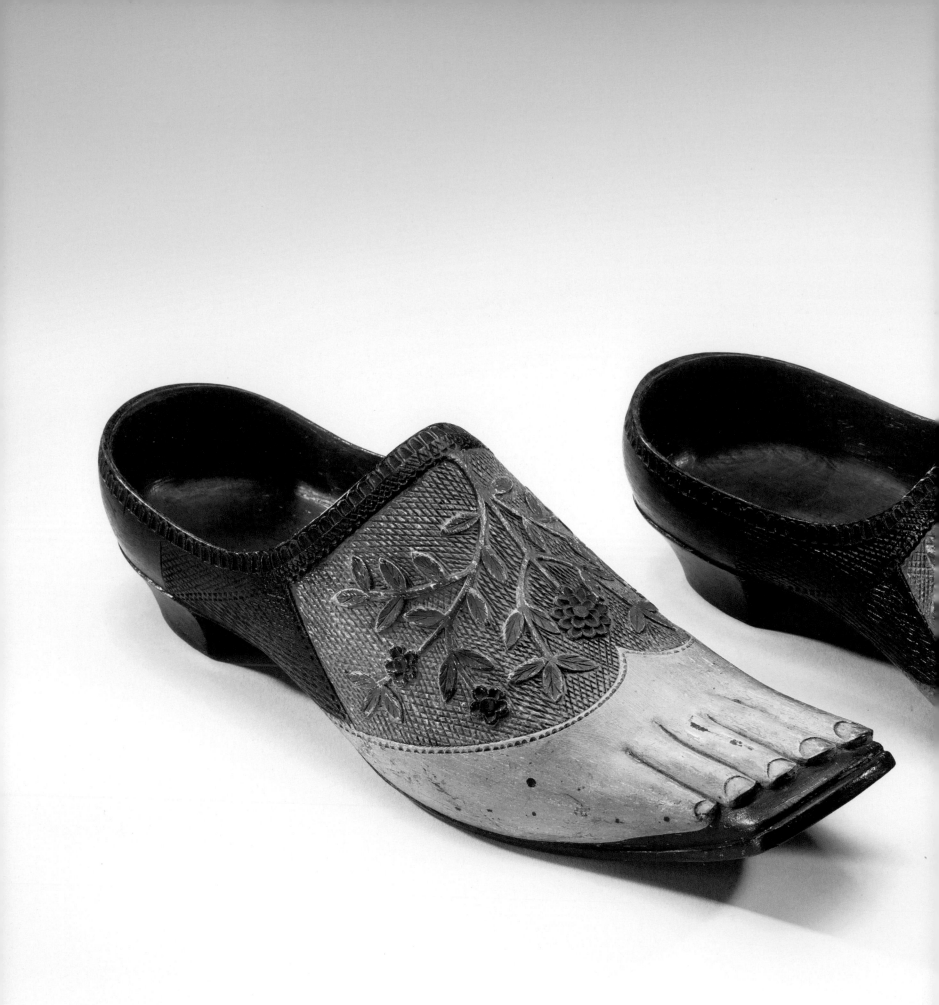

THE WORLD AT YOUR FEET

These nineteenth-century Dutch clogs feature finely carved representations of naked feet. At first glance they seem delightfully whimsical, but closer inspection reveals that the toes have been sculpted to look like the wingtips of a man's business shoe and stitched into place with a winged peak. The carefully carved floral design set against a pleasing yellow background offers a distraction from the inexplicable toes. European clogs are often thought of as simple wooden work shoes, but some historic examples, like these, feature elaborate carvings and painted motifs. This unusual pair may have been intended for special occasions. It was one of Sonja Bata's favorite artifacts.

DUTCH · LATE 19TH CENTURY

French fashion designer Christian Lacroix is famous for his love of exuberant color, his lavish embellishments, and his playful collaging of historic motifs, all of which are on ample display in this evening shoe. The rich yellow fabric with its bold floral pattern is reminiscent of eighteenth-century brocade, and the glittering rhinestones suggest both eighteenth-century shoe buckles and Art Deco jewelry of the 1920s. Another reference to the 1920s is seen in the classic T-strap, but the high thin heel and elongated toe are utterly contemporary.

FRENCH · DESIGNED BY
CHRISTIAN LACROIX · 2007

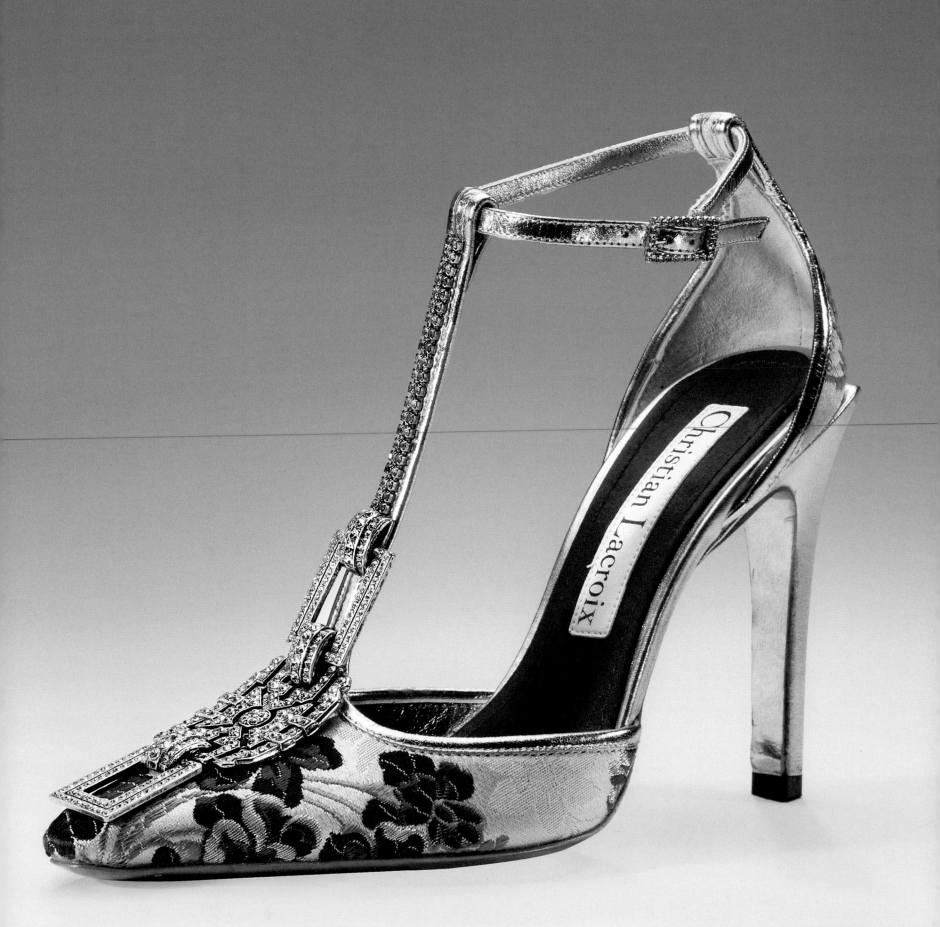

This pair of Jicarilla N'de (Apache) shoes dates to the late nineteenth century and displays many of the features associated with traditional N'de footwear, including a strongly asymmetrical cut of the sole, slightly upturned toes, and high angled collars. The fine beadwork is influenced by designs found across the Great Plains, while the use of yellow pigment reflects a more Southwestern aesthetic, as does the use of trailing fringe. An ocher mineral pigment has been rubbed into the hide to impart the warm yellow hue.

JICARILLA N'DE · c. 1890

THE WORLD AT YOUR FEET

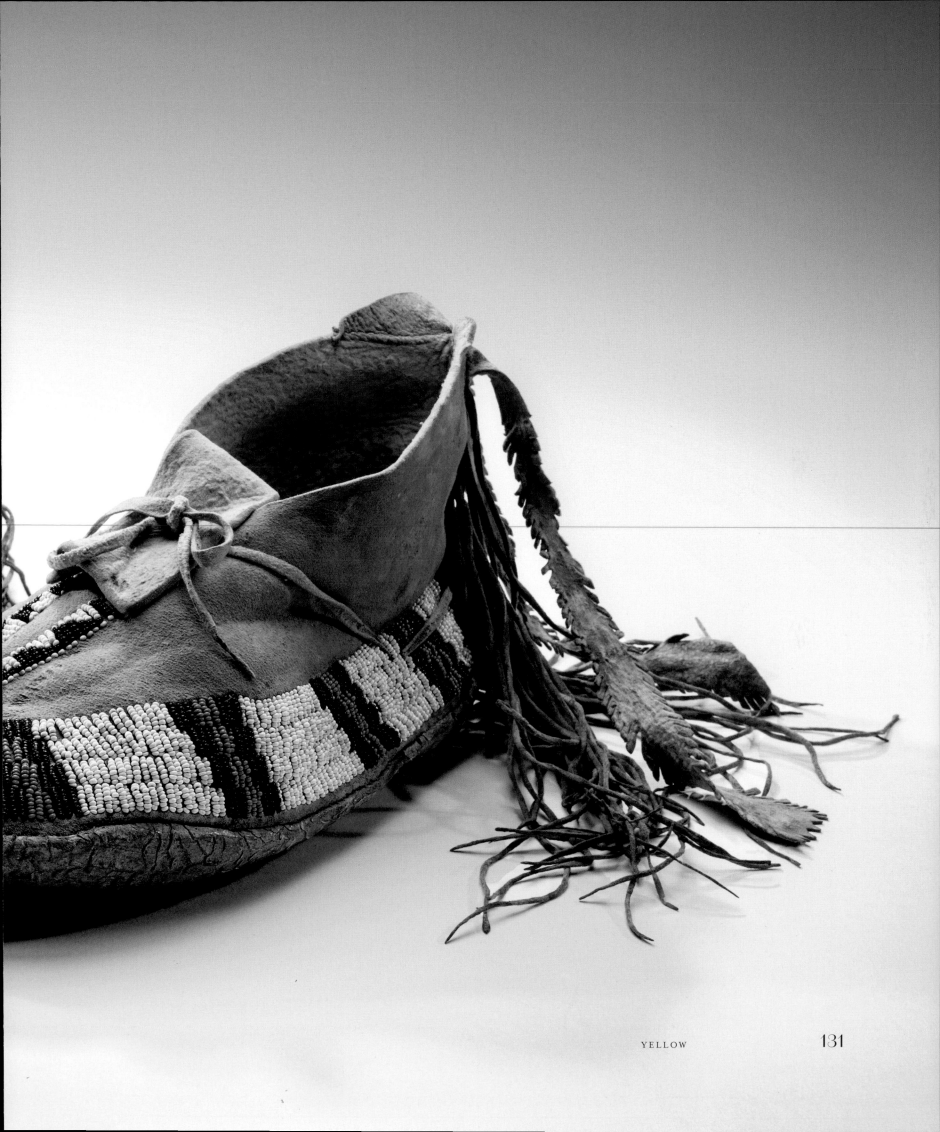

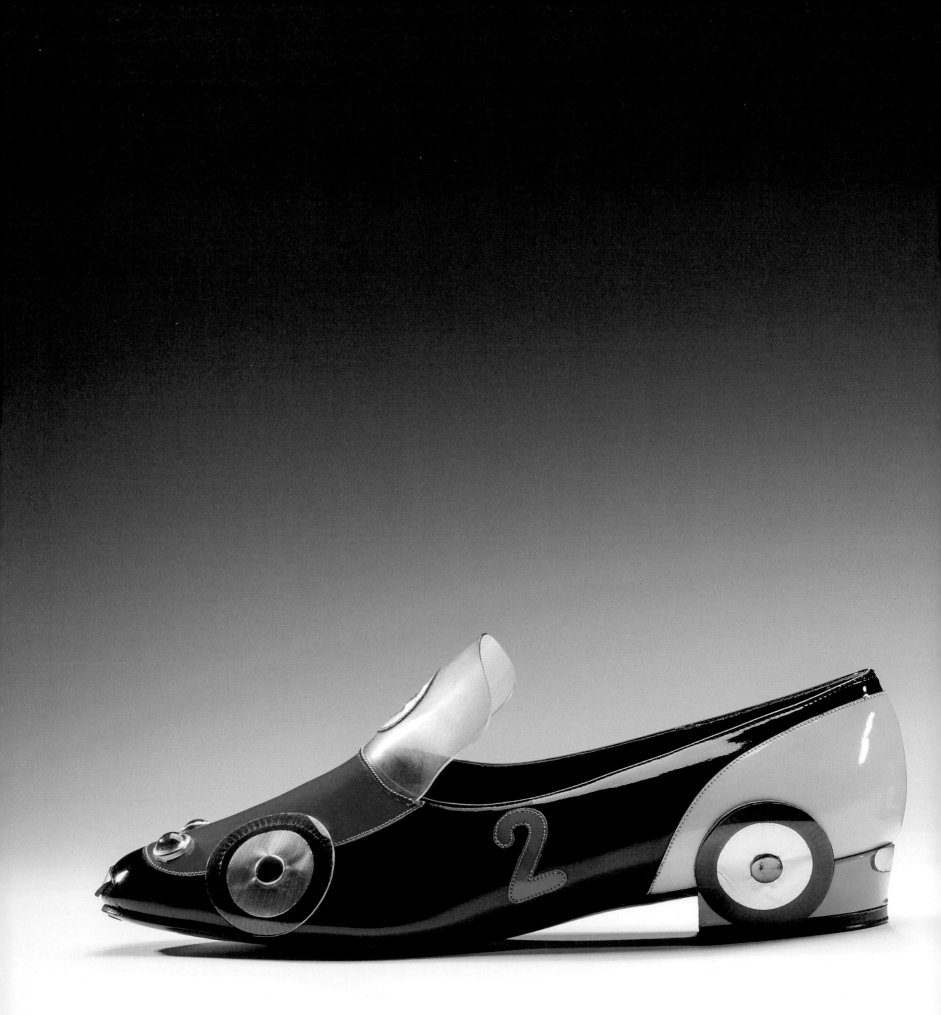

THE WORLD AT YOUR FEET

American Beth Levine was one of the most innovative shoe designers of the twentieth century. She started out in journalism and advertising before her "perfect" size-four-and-a-half feet landed her a job as a shoe model. Levine spent her nights dreaming about making shoes, and her dream came true when she and her husband, Herbert Levine, established their own company in the 1940s. Together they went on to win many of fashion's most prestigious accolades, including the 1967 and 1973 Coty Awards. Her wit found expression in almost everything she created, including this playful pair inspired by race cars, complete with windshields, tires, and racing numbers.

AMERICAN · DESIGNED BY
BETH LEVINE · 1965–68

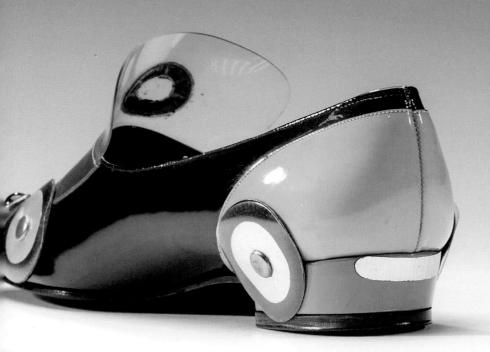

This pair of bright sunny yellow *balgha*, also called *babouche*, comes from Morocco. *Balgha* are a type of flat-soled footwear that typically have the back quarters pressed down flat against the insole. They are commonly worn throughout North Africa, in part as a reflection of Muslim faith. Their distinctive design is thought to reflect the wearer's piety, as they can easily be slipped off for *salat*, the five daily prayers offered by the devout. *Balgha* can be unadorned or they can be heavily embellished, as is this pair, which features elaborate leather and silk embroidery. The back quarters of these shoes have been stitched in place, adding another design element.

MOROCCAN · 1980s

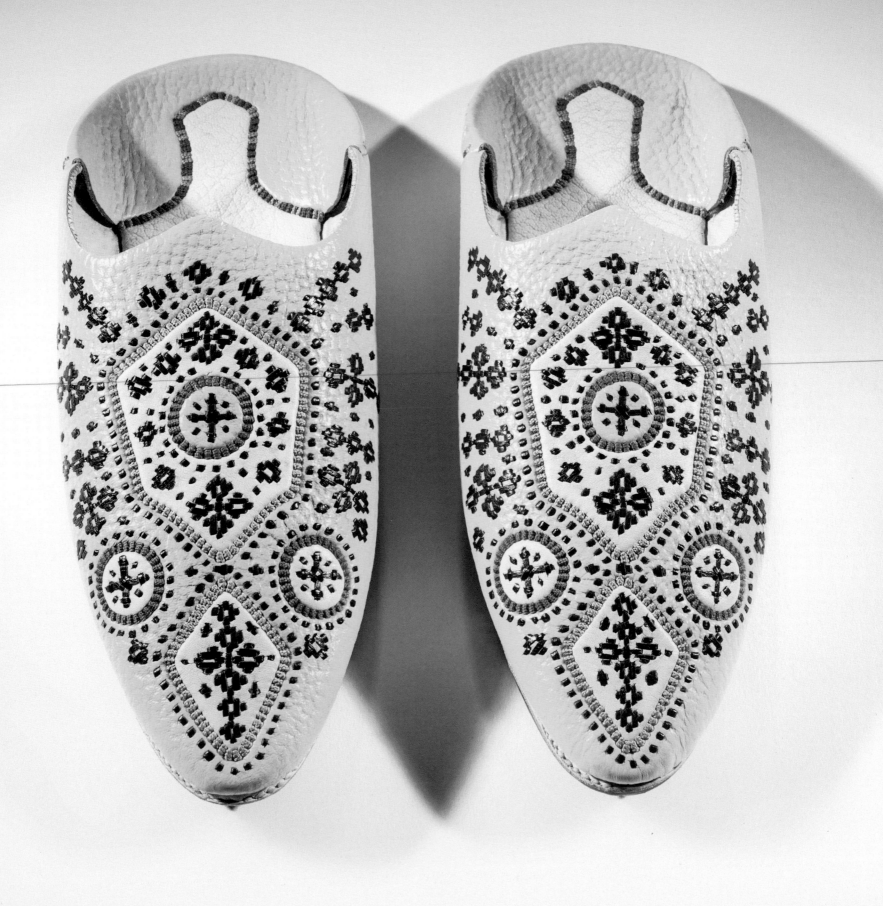

This pair of elegant Italian boudoir slippers from the early twentieth century must have brought some brightness to their owner's daily toilette. In addition to their yellow silk uppers, the slippers were embellished with two small bouquets of silk flowers attached with snaps. Perhaps the slippers came with a variety of interchangeable blossoms, or maybe the owner cleverly added the flowers to the slippers after purchase. If so, they would be part of a long history of embellishments added by owners after purchase to customize their footwear.

ITALIAN · 1920s

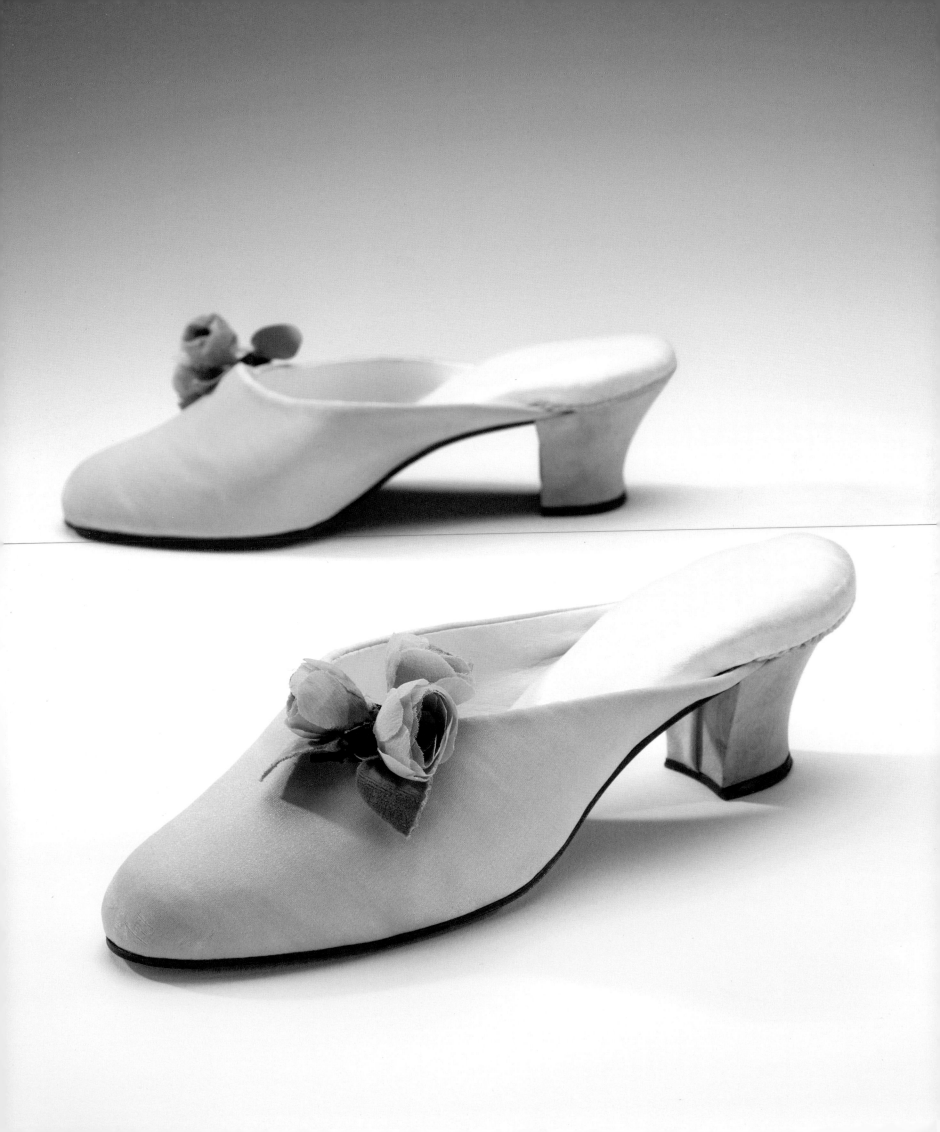

This exceptionally rare pair of moccasins has been identified as Tsalagi (Cherokee) in style. The deerskin used to make them was dyed a deep black with oxidized pulp of walnuts, providing a perfect background for the vibrant beadwork that adorns them. Colorful glass beads were introduced into North America by Europeans as trade goods, and women in many Indigenous nations quickly incorporated them as embellishments for the clothing and footwear they created. The Tsalagi comprised one of the largest nations living in the southeastern region of what is now the United States. Beginning in 1830, they, along with many other nations, were pushed off their homeland as a result of the Indian Removal Act. Their long journey westward became known as the Trail of Tears. These moccasins date to this profoundly difficult period in Tsalagi history.

PROBABLY TSALAGI · c. 1840

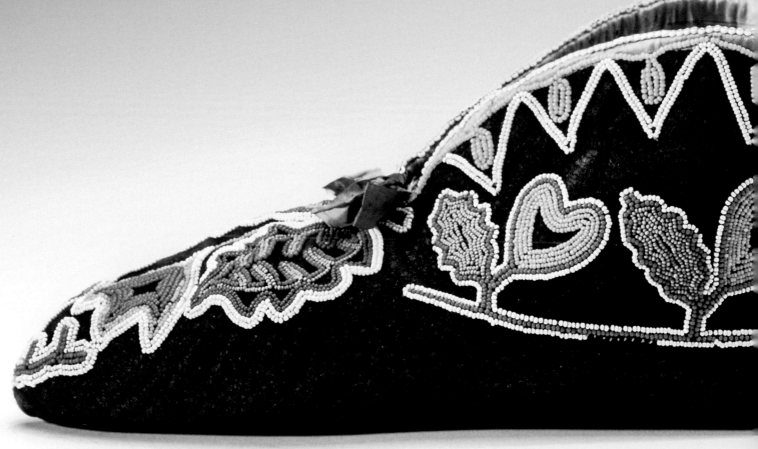

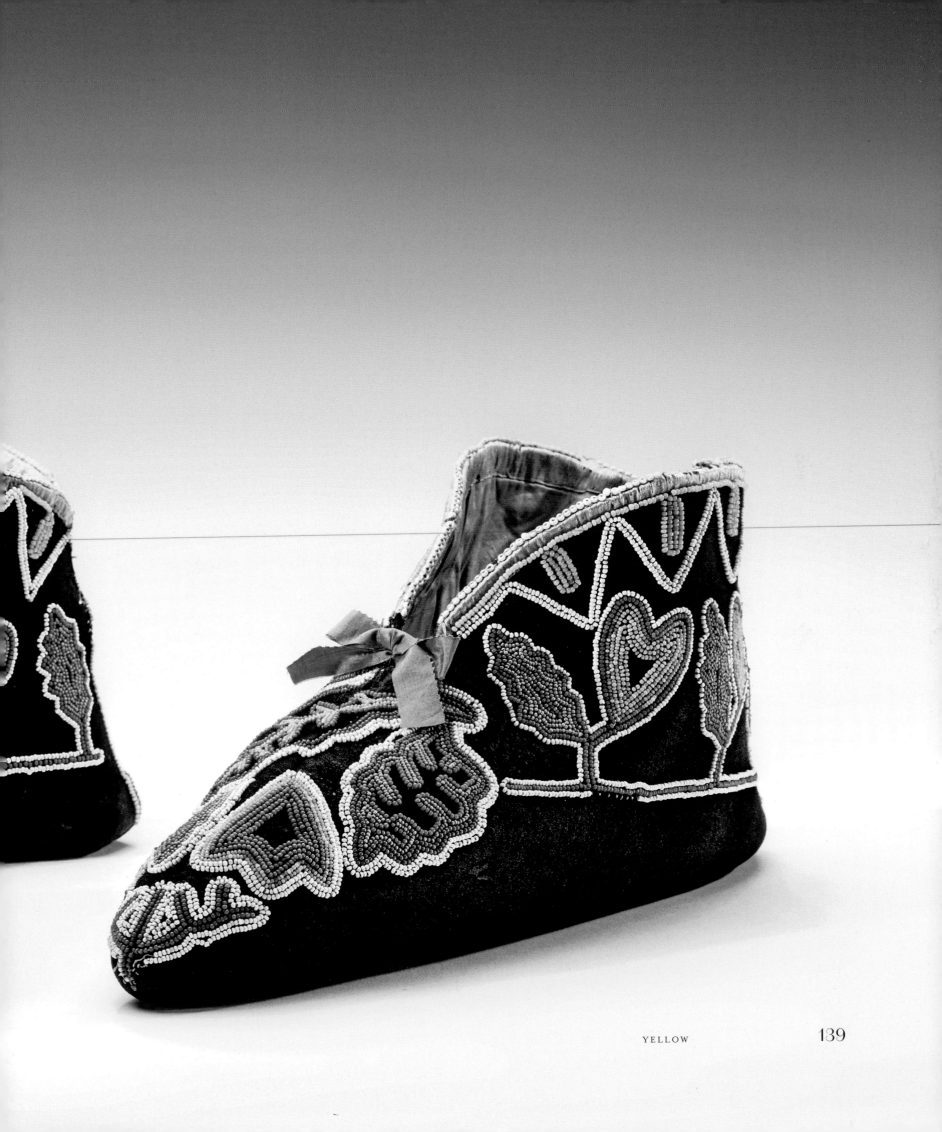

In the early 1990s, Steven Smith originally designed the Instapump Fury as one in a series of innovative sneakers for Reebok that employed pneumatic inflation technology. The idea was to create the lightest running shoe possible through a radical reduction of the structural materials used to form the sole and upper, as well as the implementation of an inflation bladder device at the instep to help secure the shoe to the foot without the need for traditional lacing. According to Smith, the epiphany came when he and Paul Litchfield realized that the pump, one of the most interesting elements of the shoe, was concealed from view inside the uppers. Smith pulled the air bladder out of the upper and wrapped it onto a shoemaker's last, demonstrating that they could complete the design by simply attaching the sole directly to the bladder, which would then function as an upper. The design was first tested at the 1992 Summer Olympic Games and was commercialized in 1993. Although the Instapump Fury had great success as a performance shoe, it made history due to its radical architecture and design principles.

AMERICAN · DESIGNED BY STEVEN SMITH
FOR REEBOK · 1993

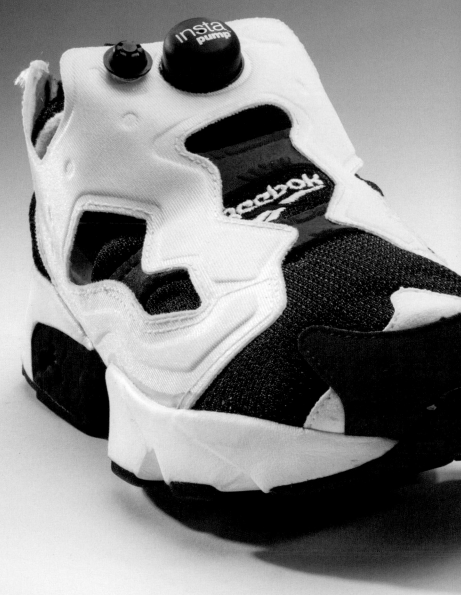

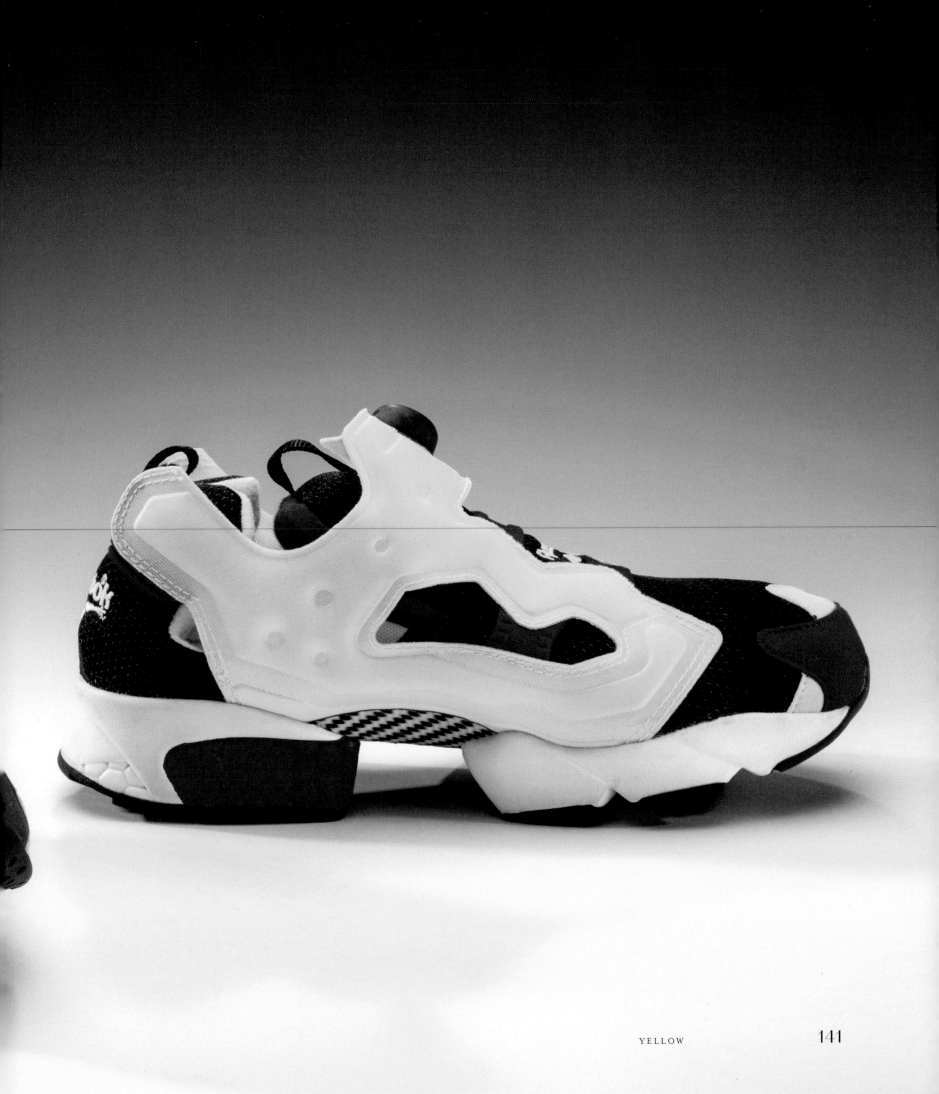

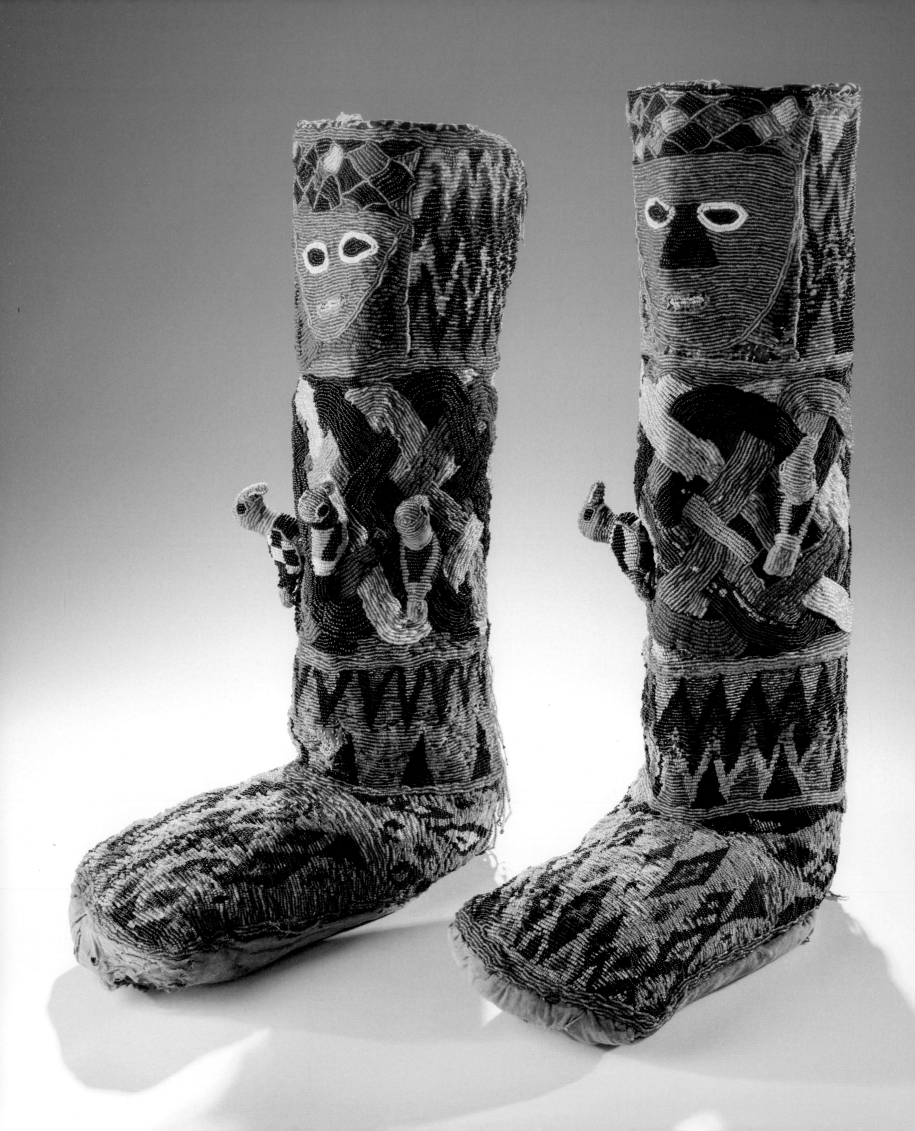

Elaborately beaded footwear is traditionally part of the regalia that proclaims the status of the oba, or leader, of Yoruba peoples of Nigeria. Color is of principal importance in Yoruba ceremonial dress and is linked to a complex range of meanings and classifications. Yellow, for example, is understood as a hot color and was the color chosen for the beaded faces that honor Oduduwa, the ancestral oba of the Yoruba. While the interlacing patterns of colorful beadwork symbolize the connectivity between the divine and the living, the birds signify female power. At first glance, these heavily beaded Yoruba boots appear to be a matching pair, but are they? One boot came to the museum from Zurich and the other from New York. Close examination of the beadwork reveals that although they were evidently created by the same hand, the boots are distinguished by subtle but definite differences. Whether or not they are, in fact, a matching pair remains to be established, but it is remarkable that two examples from the same Yoruba workshop found their way to the Bata Shoe Museum.

YORUBA · 1920s

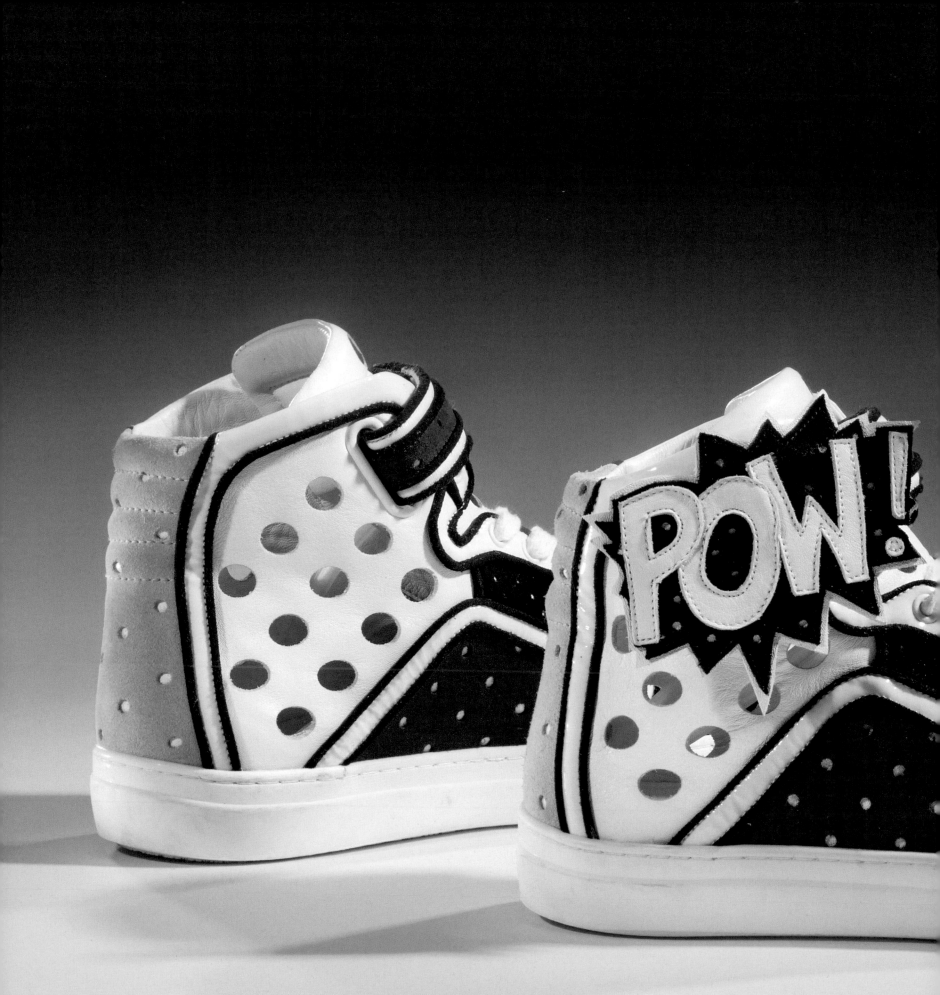

THE WORLD AT YOUR FEET

French shoe designer Pierre Hardy studied fine art before turning to footwear. His love of art runs through his collections, and these limited edition Poworama sneakers for men were clearly inspired by the work of Roy Lichtenstein. Hardy has designed footwear for many of the French couture houses, including Hermès and Balenciaga. In 1999 he launched his eponymous line of footwear for women and he expanded into men's shoes in 2002. Over the years, his interest in designing sneakers has continued to grow.

FRENCH · DESIGNED BY PIERRE HARDY · 2011 · GIFT OF PIERRE HARDY

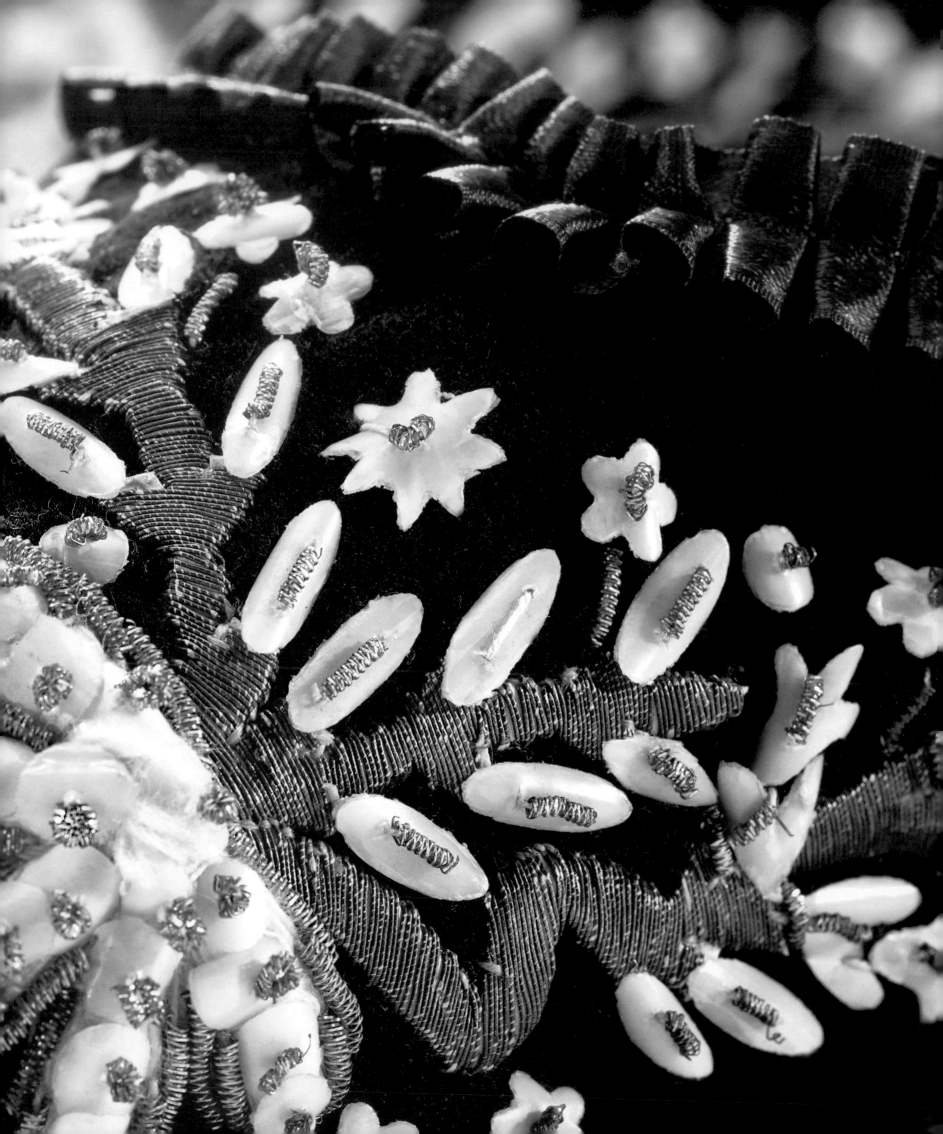

purple

Tokio Kumagai was a Paris-based Japanese designer who rose to fame in the 1980s for footwear that merged fashion and art. Kumagai drew inspiration from a wide range of sources, including nature and the works of Salvador Dalí and Piet Mondrian. He also infused his sense of humor into his creations. This pair features an upper of deep purple suede designed to resemble a bunch of grapes. In the postmodern second half of the twentieth century, as the importance of footwear in the construction of personal identity grew in importance, humor and wit were increasingly embraced in shoe design. Despite the fact that Kumagai died in 1987 at age thirty-nine, his impact on shoe design was far reaching.

FRENCH · DESIGNED BY TOKIO KUMAGAI · 1980s

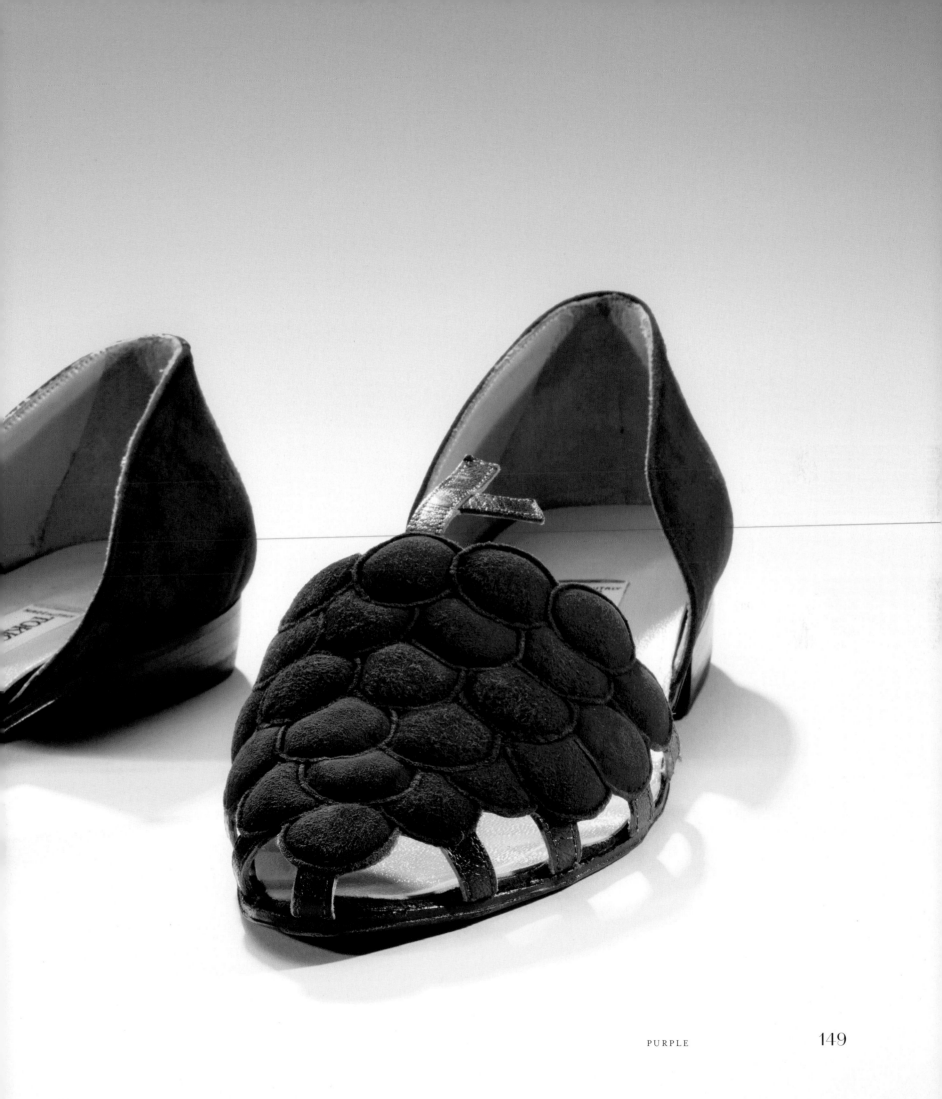

This exceptionally rare pair of mid-nineteenth-century moccasins features bold curvilinear beadwork in shades of purple. This embellishment and the cut of the pattern suggest that the moccasins may have been made by a Muscogee (Creek) woman. The beadwork remains vibrant today, but the beautiful green silk that originally lined the collars is now almost entirely missing. When the moccasins were first made, the contrast between the verdantly hued silk and the cool-colored beads must have been stunning.

PROBABLY MUSCOGEE · 1820–50

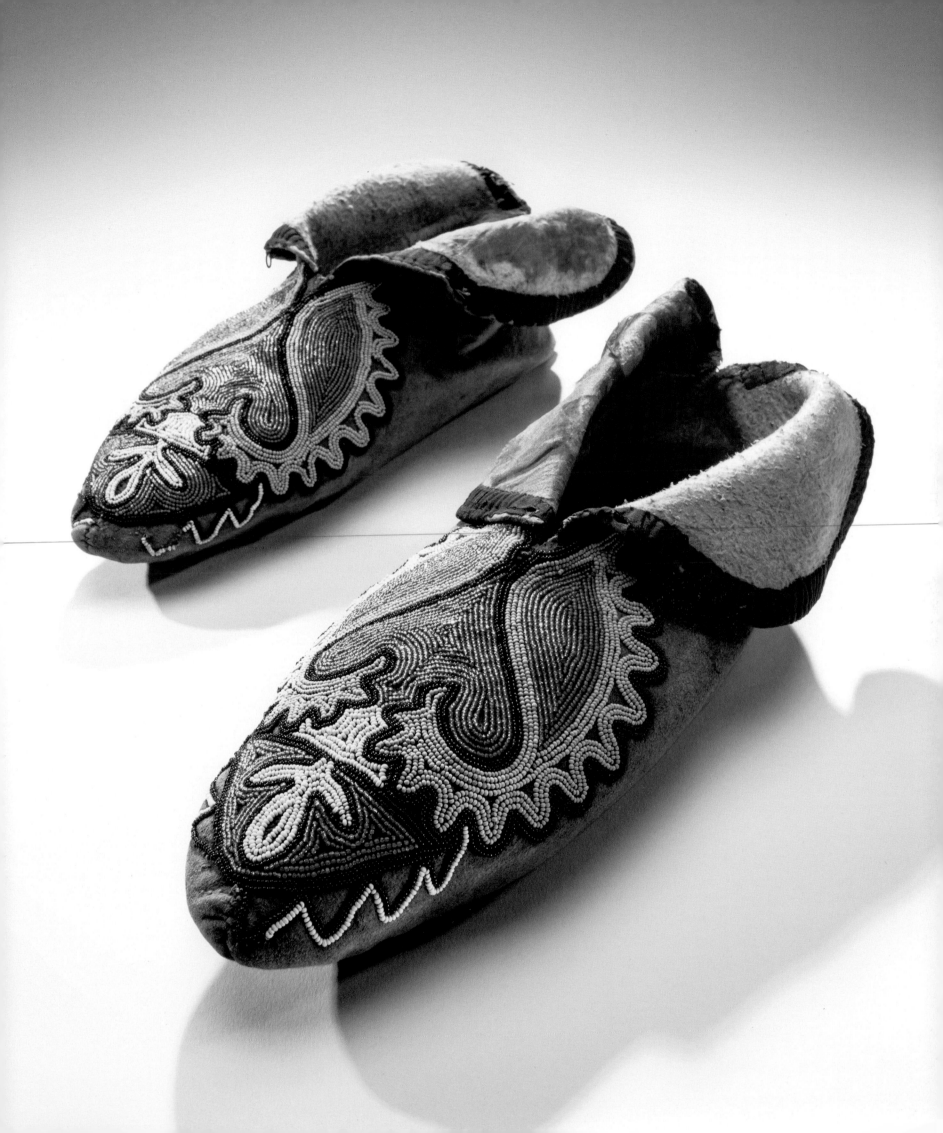

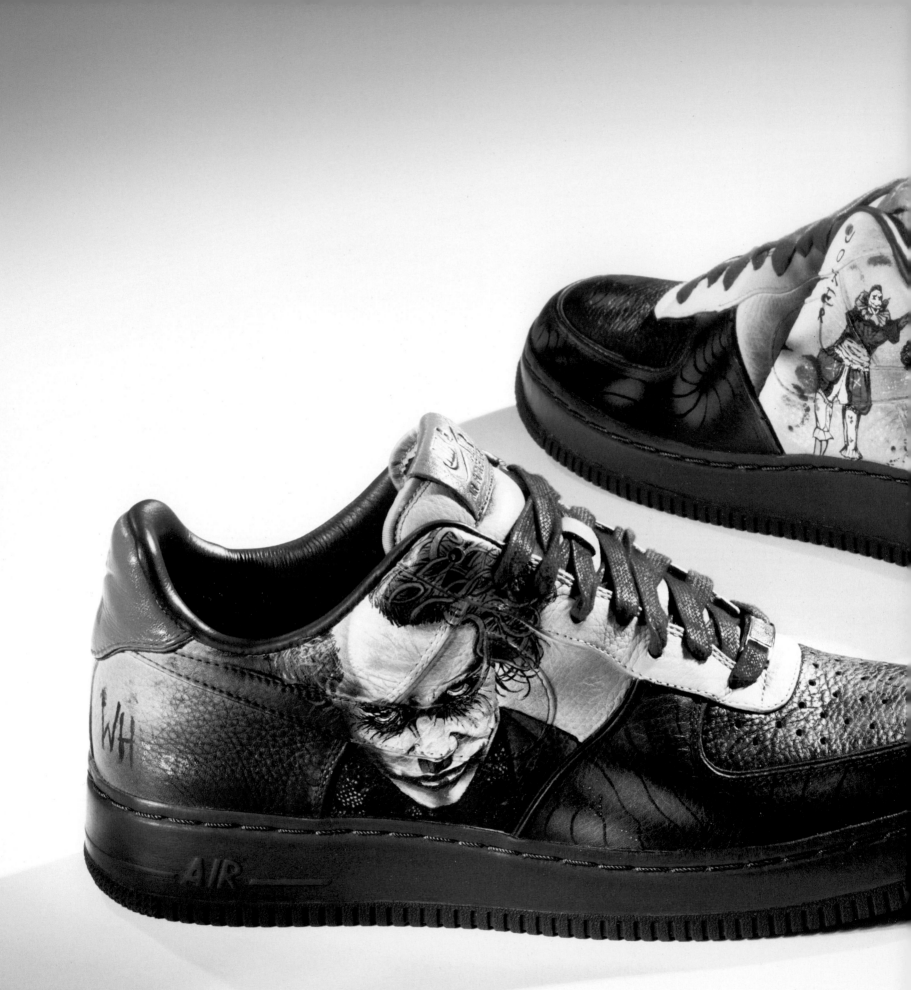

Some of the rarest and most exclusive sneakers are those customized by Daniel Gamache, a.k.a. Mache, the founder of Mache Custom Kicks. This pair of hand-painted Nike Air Force XXV was produced by Mache and features a portrait of the actor Heath Ledger in character as the Joker from the Batman movie *The Dark Knight*. Mache's work has garnered him an international reputation and a long list of celebrity clients, including Jay-Z, Kanye West, and LeBron James, to name but a few. He gifted this pair to the Bata Shoe Museum in 2017.

AMERICAN · CUSTOMIZED BY MACHE ·
2009 · GIFT OF DANIEL GAMACHE

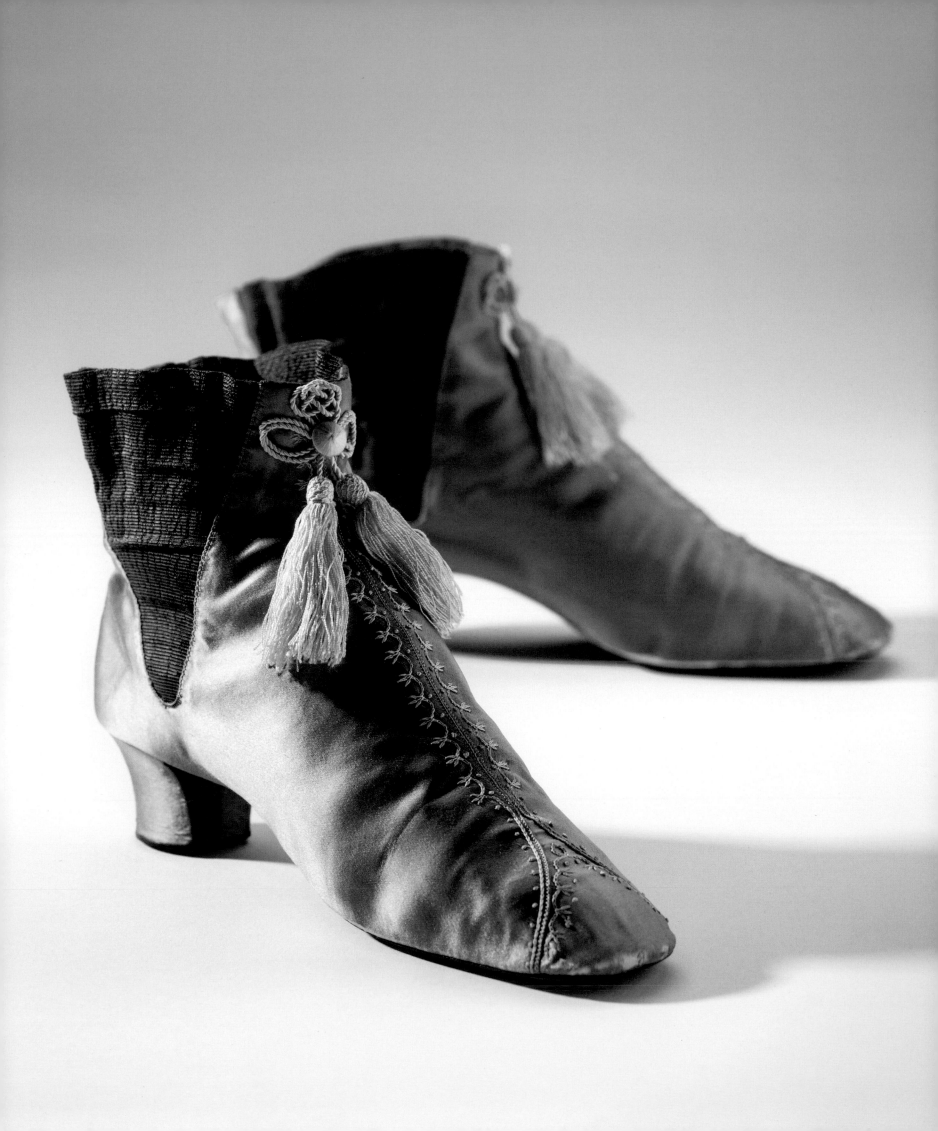

In his efforts to develop a treatment for malaria, the young British chemist and entrepreneur William Henry Perkin serendipitously produced the first synthetic dye—an intense shade of purple that he named mauveine. By the late 1850s, the color purple, formerly accessible only to royals and the wealthy, was within the reach of middle-class consumers, and Perkin made a fortune. Mauve, as the color came to be known, grew so popular that its virulent spread was compared to that of a contagious disease. The humor magazine *Punch* quipped that "bonnet shops were infected places that should just now be marked as 'Dangerous.'" The lampoon continued with the claim that its "ravages [w]ere principally among the weaker sex," but that men who had caught it could be cured with "one good dose of ridicule." This pair of on-trend mauve silk boots was purchased on the fashionable Rue Saint-Honoré in Paris during the height of the "epidemic."

FRENCH · c. 1860

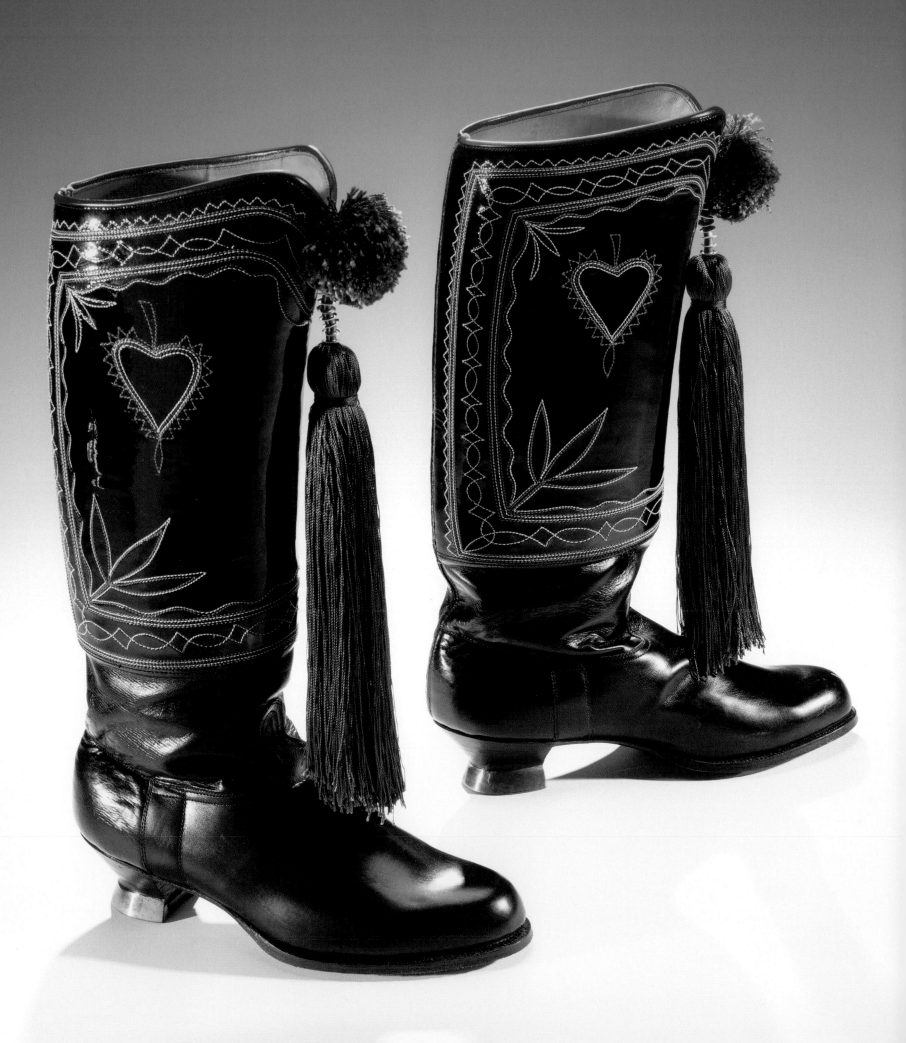

The Czech Republic is a country rich in distinctive regional dress, and many people still wear folk costumes to celebrate holidays, festivals, and weddings. This pair of men's boots is part of the traditional dress worn in the southernmost part of Moravia. The boots feature embroidered heart motifs on the shafts, brass top lifts on the heels, and long silk tassels in deep purple. Sonja Bata commissioned master Czech shoemaker Josef Janulik to make them for the Bata Shoe Museum collection in the mid-1990s.

MORAVIAN · CREATED BY JOSEF JANULIK · 1998

his pair of brilliant purple shoes, made by the Dutch shoemaker H. W. Berenbak, who supplied shoes to the Dutch court, are thought to have been worn by a member of the House of Orange-Nassau in the 1880s. The invention of synthetic dyes in the 1850s ignited a craze for bright colors in fashion; the color of this pair is a testament to that trend, yet the style of the bows was an historical reference. Called Fenelon bows, these bold adornments recalled the "shoe roses" of the seventeenth century, and their name refers to François Fénelon, the royal tutor of Louis XIV. The remarkably vivid color and excellent condition along with the fact that they still carry their maker's label on the insole make this pair a unique treasure of the Bata Shoe Museum.

DUTCH · CREATED BY H. W. BERENBAK · 1880s

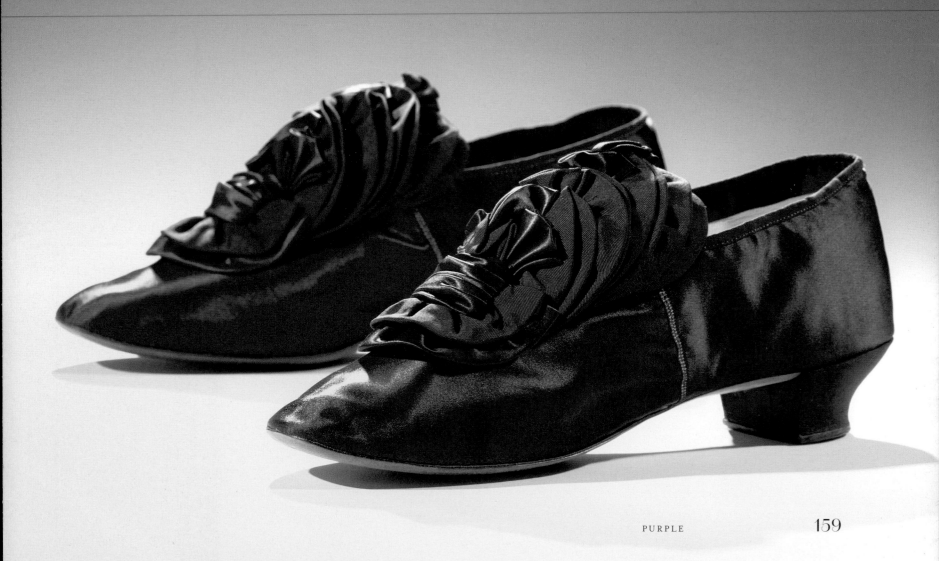

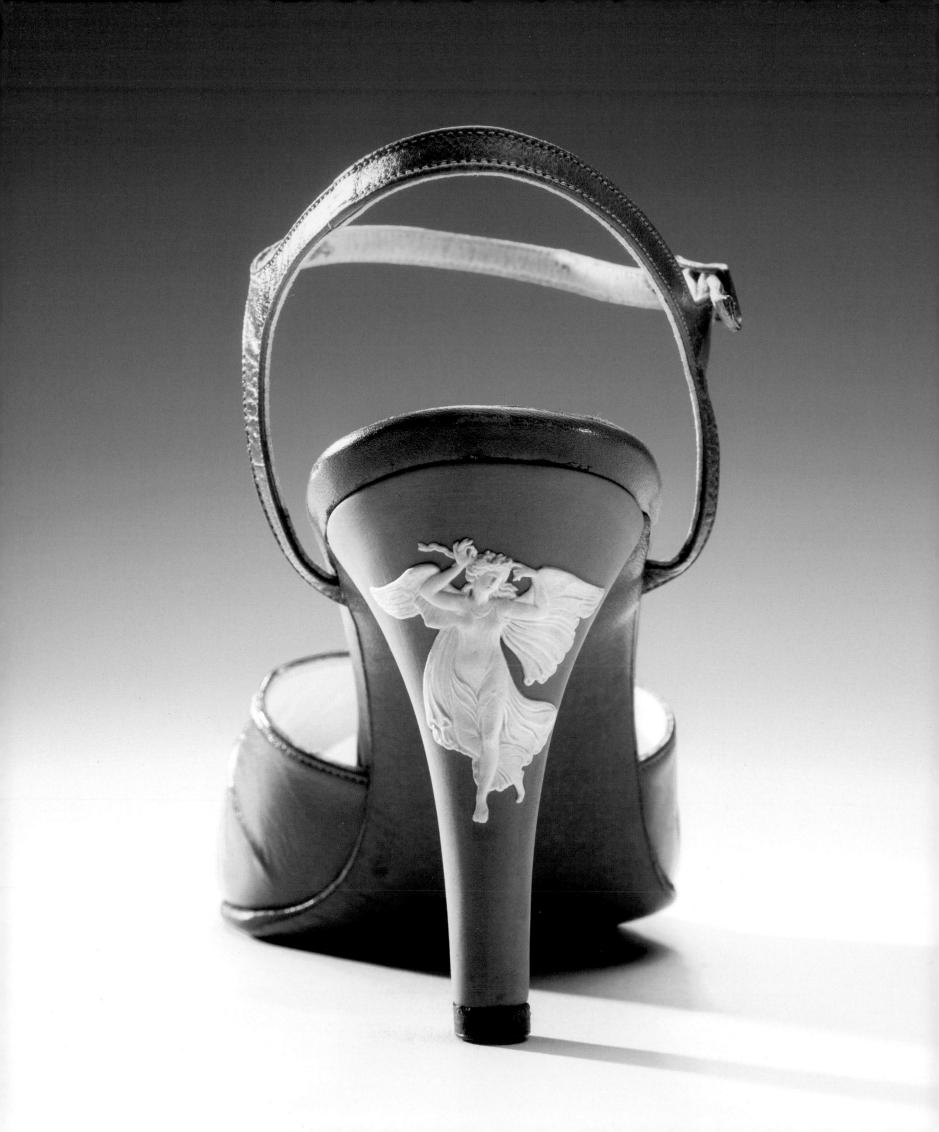

I n the 1950s, Wedgwood, the English maker of fine ceramics, collaborated with H & M Rayne, shoemakers with a royal warrant to make shoes for Queen Elizabeth II, to create a line of shoes and purses featuring traditional Wedgwood Jasperware designs in soft blue and sage green. The use of Wedgewood ceramic cameos as a decorative element for purses seemed sensible enough, but designing heels made in a breakable bisque was certainly a bold move and captured media attention. The successful collaboration between Wedgwood and Rayne was relaunched in 1978, and that second collaboration featured a wider range of colors, including pale shades of pink and purple. Despite being made of ceramic, the Jasperware heels were surprisingly durable.

ENGLISH · DESIGNED BY RAYNE · 1978

Beginning with the Great Exhibition of 1851 in London, exhibitions of international wares became popular across Europe and the United States, fueling desire for objects from distant lands and greatly influencing fashion. Just as industrialization was forcing traditional modes of shoemaking into obsolescence in the West, handmade footwear from the Ottoman Empire became prized for its luxurious materials and meticulous handwork. This pair of purple velvet mules was made in Turkey for French consumption and features vamps heavily decorated with mother-of-pearl, gold, and silver embellishments, and the insoles are embroidered with gilded thread.

TURKISH · MADE FOR THE
WESTERN MARKET · 1860–80

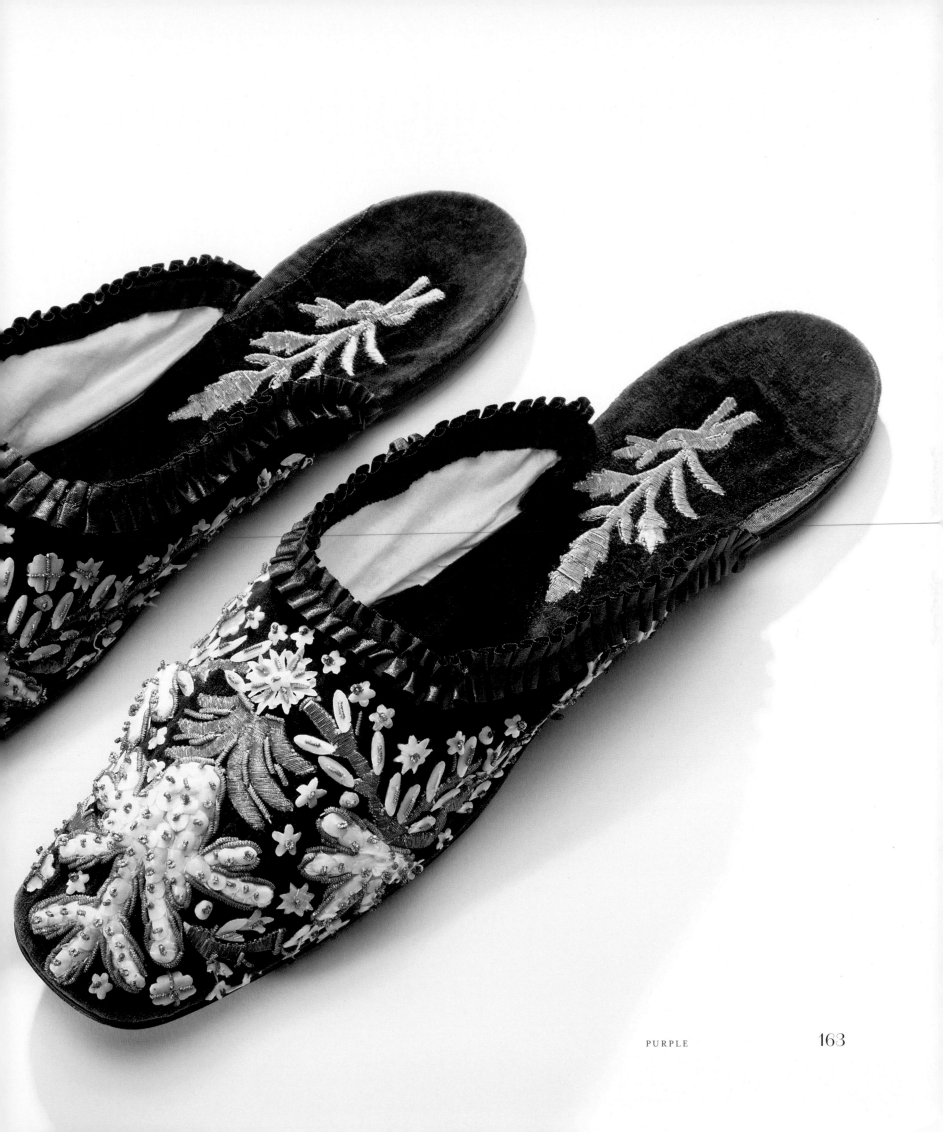

Superstar Madonna has demonstrated an ability to maintain an ever-changing yet always cutting-edge image across many decades of public life. This talent, combined with her versatile and adaptive musical style, has made her a fixture in music and fashion since the 1980s. A great admirer of the designers Dolce & Gabbana, Madonna has assembled a wardrobe that features many of their daring designs. This Dolce & Gabbana platform shoe was designed for Madonna's 1993 Girlie Show World Tour. Although the design of this sandal is sturdy, the shanks of the shoes were further reinforced with metal for added stability during her performances.

ITALIAN · DESIGNED BY
DOLCE & GABBANA · MID-1990s

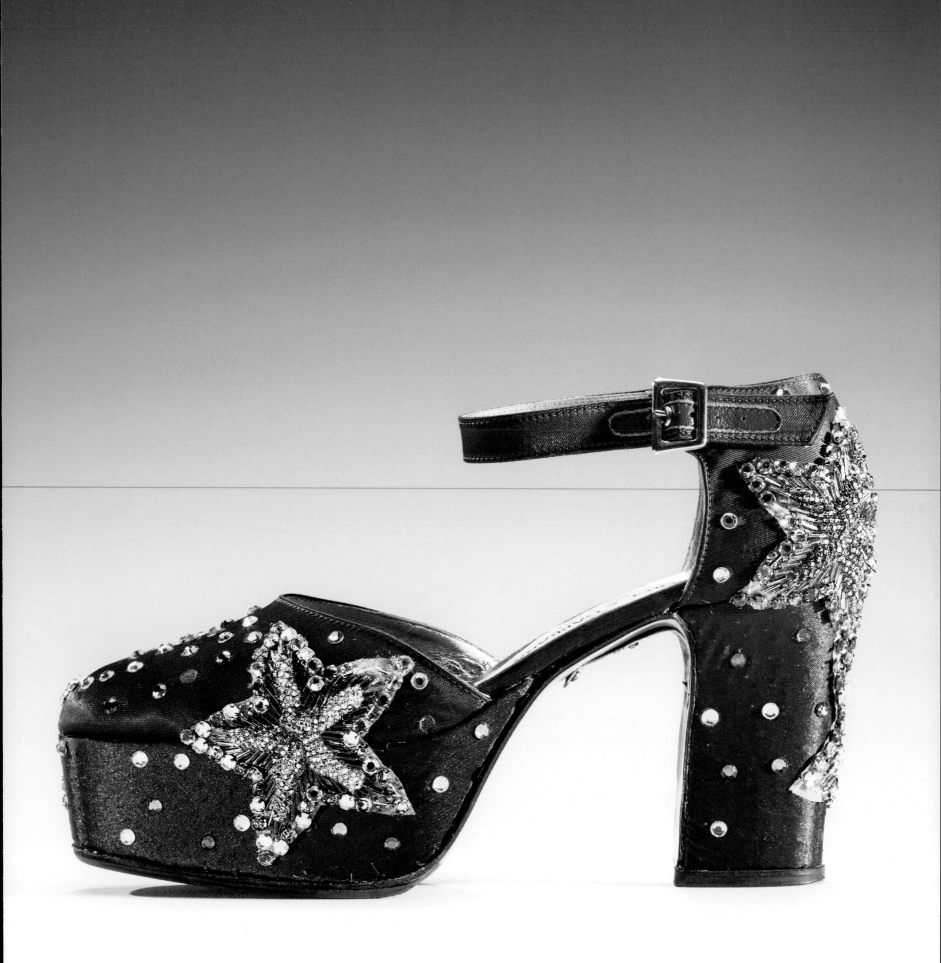

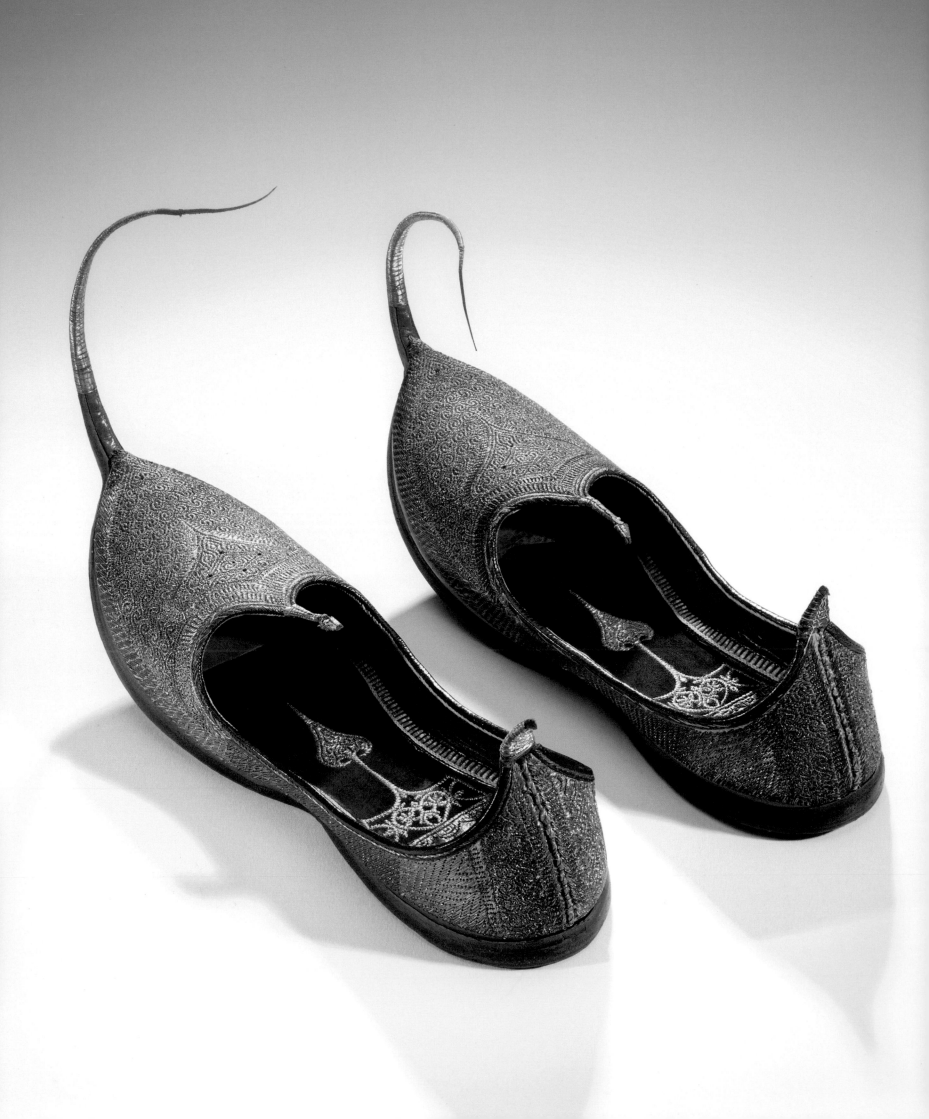

In parts of northern India, beautifully embroidered shoes called *khussa* are worn for special occasions such as weddings. Elaborate gold embroidery and attenuated upturned toes reflect the impact of the Mughal court on Indian dress, and *khussa* are considered appropriate footwear for grooms. These shoes become the object of attention when grooms remove them before the start of wedding ceremonies and the sisters of brides playfully "steal" the shoes and only return them once their ransom demands are met. This pair features heavily embellished uppers as well as gold embroidery on the purple velveteen insoles. They were acquired by Sonja Bata on her first trip to India in 1950.

INDIAN · 1950

French shoe designer Roger Vivier, known as the Fabergé of footwear, created many of the most sought-after shoes in the middle of the twentieth century. He first rose to fame at Christian Dior, and his reputation only increased after he left Dior to establish his own eponymous label in 1963. This magenta evening shoe is an example of Vivier's post-Dior work, in which the restrained elegance of line is contrasted with a penchant for embellishment. Although the aglets that adorn the tips of the silk ties are the sole decorations, their bold size, assertive shape, and sparkling rhinestone details add drama.

FRENCH · DESIGNED BY ROGER VIVIER · 1965–69

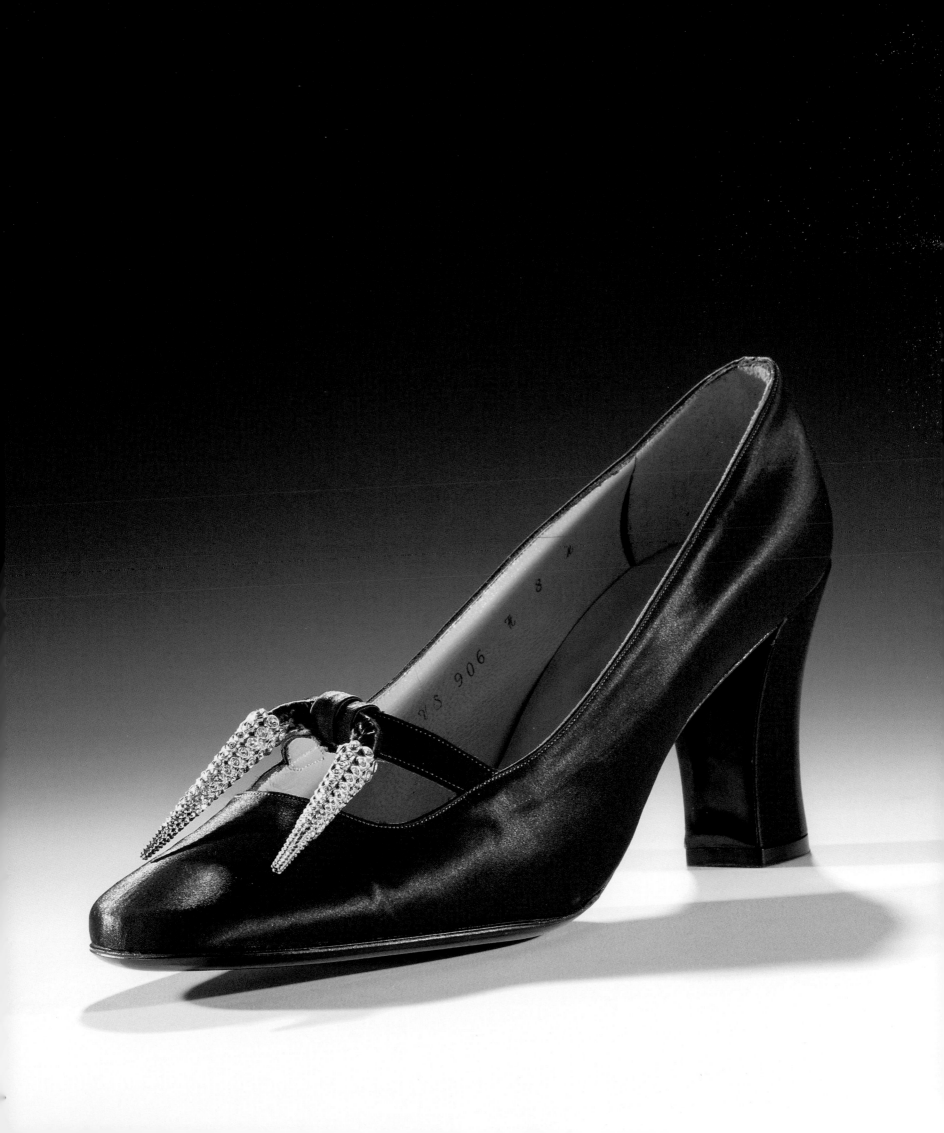

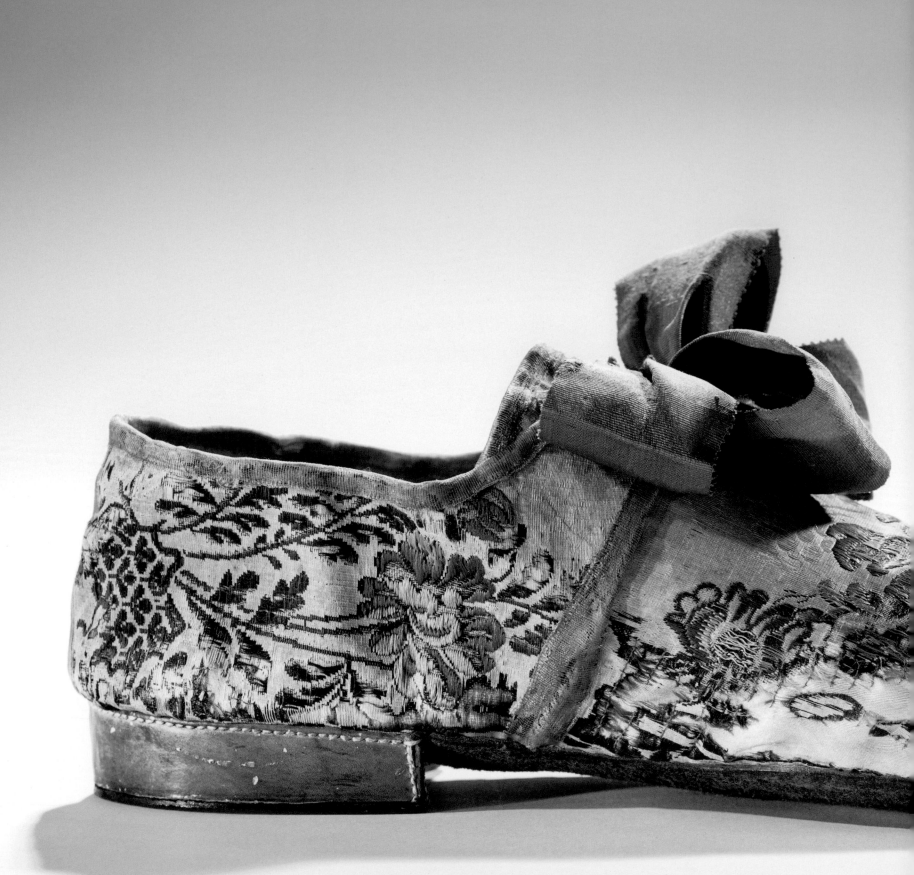

THE WORLD AT YOUR FEET

A ccused of being too effete, high heels fell out of European men's fashion in the eighteenth century. Yet other aspects of men's attire that today might be coded female were central to men's dress, including the use of floral motifs and the color pink, as seen on this men's shoe. Although pink has come to be regarded as highly feminine, in the eighteenth century both men and women proudly wore the color.

ENGLISH · 1760–80

The distinctive platform shoes worn by upper-class Manchu women during the late Qing dynasty were often highly decorated. This example features embroidered butterflies across the entire upper. Each butterfly is embellished with voluminous silk tassels to represent its antennae. Those unfamiliar with Chinese iconography often mistake the butterflies for bats, as they are frequently represented in visually similar ways. Bats, however, are never depicted with antennae. Images of both bats and butterflies were used to convey good wishes: bats brought hopes for wealth, while butterflies symbolized beauty and wishes for long life.

MANCHU · LATE 19TH CENTURY

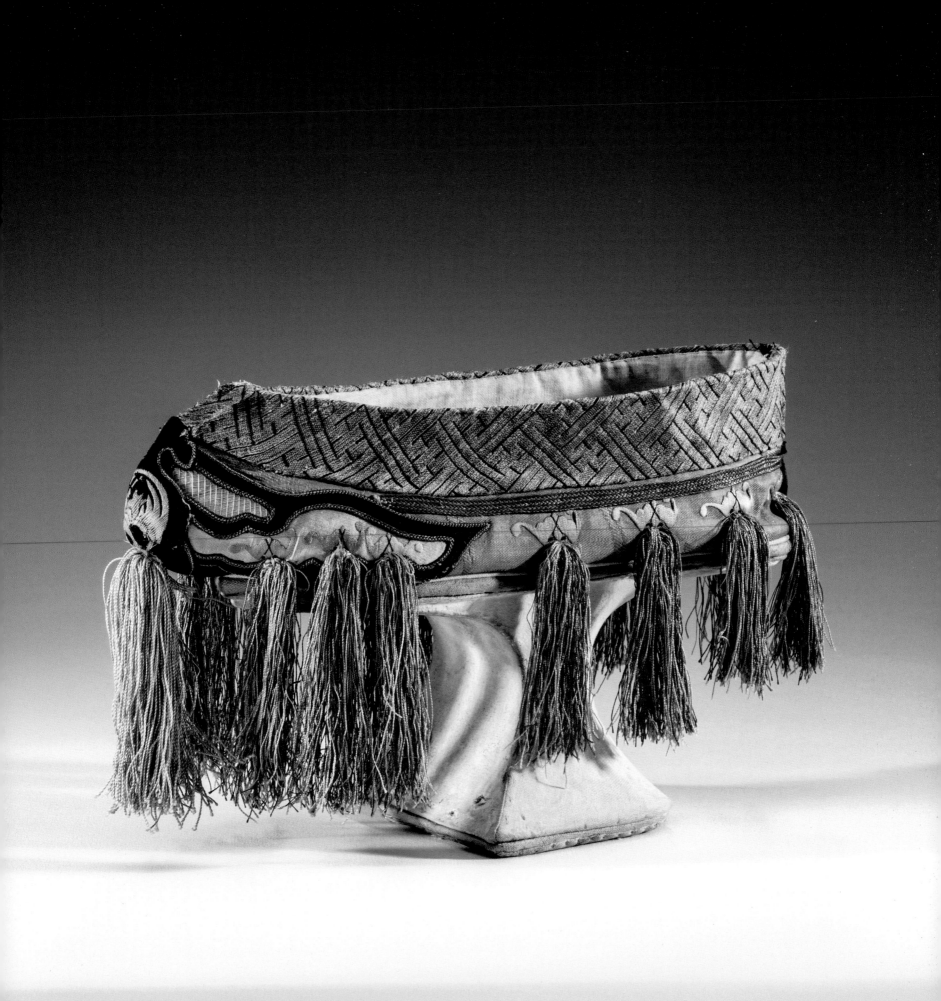

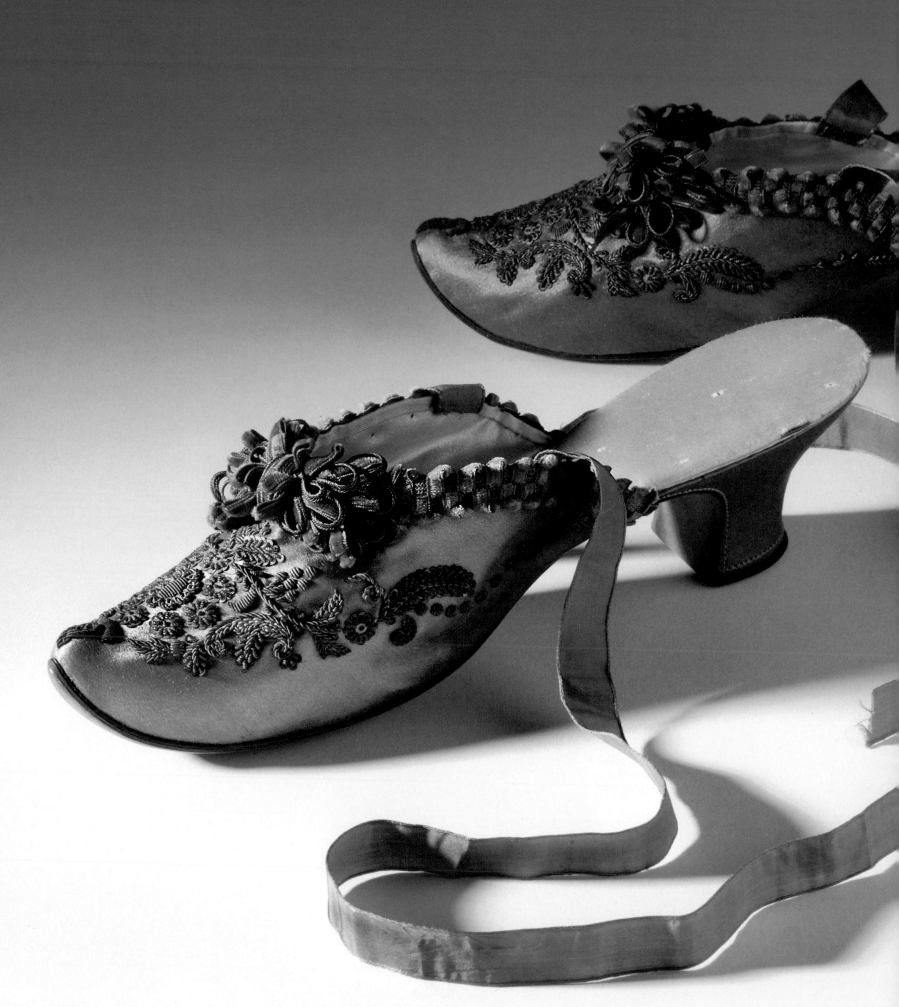

THE WORLD AT YOUR FEET

The high heel was banished from women's fashion in the West during the first half of the nineteenth century in part due to its association with aristocratic excess and allegations of promiscuity among upper-class women. It was reintroduced in the mid-1850s as part of a wave of nostalgia for eighteenth-century dress—for example, the term "Louis heel" was coined at this time in honor of King Louis XV. During this fashion revival, the specter of the "licentious woman" was also resuscitated. In work by artists from Édouard Manet to Émile Zola, courtesans and other women of questionable virtue captured the imagination of popular culture. This pair of 1880s boudoir slippers, intended to be worn in an intimate setting, links these two concepts and features many hallmarks of eighteenth-century mules with heels. It is interesting to note that the resurrection of hobbling heels coincided with the development of the women's rights movement and women's desire to make greater strides toward equality.

FRENCH · 1880s

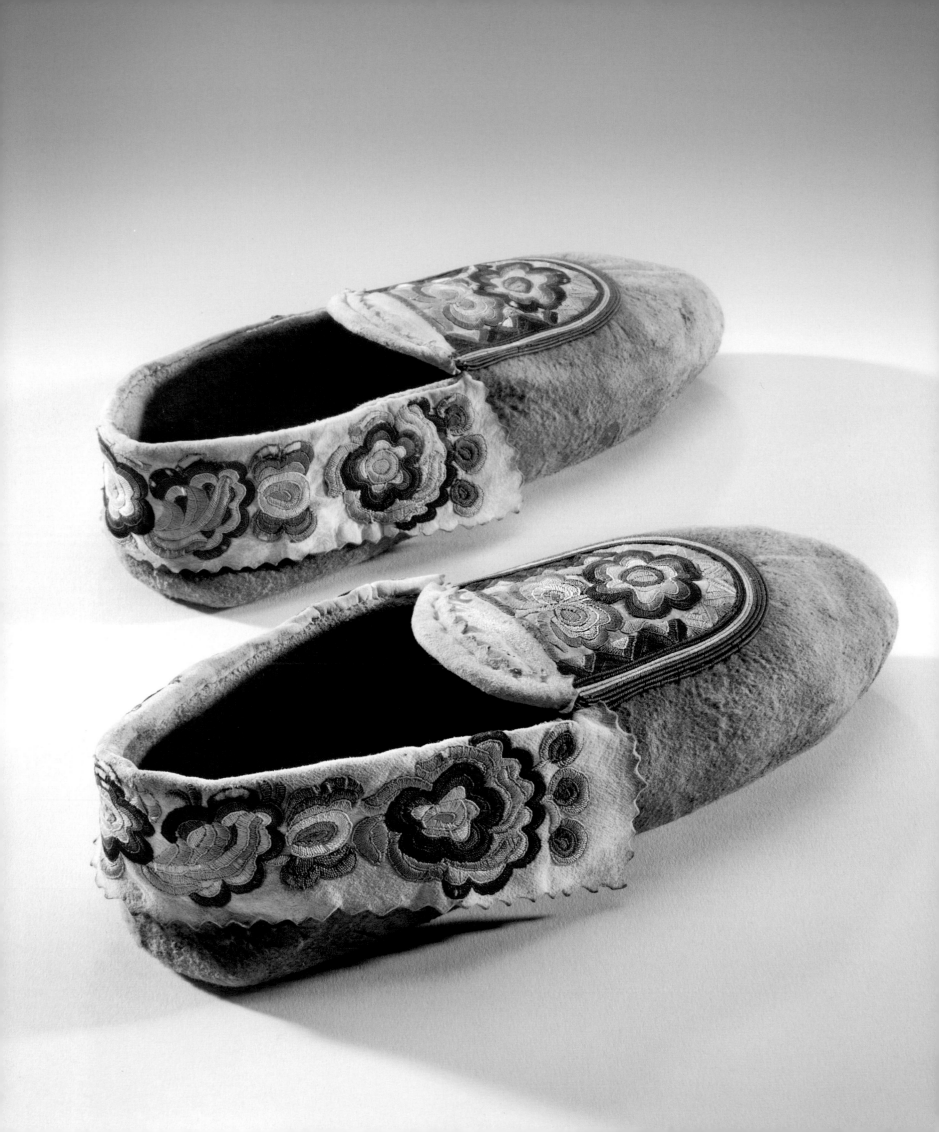

This pair of moccasins features elaborate silk embroidery characteristic of Norway House Cree-Métis decoration. Norway House was established in the early nineteenth century by the British as a trading post for the fur trade and grew to become the most important interior post in the region now known as Manitoba, Canada. The use of silk floss in Norway House footwear and clothing reflects the significant cultural and material exchange that took place in the region because of trade. This pair is a cherished part of the museum's collection due to the brilliant color of the silk floss and the tremendous skill required to create the moccasins.

NORWAY HOUSE CREE-MÉTIS · LATE 19TH CENTURY

he glitter of white and pink rhinestones interspersed with circles of matte pink and cream velvet creates a brilliant effect on these spectacular evening shoes. Footwear like this was very popular in the early 1960s, and many of the most glamorous examples were made by two shoemaking giants: H & M Rayne in England and Delman in the United States. The two companies collaborated first in the 1930s and then again in the early 1950s. Delman famously "loaned" their gifted shoemaker Roger Vivier, who was under contract to them, to H & M Rayne to make the shoes worn by Queen Elizabeth II for her 1953 coronation. Shortly afterward Vivier began working for Christian Dior. While this pair was not intended to be worn by a royal, it was designed to make the wearer feel elevated.

AMERICAN · DESIGNED BY DELMAN · 1960–63

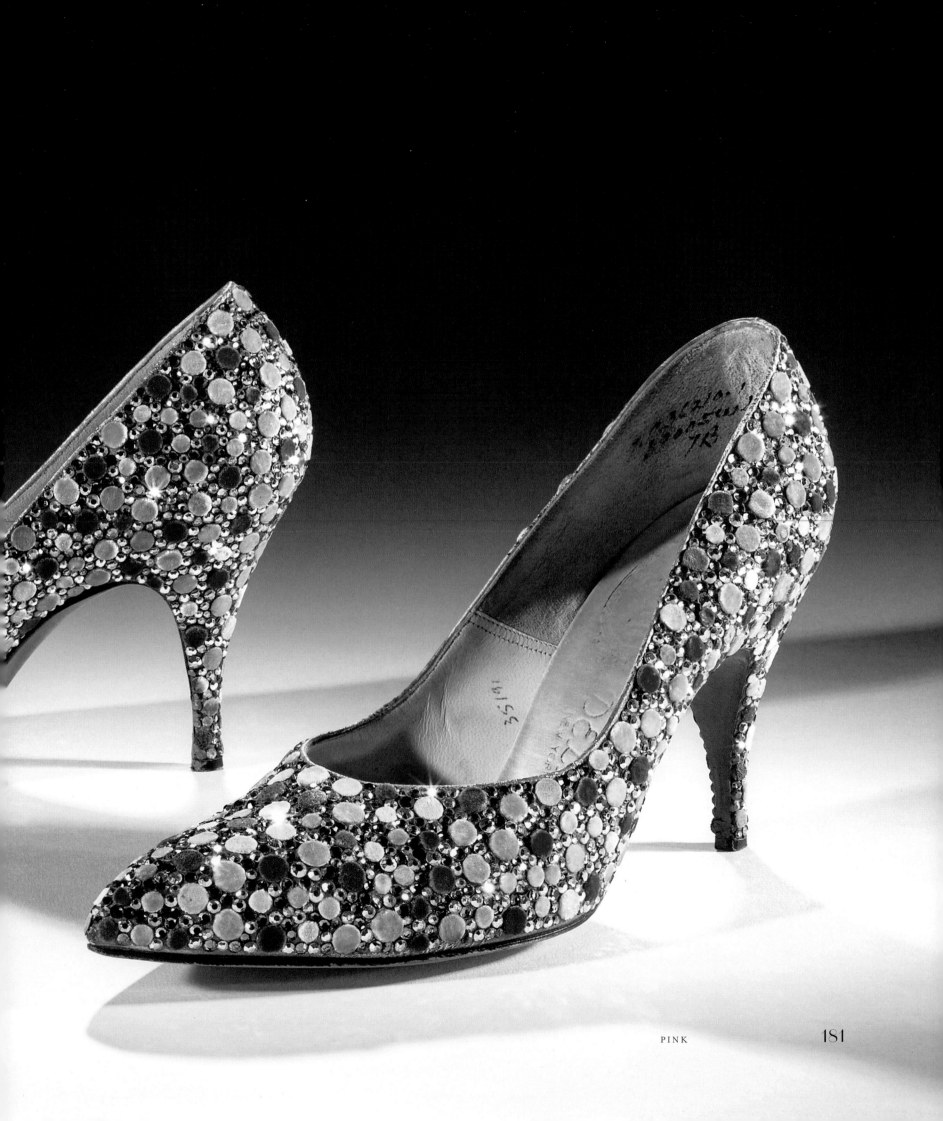

Much fashionable footwear for women in the first half of the nineteenth century was remarkably narrow in construction and often it did not feature lefts and rights. Known as "straights," such shoes created a perfectly symmetrical presentation of the feet, but they ignored the natural architecture of the human foot and led to pain and suffering in those who wore them. Although fashion embraced straights, the motivation behind their design was industrialization with its aim to increase production while keeping costs low. To create straights, shoemakers needed only one last (the wooden foot-shaped model a shoe is made on) per size rather than a left and a right per size, and therefore they could far more rapidly and cheaply make singles, which were easily assembled into pairs for sale. In order to fit into such constricting footwear, some wearers had to overlap or curl their toes.

FRENCH · MID-19TH CENTURY

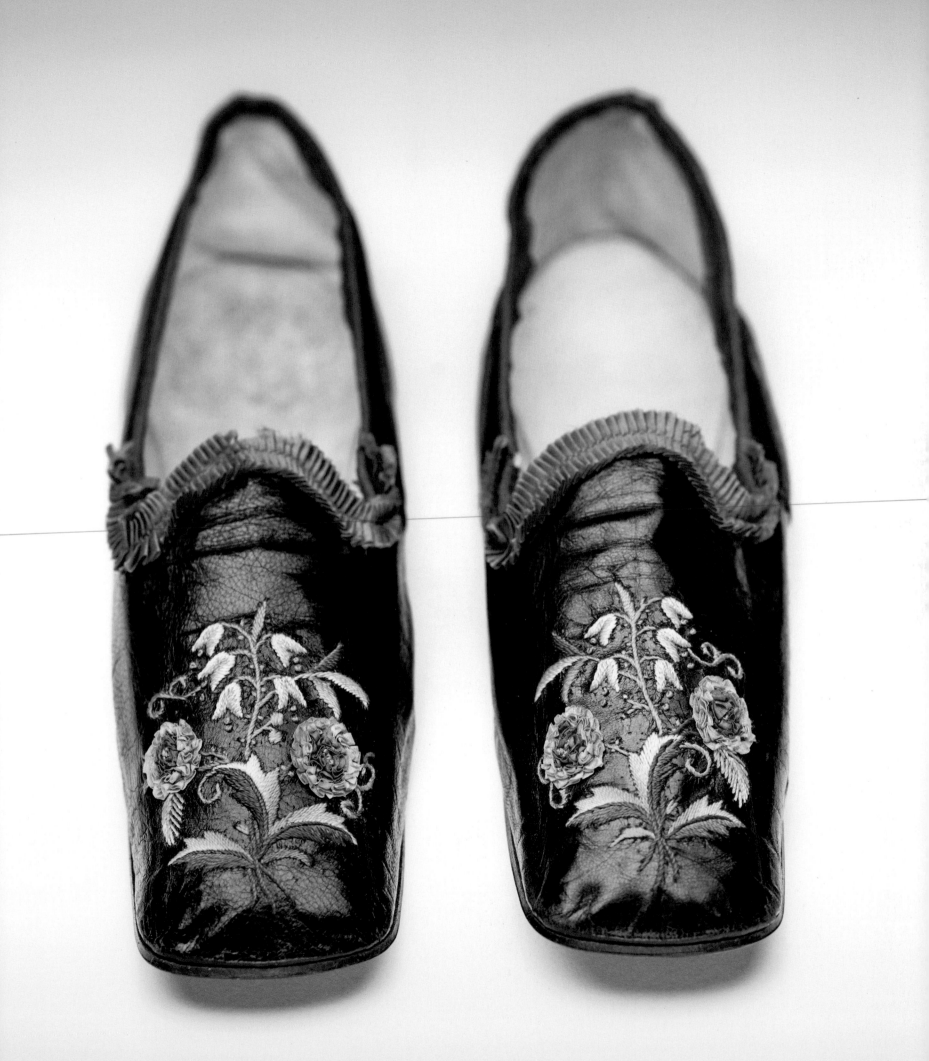

The northern Great Plains area extends from what are now the states of Montana, Wyoming, and North Dakota up into the provinces of Manitoba, Saskatchewan, and Alberta. Although this region is home to distinct nations, many northern Plains women shared similar approaches to moccasin making. These included using side-seam construction and transmontane beadwork, which features couching along the bead string to hold the beads tightly in place. This pair of buffalo-hide moccasins was made by a gifted Nakoda Oyadebi (Assiniboine) seamstress using both those techniques. Pink beads were popular across the northern Great Plains at the end of the nineteenth century, and the maker of this pair used two different shades of pink to great effect.

NAKODA OYADEBI · 1877–88

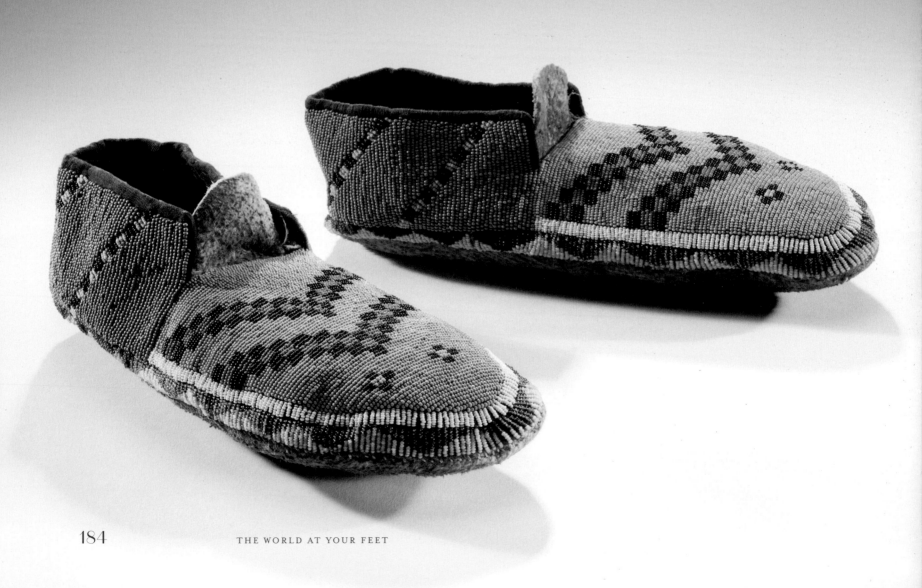

THE WORLD AT YOUR FEET

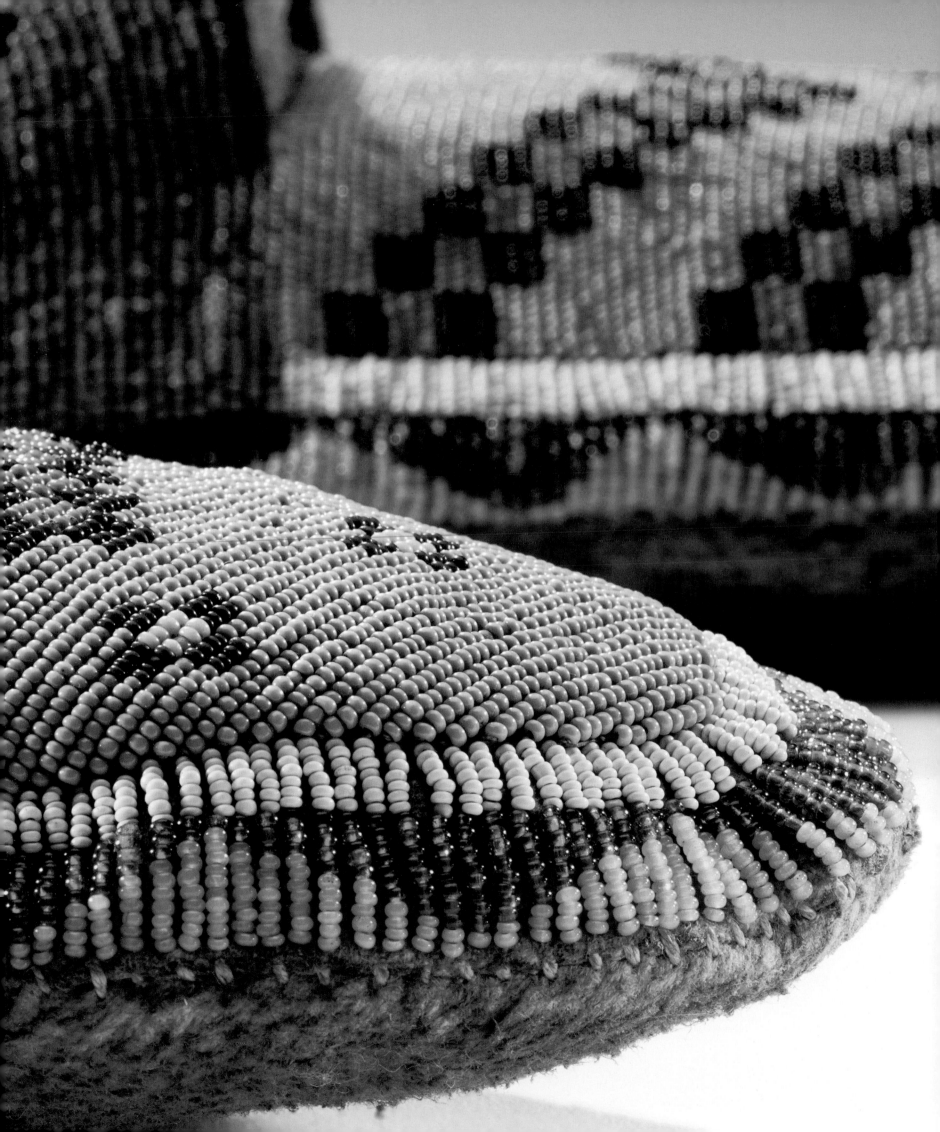

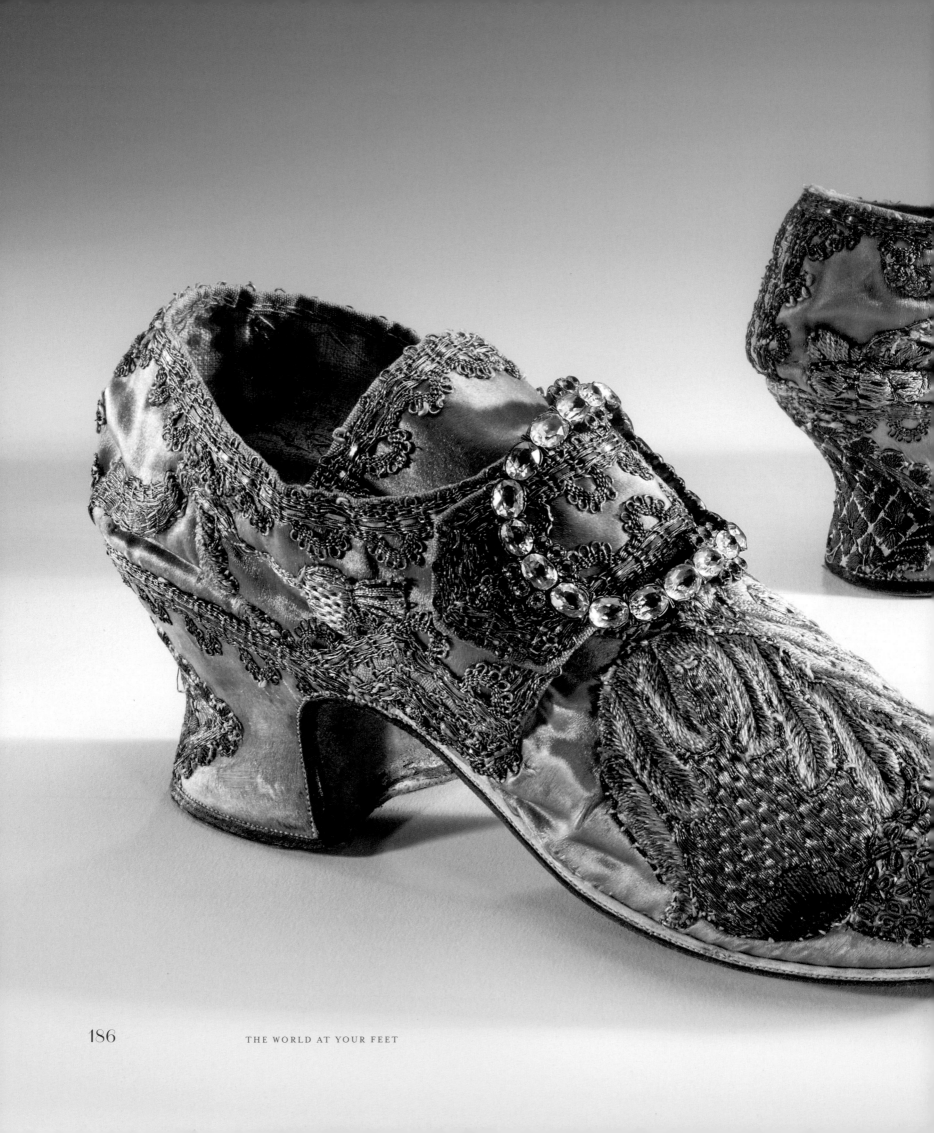

Every aspect of these shoes—beautiful embroidery, gold lace edging, vivid pink silk, and exceptional condition—suggests that they were created for a special occasion and then treasured and carefully preserved for centuries. A clue to their importance may lie in the embroidery, which depicts three large thistles and leaves. Experts agree that the embroidery was created decades before the shoes were made, around the end of the seventeenth century. Thistles are the national emblem of Scotland and the symbol of its highest chivalric order, the Order of the Thistle. The order was founded by James II (James VII of Scotland) in 1687, around the time that the embroidery was likely made. Perhaps these shoes from the 1740s repurposed the embroidery in connection with this high honor. The story of how the thistle came to be the emblem of Scotland supposedly dates to the thirteenth century, when an invasion of barefoot Vikings was foiled by a plethora of Scottish thistles; the Vikings' cries of pain alerted the Scots to their impending attack, and the day was saved.

POSSIBLY SCOTTISH · 1740s

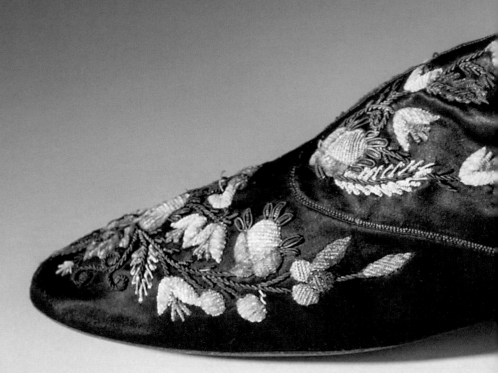

Side-lacing ankle boots called Adelaides, after the queen consort to King William IV of England, became de rigueur in Western fashion when the crinoline became popular in the middle of the nineteenth century. The lightweight metal cage like structure of the crinoline was designed to help women achieve a fashionably full look without the weight of innumerable petticoats. However, the crinoline was extremely sensitive to motion: a slight jostle, or an unexpected gust of wind, would cause the skirt and its understructure to lift and sway, coquettishly revealing glimpses of the wearer's shoes and legs. Adelaides were ostensibly worn to preserve feminine modesty, yet lavishly embellished examples such as these were clearly intended to attract attention. The extraordinarily rich embroidery on these boots foreshadows the impending shift in taste toward increased ornamentation in late-nineteenth-century footwear for women.

FRENCH · 1855

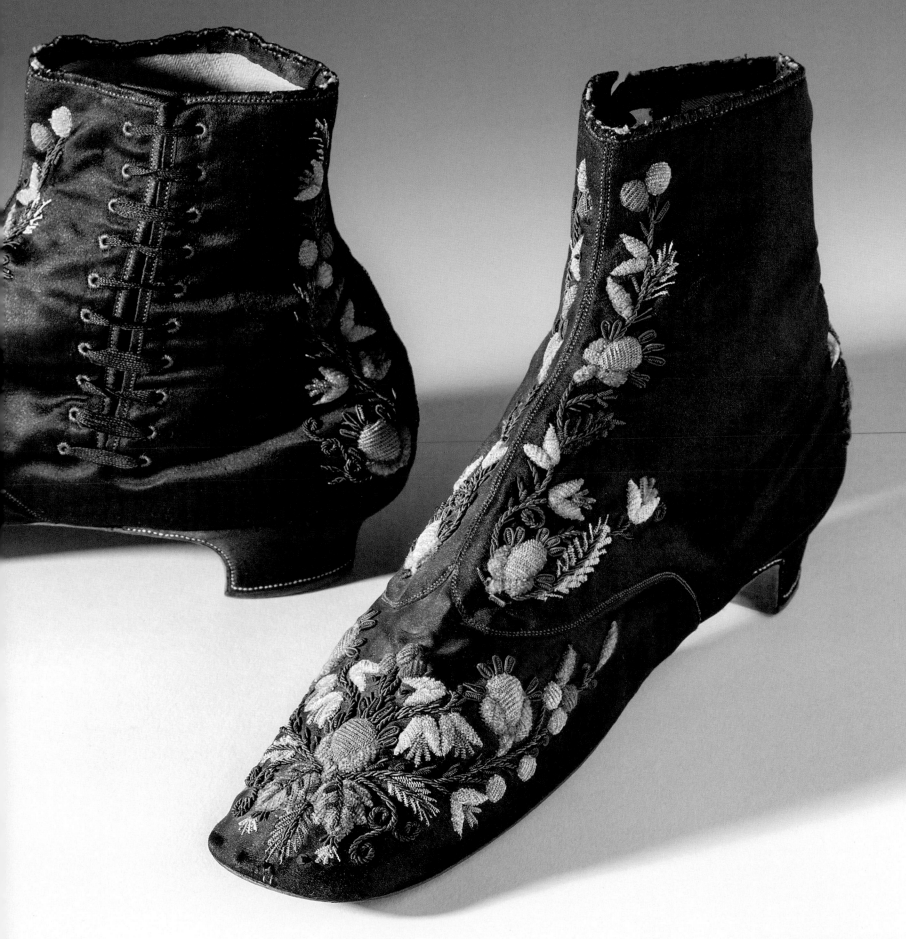

green

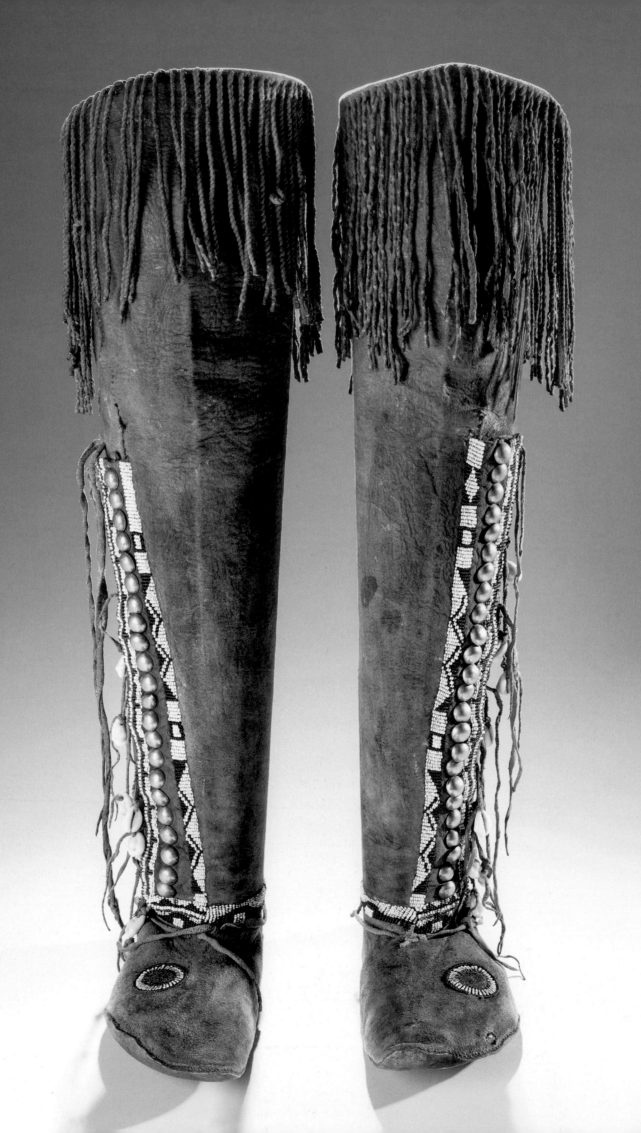

Kiowa women's boots were traditionally knee-high and were made of buttery-soft deerskin pigmented with organic colors such as yellow and green. Decoration included exceptionally fine bead-work, German silver buttons, and fringe created by twisting strips of deerskin. The Kiowa, along with the Comanche and the N'de (Apache), with whom they were closely allied, preferred simple delicate adornment on their clothing and footwear and restricted applied decoration to pigment and fringes. A particular feature of a Kiowa woman's boot is a small beaded star or circle on the vamp.

KIOWA · c. 1890

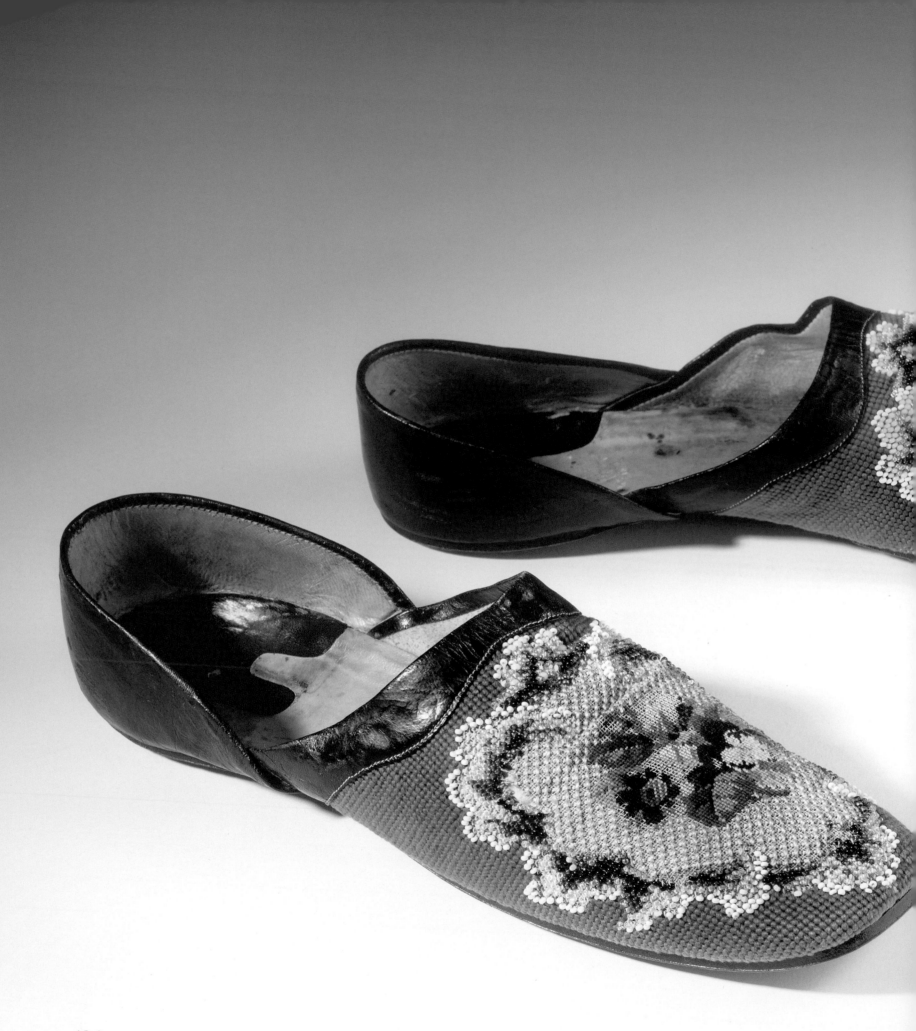

THE WORLD AT YOUR FEET

We sew, sew, prick our fingers, dull our sight,

Producing what? A pair of slippers, sir.

—ELIZABETH BARRETT BROWNING, *AURORA LEIGH*, 1857

Berlin was the dye center of Europe in the mid-1800s, and yarns in highly saturated bright hues—many laced with arsenic—stimulated a craze among upper-class women to do "Berlin work." Some of the most popular items to needlepoint were slippers, which were made as gifts for the men in women's lives. This enthusiasm developed as industrialization was transforming shoemaking from a craft done entirely by hand to one involving factory production. The growing interest in both worsted wool work and the "gentle craft" of shoemaking in mid-century was a harbinger of the Arts and Crafts movement, which developed in reaction to industrialization's displacement of much traditional handiwork. This was an especially important issue for women, because needlework had long been a measure of virtuous femininity.

ENGLISH · 1860s

Wabanaki women excelled at fine beadwork and frequently made moccasins with heavily beaded aprons and collars. This pair of moccasins features a repetitive round motif typical of beadwork across the Wabanaki Confederacy, which in the past extended from Nova Scotia to Maine. It is called nested circle style and may be a reference to the flower that today is called the pearly everlasting. There is some disagreement as to whether or not the maker was Wolastoqiyik (Maliseet) or Penobscot, but there is no argument about her artistry. The elaborate floral beadwork, which was stitched onto a lush green velvet backing and then applied to the deerskin moccasins, is a remarkable study in symmetry and skill.

WABANAKI · 1860–80

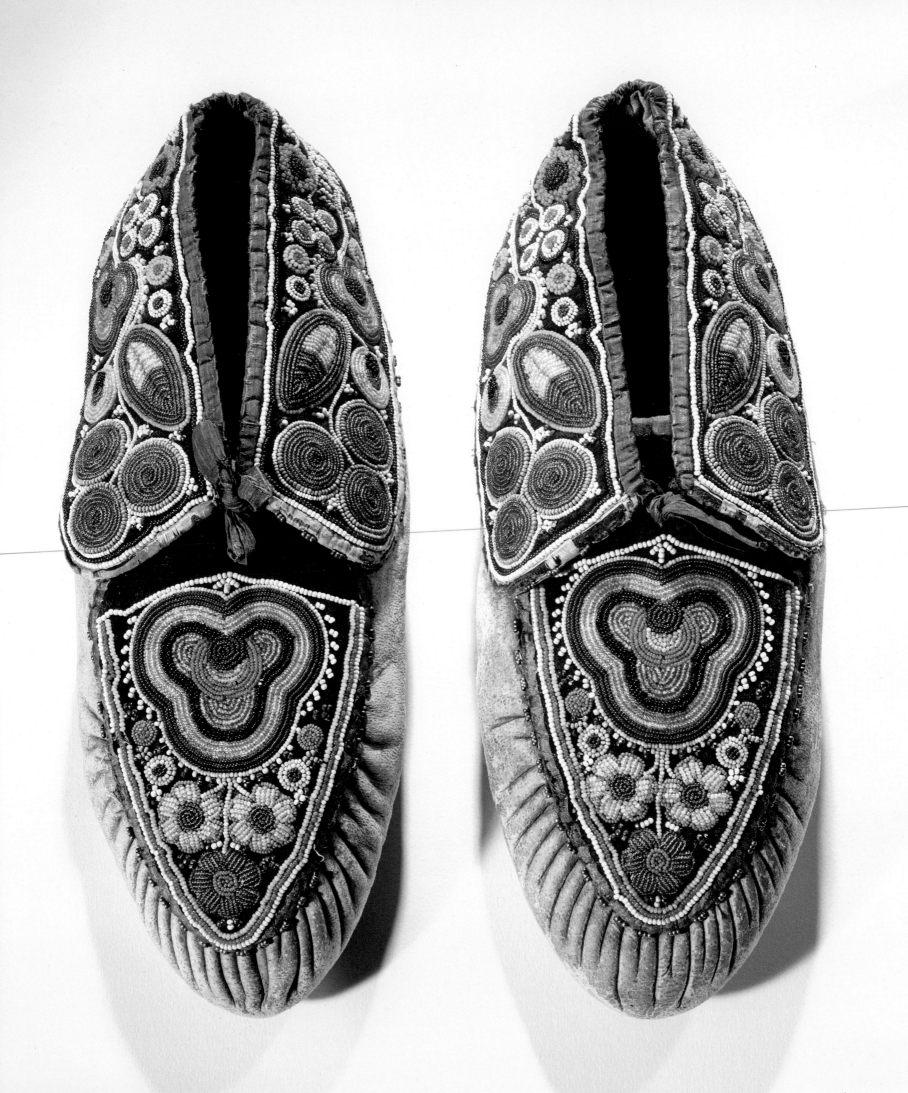

The precise origin of the heel remains unknown, but evidence dating from tenth-century Persia suggests that heels may have been developed in connection with the invention of the stirrup. The stirrup profoundly changed horseback riding and even helped improve the effectiveness of military campaigns, as it enabled riders to steady themselves while using heavy weapons. Heels gave riders even greater stability by allowing them to hook their feet into the stirrups. This Persian riding boot dates to the seventeenth century, when European interest in Persia as a trading partner and potential ally sparked interest in incorporating heels into Western men's fashion.

PERSIAN · 17TH CENTURY

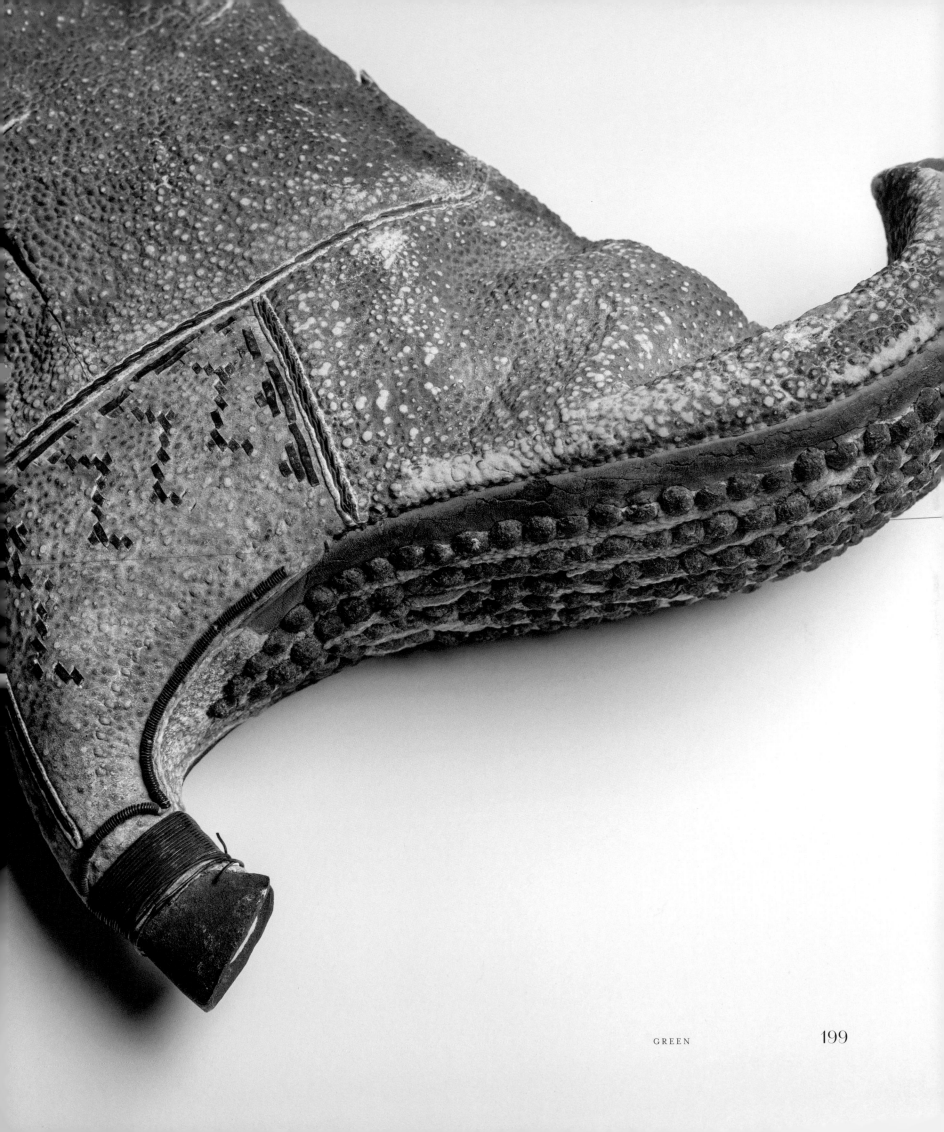

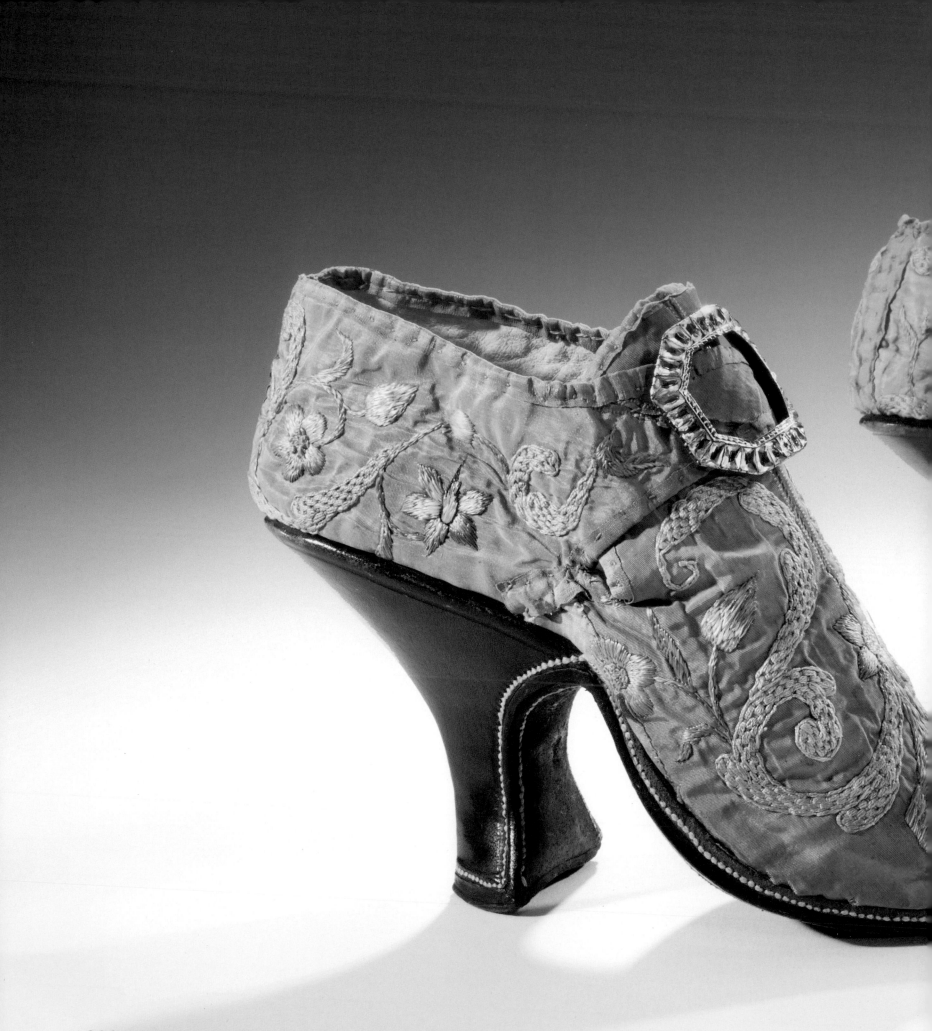

THE WORLD AT YOUR FEET

One of the great strengths of the Bata Shoe Museum holdings is its eighteenth-century European collection. This pair of extremely well-preserved high-heeled shoes from Venice dates to the early 1700s. The apple-green silk on the uppers is still vibrant, as is the silk-thread embroidery. Of the embroidered motifs, the blooming carnations take pride of place across the toes. The heels are made of bevel-carved wood covered in deep red Moroccan leather, while the uppers feature brightly colored embroidery on luxurious silk.

ITALIAN · 1700–20

This citrus-green "moc-croc" platform shoe designed by Vivienne Westwood features a heel that soars eight and one half inches high. It was created for her 1993 Anglomania collection and gained notoriety after supermodel Naomi Campbell fell on the runway while wearing a pair. Westwood began to create her own shoes when she could not find anything flamboyant enough to complement her daring ensembles. Westwood's footwear, like her clothing, frequently parodies historic styles and aggressively pushes the boundaries of design. Vivienne Westwood entered the world of fashion in 1971 when she opened the punk-culture shop Let It Rock with her partner, Malcolm McLaren. Westwood has gone on to become one of the most important designers in the history of Western fashion.

ENGLISH · DESIGNED BY
VIVIENNE WESTWOOD · 1993

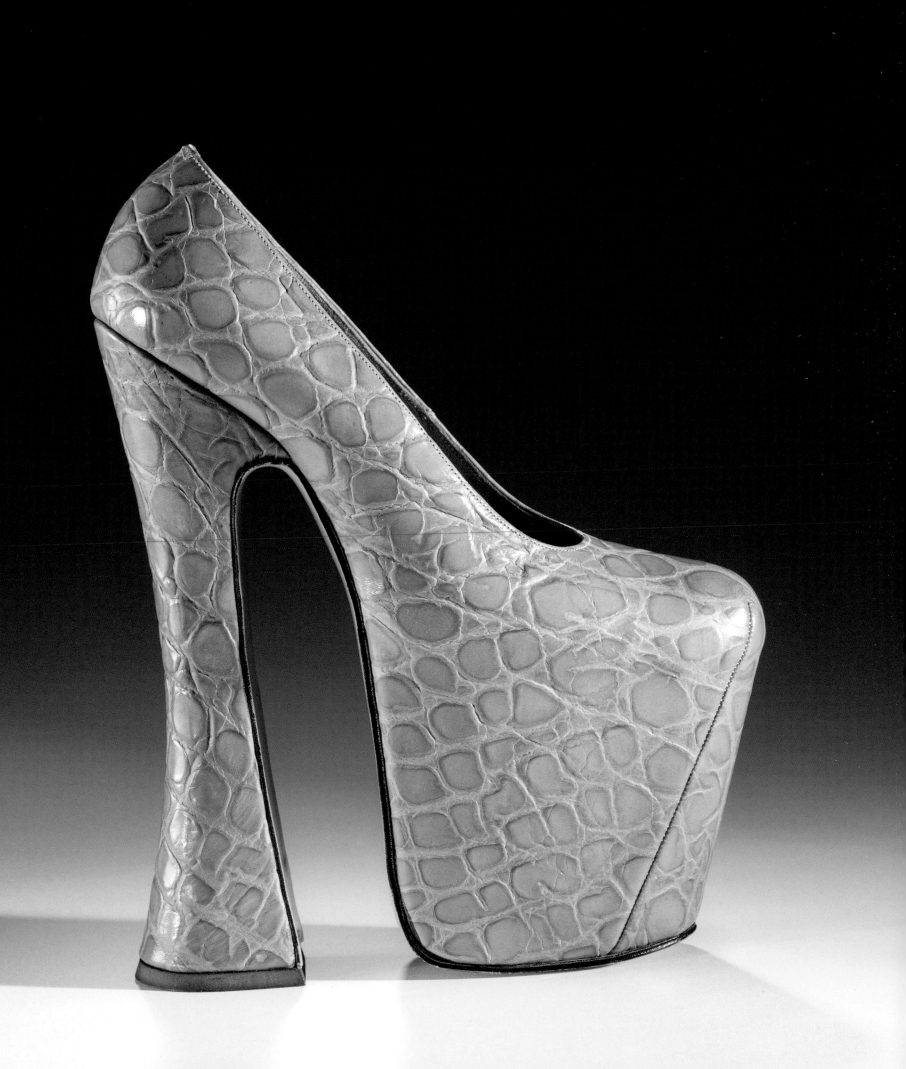

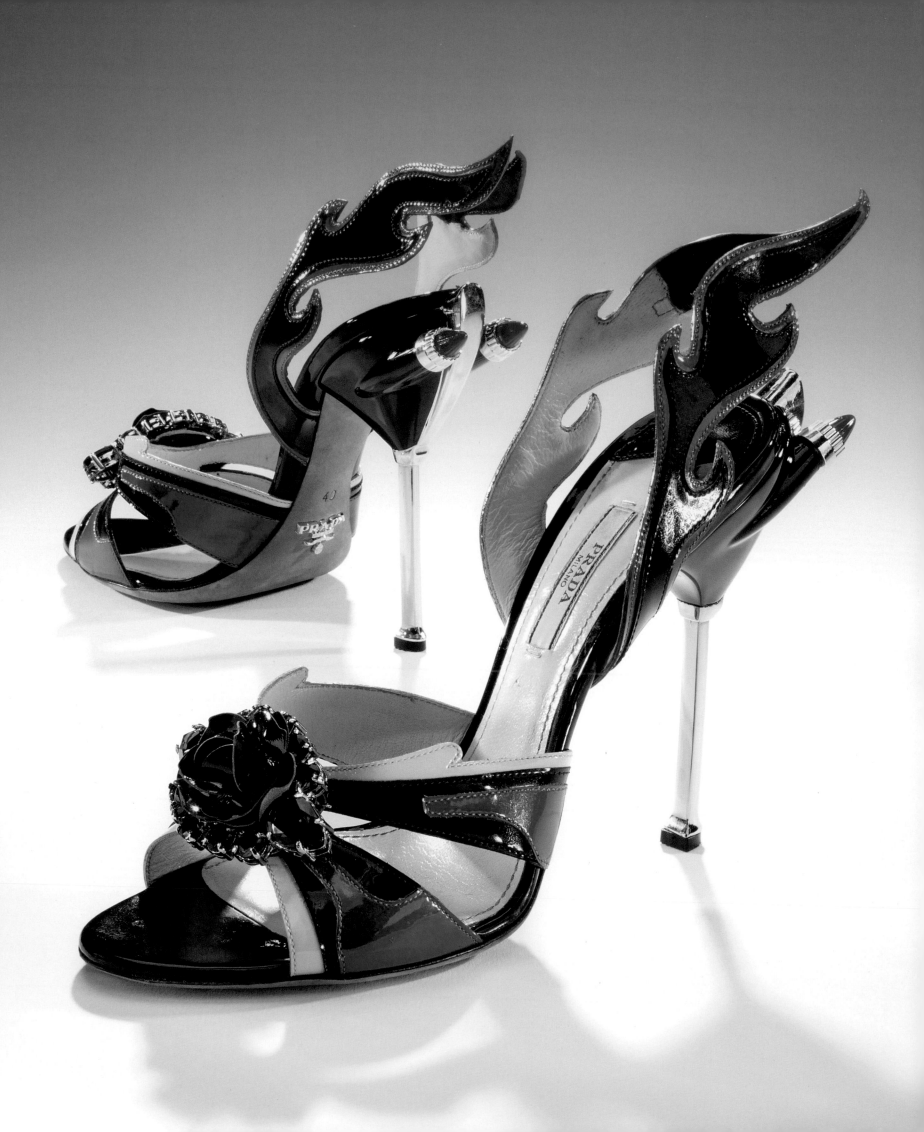

Designer Miuccia Prada, founder of Prada, turned to 1950s classic car design as inspiration for her Spring/Summer 2012 shoe collection. The tailfins and taillights were translated into patent leather uppers and shiny chrome heels, and the resulting design became so popular that Prada has rereleased it a number of times. This slick sandal was part of the original collection and was gifted to the museum along with two other pairs in 2012.

ITALIAN · DESIGNED BY PRADA ·
2012 · GIFT OF PRADA

This pair of Nêhiyawak (Plains Cree) moccasins was collected by Gradin Heath in Saskatchewan in the 1930s but is believed to have been made in the late nineteenth century. The moccasins are intricately beaded using a transmontane stitch. Exceptionally tight beadwork and lively color are hallmarks of Nêhiyawak women's artistry. This pair is particularly delightful due to its ample use of luminous clear green beads that allow an engaging play of light across the uppers.

NÊHIYAWAK · c. 1890

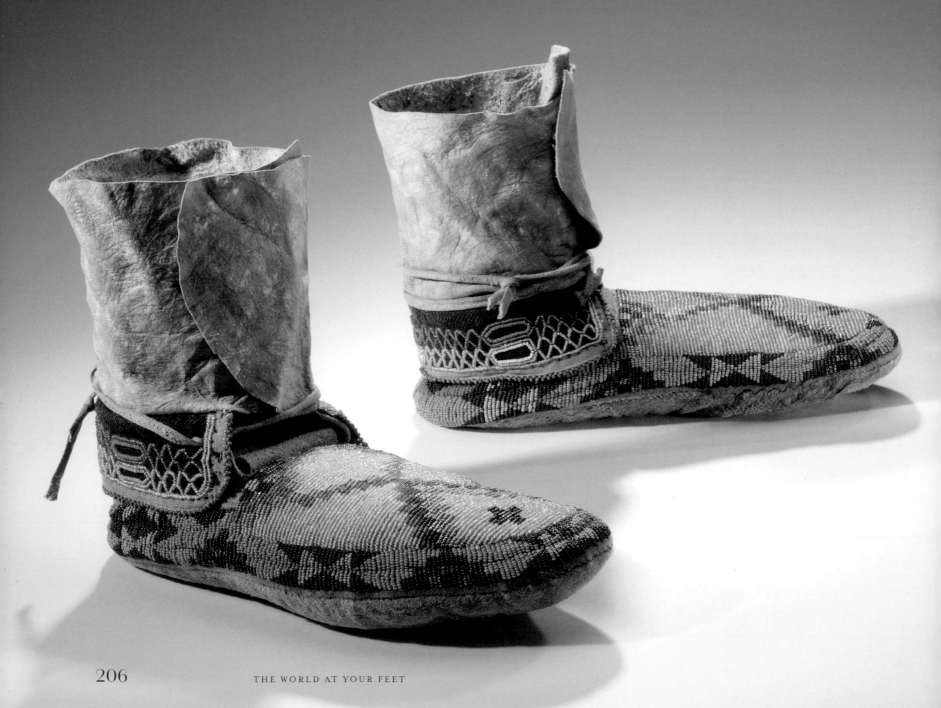

THE WORLD AT YOUR FEET

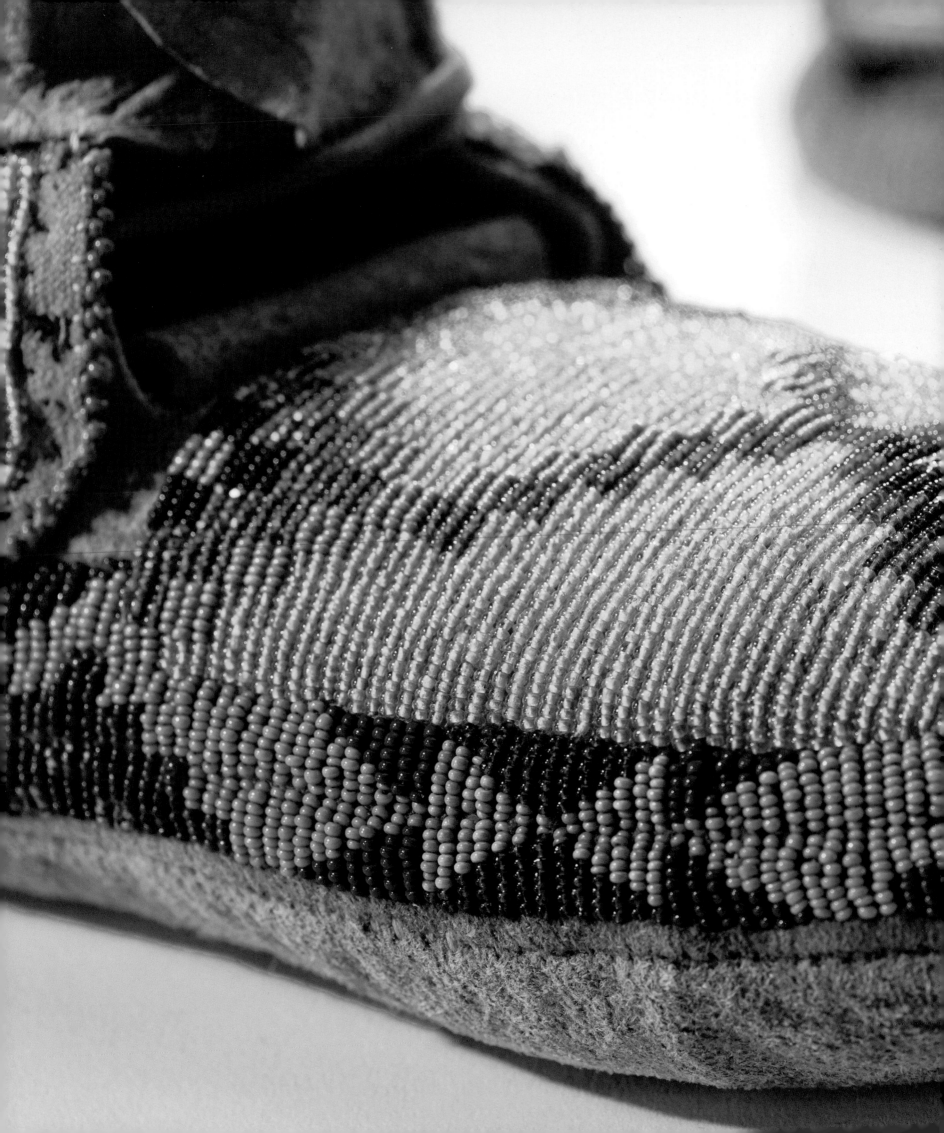

The bold floral brocade used to make these eighteenth-century shoes appears strikingly modern. In the middle of the eighteenth century, Western fashion was enthralled with "exotic" textiles that referenced sophisticated Chinese materials. Given the high cost of fine brocades, the shoemaker who created this pair probably made the shoes from remnants left over from the construction of a gown. The use of repurposed textile fragments was often challenging for shoemakers, as the pieces available for the pair did not always include identical parts of the repeated pattern. The shoemaker of this pair, however, was furnished with enough cloth to make a matching pair. Sonja Bata's husband, Thomas Bata, donated this pair to the museum in honor of her eightieth birthday in 2006.

POSSIBLY COLONIAL AMERICAN · c. 1750–70

THE WORLD AT YOUR FEET

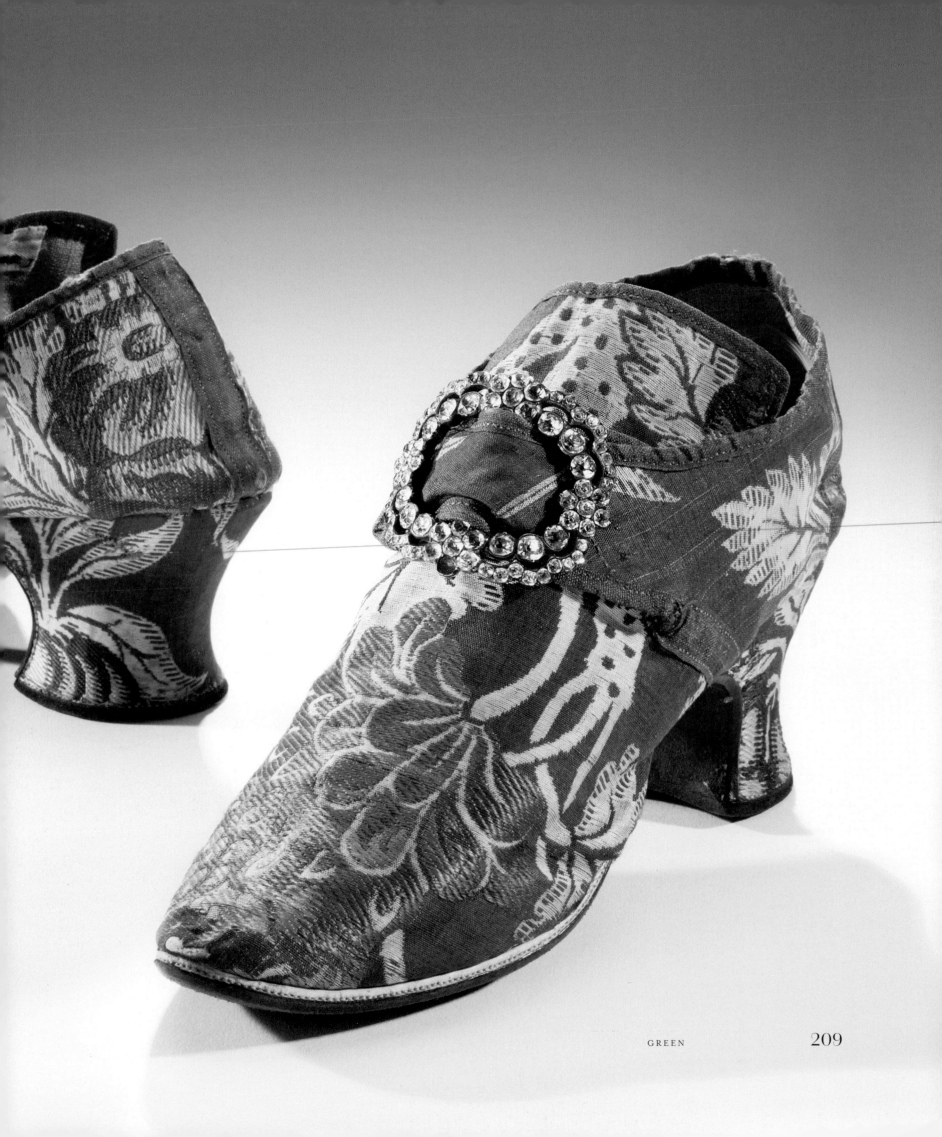

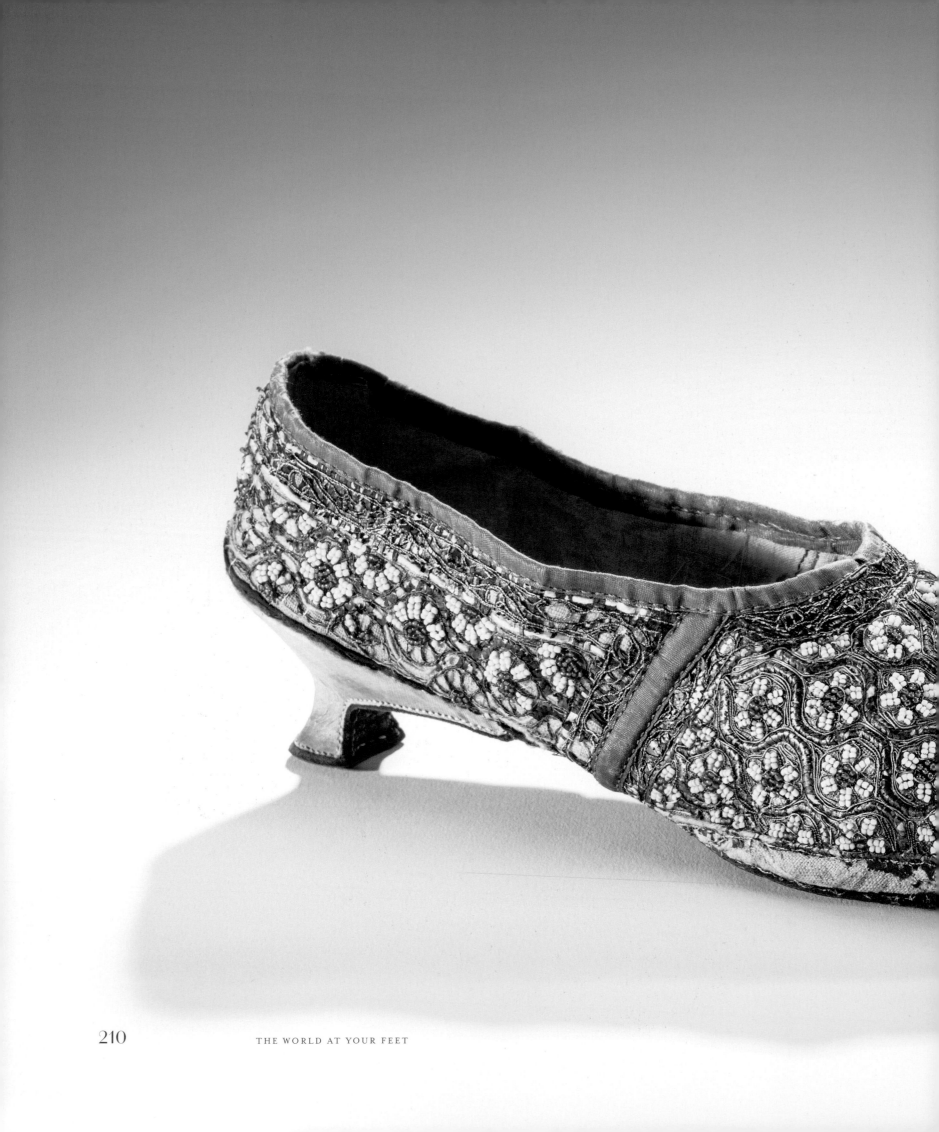

THE WORLD AT YOUR FEET

As European imperialism began to encircle the globe, interest in so-called exoticism became a defining feature of eighteenth-century European fashion, including footwear. Some fashionable shoes betrayed this interest structurally—extravagantly pointed toes suggested Han Chinese footwear, while exaggeratedly upturned toes played on European fantasies of Western Asian dress. Likewise, the decorative textiles used to make shoes evoked distant lands, with motifs ranging from the bold florals of "bizarre silks" to more delicately embroidered paisleys that embellished the toes of women's shoes later in the century. An outstanding example of the complexities of emerging colonial desire is found in this woman's shoe. They began as a pair of Indian women's *jutti* but were then deconstructed and remade as a pair of British women's shoes in the 1790s.

INDIAN · 18TH CENTURY

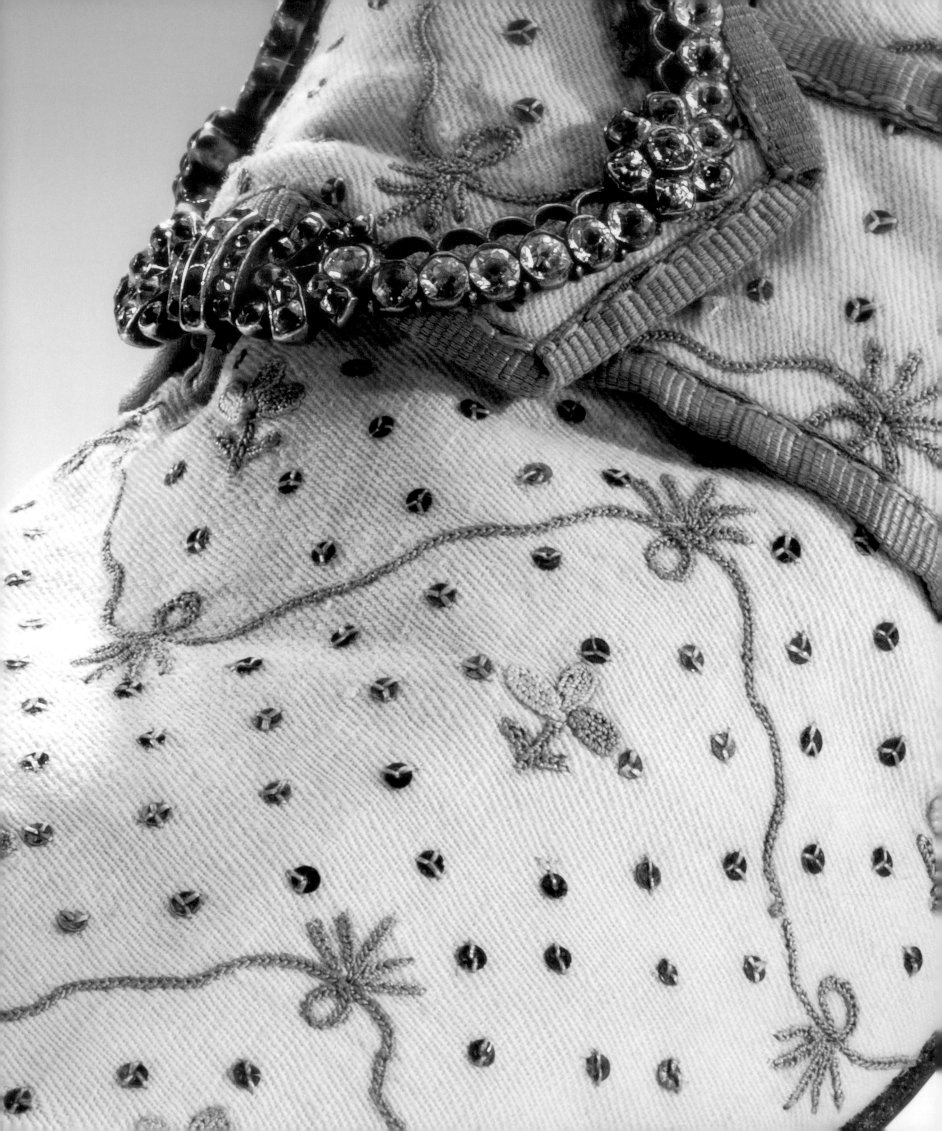

white

By the turn of the nineteenth century, heels had fallen out of favor in Western women's dress and flat, thin-soled shoes became fashionable. This new style of footwear reflected society's embrace of French philosopher Jean-Jacques Rousseau's ideas of motherhood, modesty, and female domesticity and the rejection of the extravagant opulence of aristocratic women in the previous century. This pair of demure shoes was probably made in Cuba and shows how far-reaching these continental ideals were.

PROBABLY CUBAN · 1830s

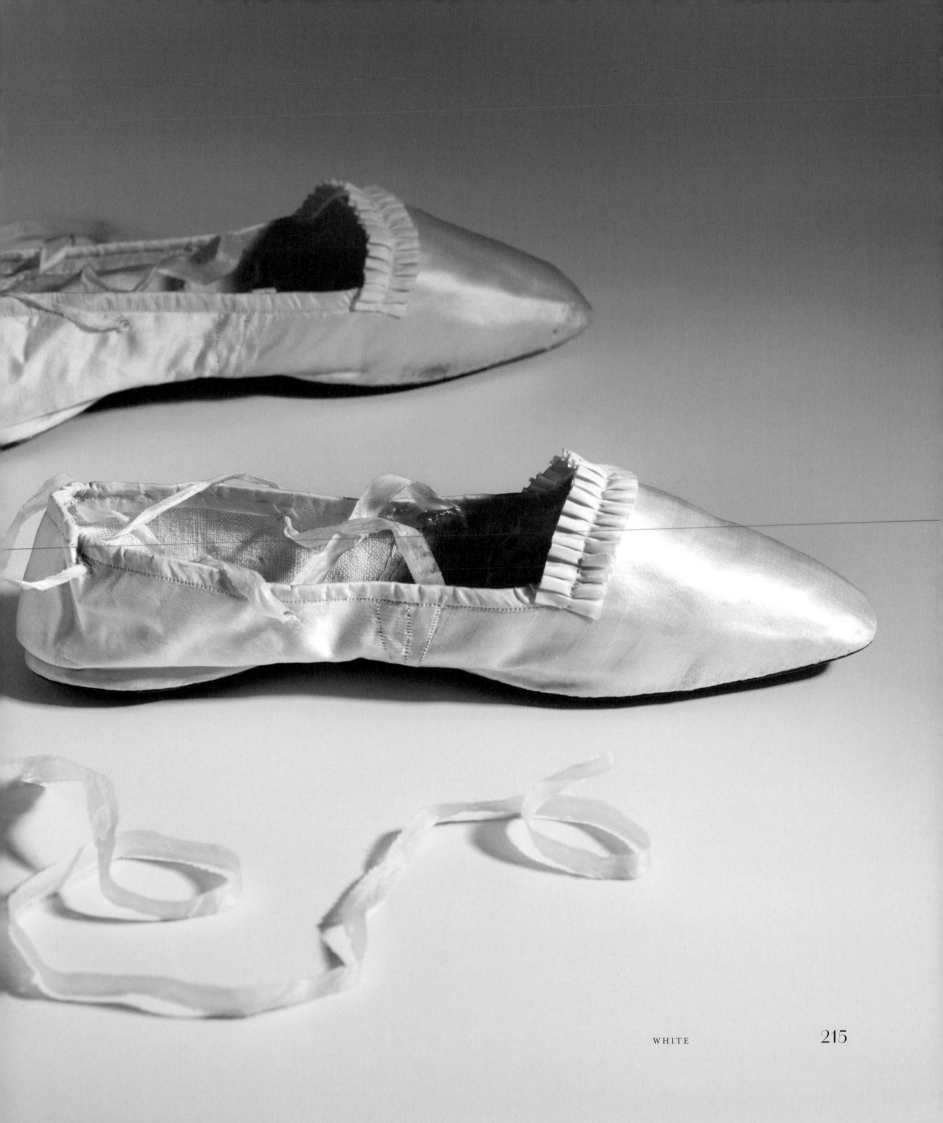

ur inlay is a technique used by Inuit seamstresses to create highly intricate designs on their clothing and footwear. Historic patterns tend to be geometric, while more contemporary designs are highly curvilinear. A particular challenge when creating this type of decoration is matching the nap of the different furs so that all the hairs lie in the same direction. Leah Okadluk, an Iglulingmiut Inuit seamstress, made these sealskin kamiks decorated with inlaid designs of polar bears for a 1987 competition held by the Bata Shoe Museum Foundation. Her prize winning boots became treasures of the collection.

**IGLULINGMIUT INUIT · CREATED BY
LEAH OKADLUK · 1987**

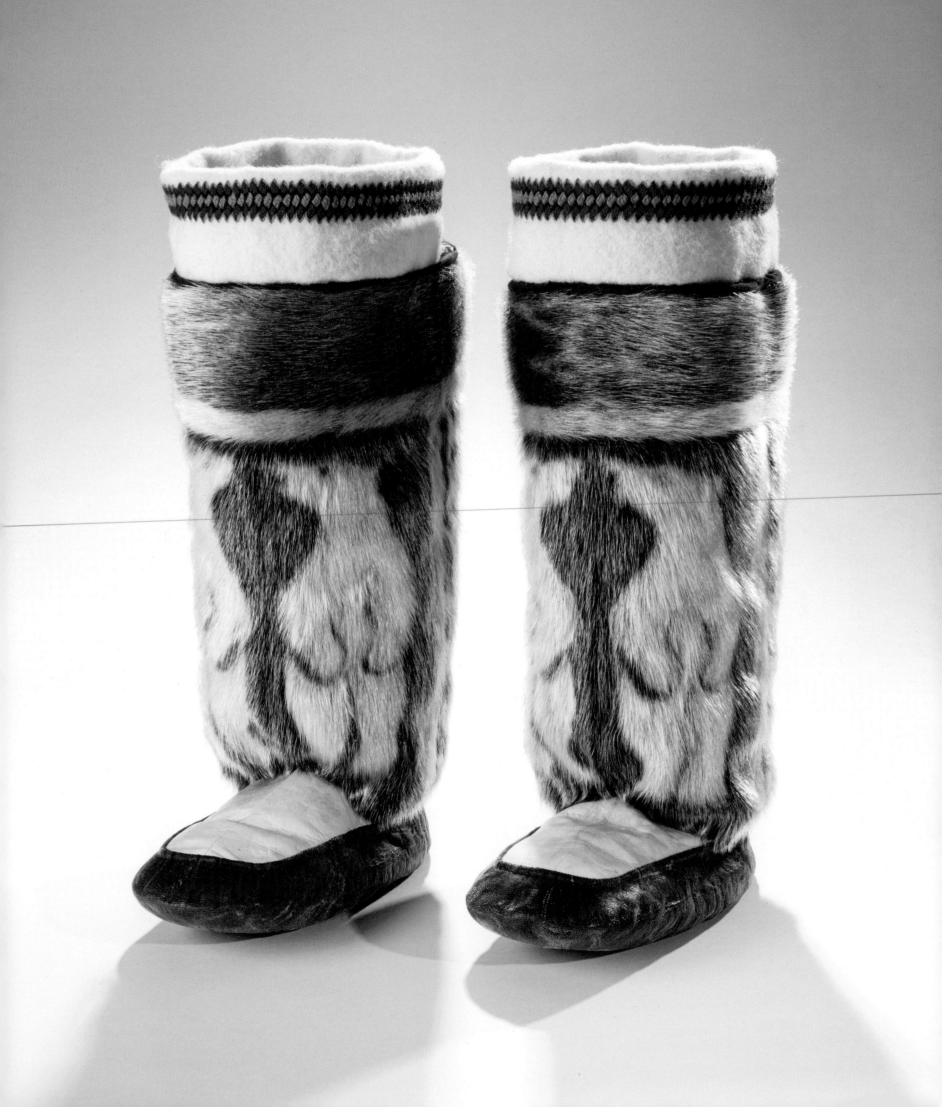

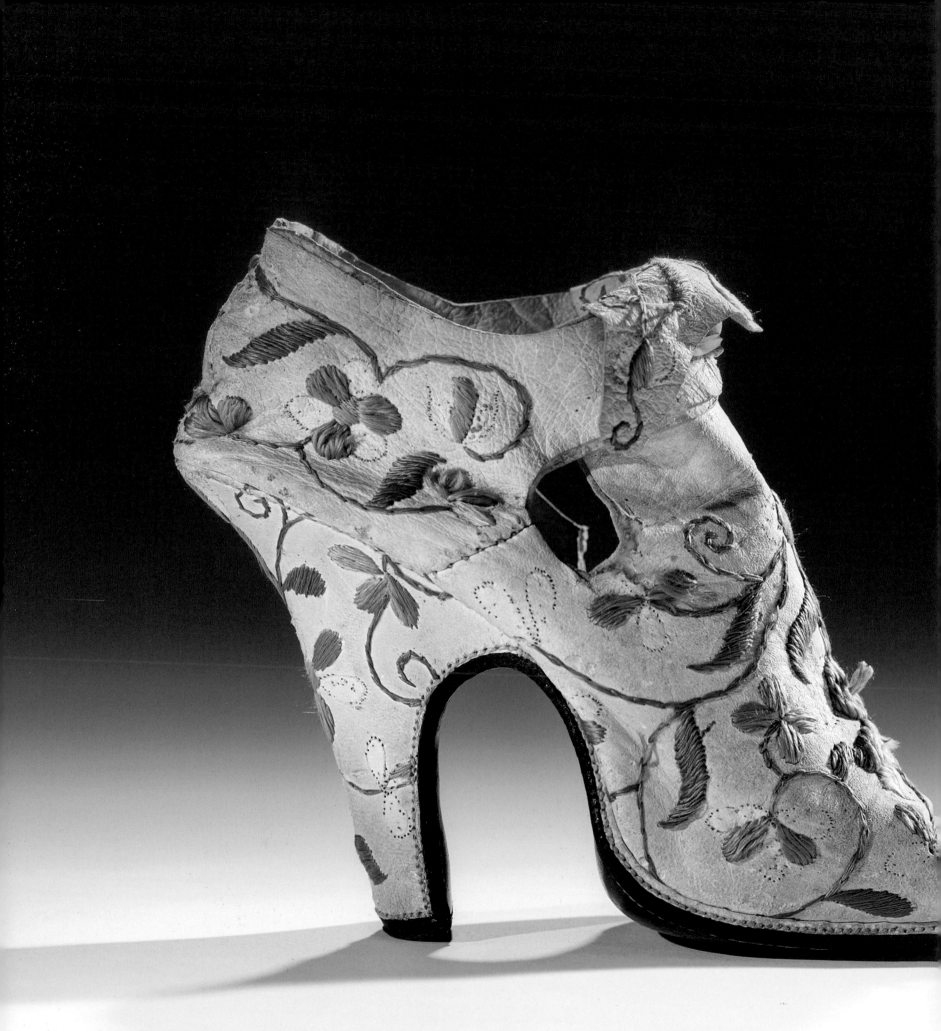

THE WORLD AT YOUR FEET

Heels in European women's footwear soared at the end of the seventeenth century in reaction to shifting beauty ideals, which promoted the concept that dainty feet were the most feminine. The classic story *Cinderella*, written by French author Charles Perrault in 1697, reflected this new ideal. When small dainty feet began to be seen as desirable, high heels were pressed into service as a means of achieving the look of small feet by hiding most of a woman's foot up under the hem of her skirt, leaving only the tips of the toes visible. The placement of the heel also helped the ruse. When the heel was positioned under the instep rather than at the back of the foot, the footprint appeared artificially small. This shoe of embroidered white kid demonstrates all these features and would have enabled the wearer to achieve the look of a fashionably diminutive foot.

ITALIAN · 1690s

In the twelfth century, a small Italian coin called a *zecchino* was pierced and used decoratively on clothing to signify abundance and wealth. This type of embellishment came to be called a sequin, and by the seventeenth century sequins had morphed into small metal disks that were frequently sewn onto footwear and clothing to add a shimmering opulence. The exceptionally small sequins on this pair of fine white eighteenth-century high heels are almost imperceptible, but they add just the right amount of glimmer in keeping with the delicacy of Rococo aesthetics.

FRENCH · 1770–80

THE WORLD AT YOUR FEET

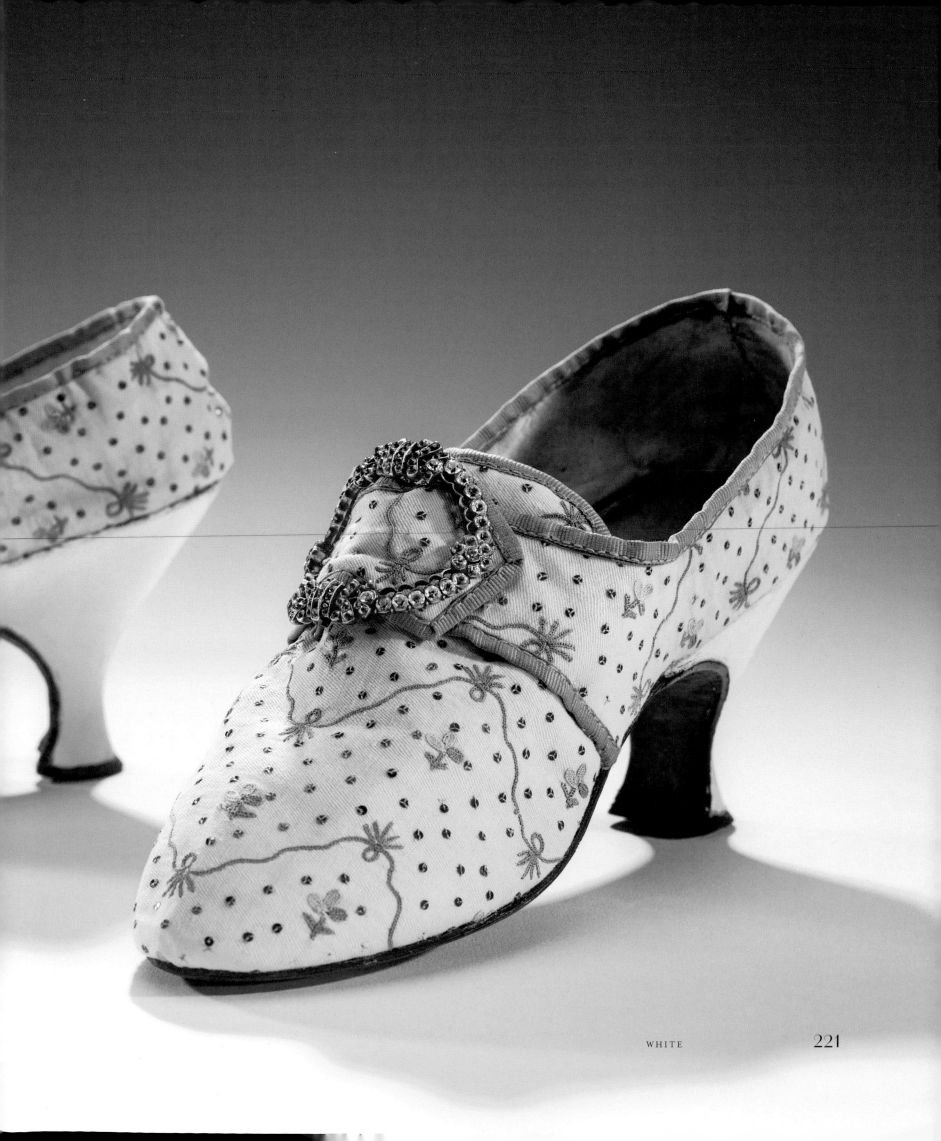

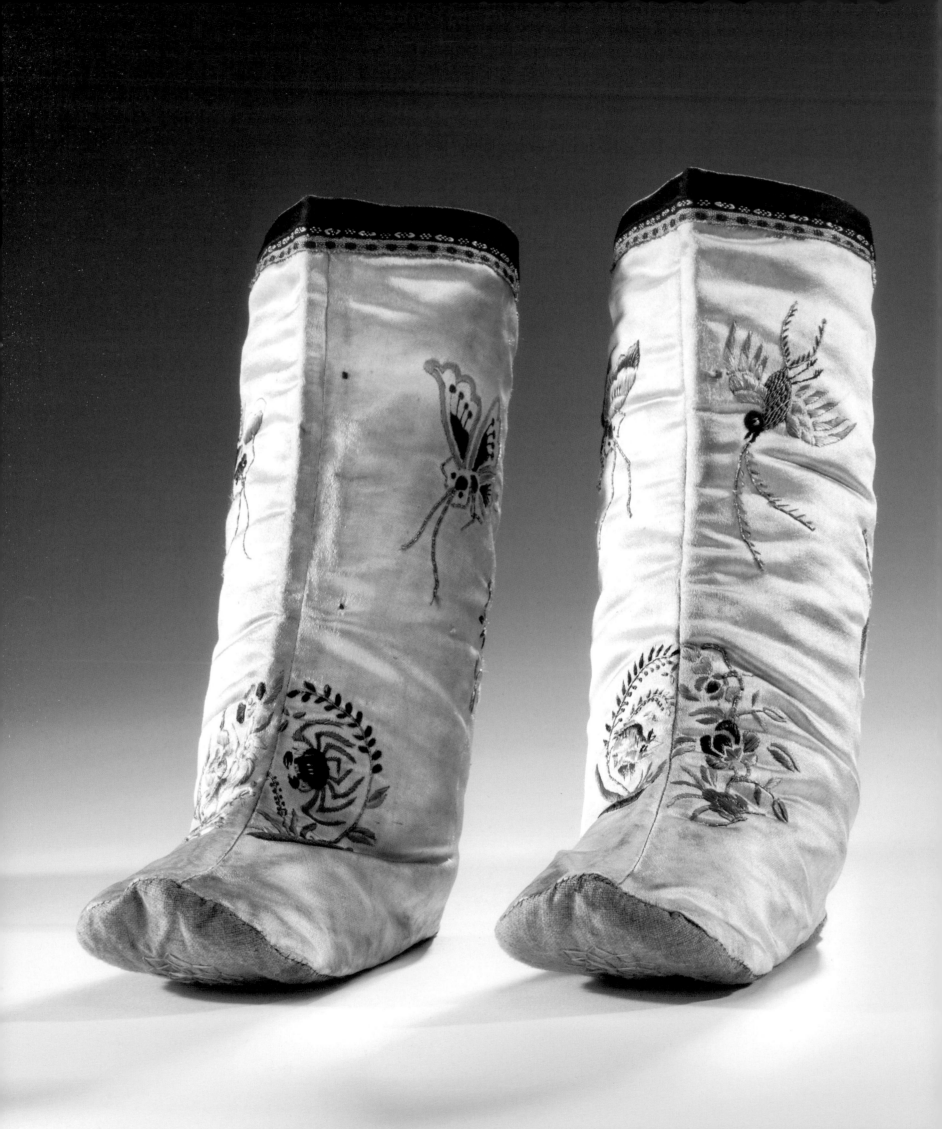

For thousands of years, people around the world have separated themselves from their shoes with socks. Socks are worn to provide warmth, keep feet dry, and provide a comfortable barrier between the foot and often stiff footwear. Socks have also long been culturally important elements of dress, and many examples from around the world are elaborately decorated. These lightweight silk socks from China were made for a child and were embroidered with a variety of creatures, from butterflies to birds, as well as beautiful flowers and foliage. The pink soles also feature decorative embroidery. They were probably worn in summer.

CHINESE · LATE 19TH CENTURY

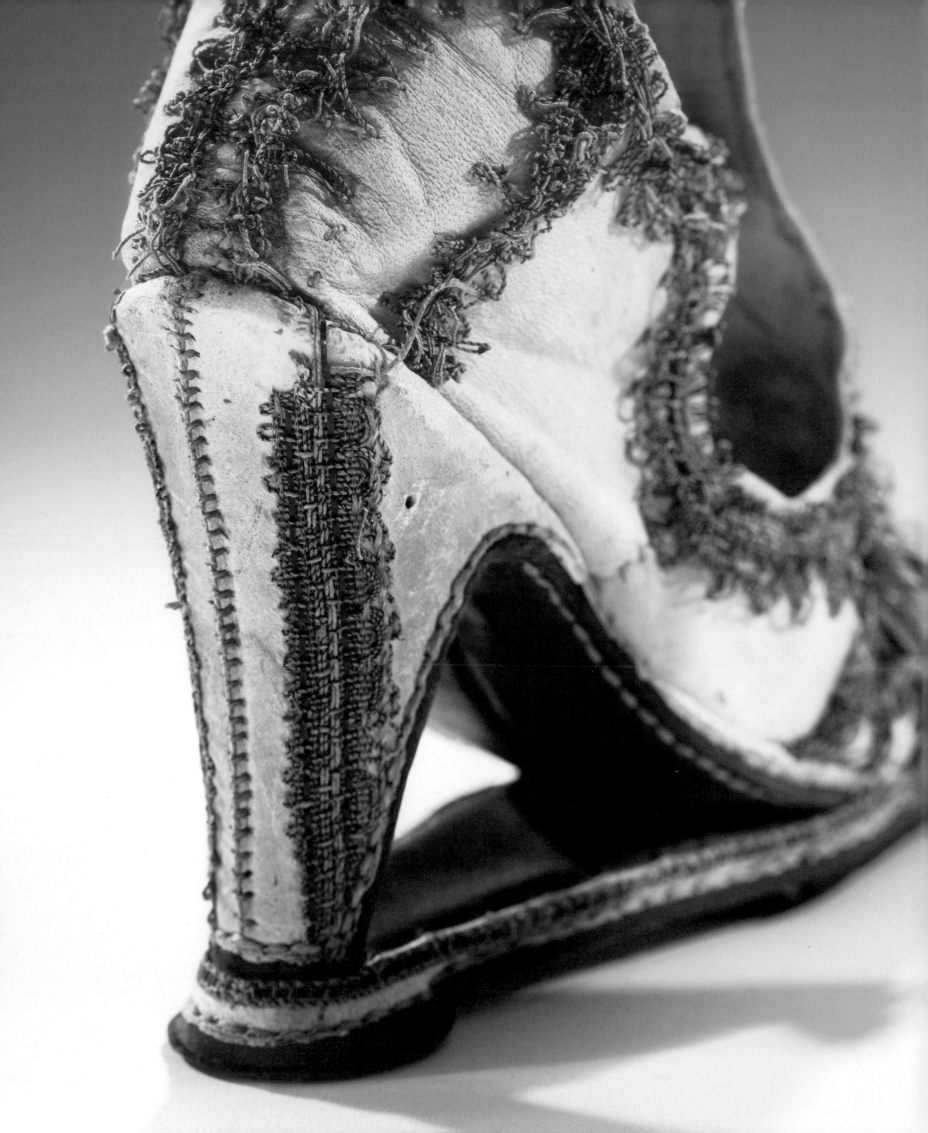

This exceptionally rare slap-soled shoe dates to the 1660s. Slap-soles originated in the early seventeenth century, when men began to wear heeled footwear that was slipped into flat-soled mules to prevent the heels from sinking into the mud when they were walking out-of-doors. When women adopted the fashion in the 1620s, shoemakers united the two forms of footwear by nailing the heel of the shoe to the sole of the mule so that the characteristic slapping noise made when walking would be muffled. Many shoemakers even added felted wool to the soles of the mules to further dampen any sound they might make when worn indoors. At the end of the fashion for slap-soles, the mule was no longer a separate component of the shoe; instead it was reduced to a vestigial form with a decorative braid outlining where the mule would have met the upper of the shoe.

PROBABLY ITALIAN · 1660s

This eighteenth-century Indian *paduka,* or toe-knob sandal, is lavishly embellished with ivory inlay. The dense meandering floral motif, as well as the careful piecing of the ivory veneer, is characteristic of expensive eighteenth-century Travancore workmanship. The *paduka* is one of the oldest forms of Indian footwear, and its design reflects the Hindu, Jain, and Buddhist concept of ahimsa, or noninjury, since it raises the foot off the ground, thereby minimizing the wearer's risk of harming any living creature, no matter how small. The use of ivory might seem to contradict the doctrine of ahimsa, but it was said that ivory was only harvested from live elephants or from those that had died of natural causes.

INDIAN · 1775–1825

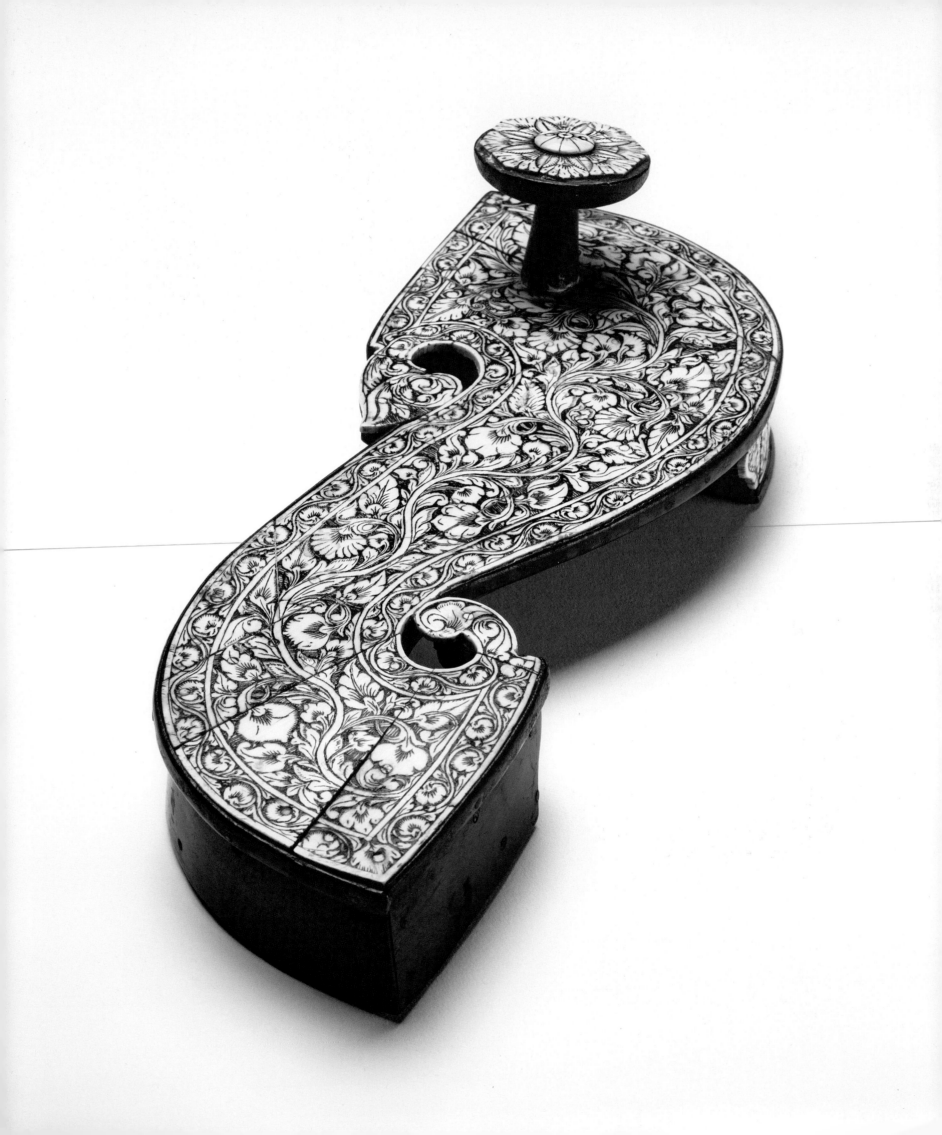

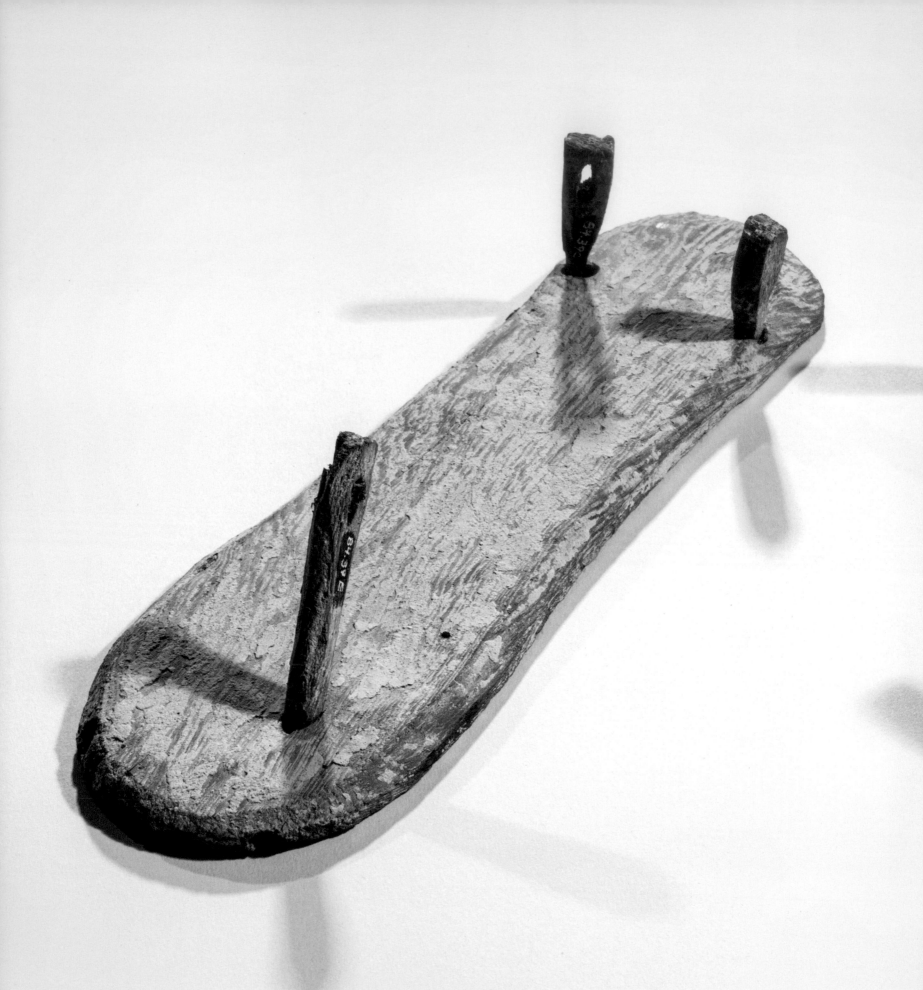

THE WORLD AT YOUR FEET

This pair of ancient Egyptian sandals was made specifically for funerary purposes. Ancient Egyptians believed the dead should be provisioned, in their tombs and graves, with everything they might require in the next life. Footwear worn in life was commonly included among the grave goods; other tombs contained footwear made expressly for the afterlife, including this pair of white wooden sandals. Sandals like these were popular in tombs in the Old and Middle Kingdoms. This example is thought to date to the Middle Kingdom, making it the oldest artifact in the Bata Shoe Museum collection.

EGYPTIAN · 2565–2278 BCE

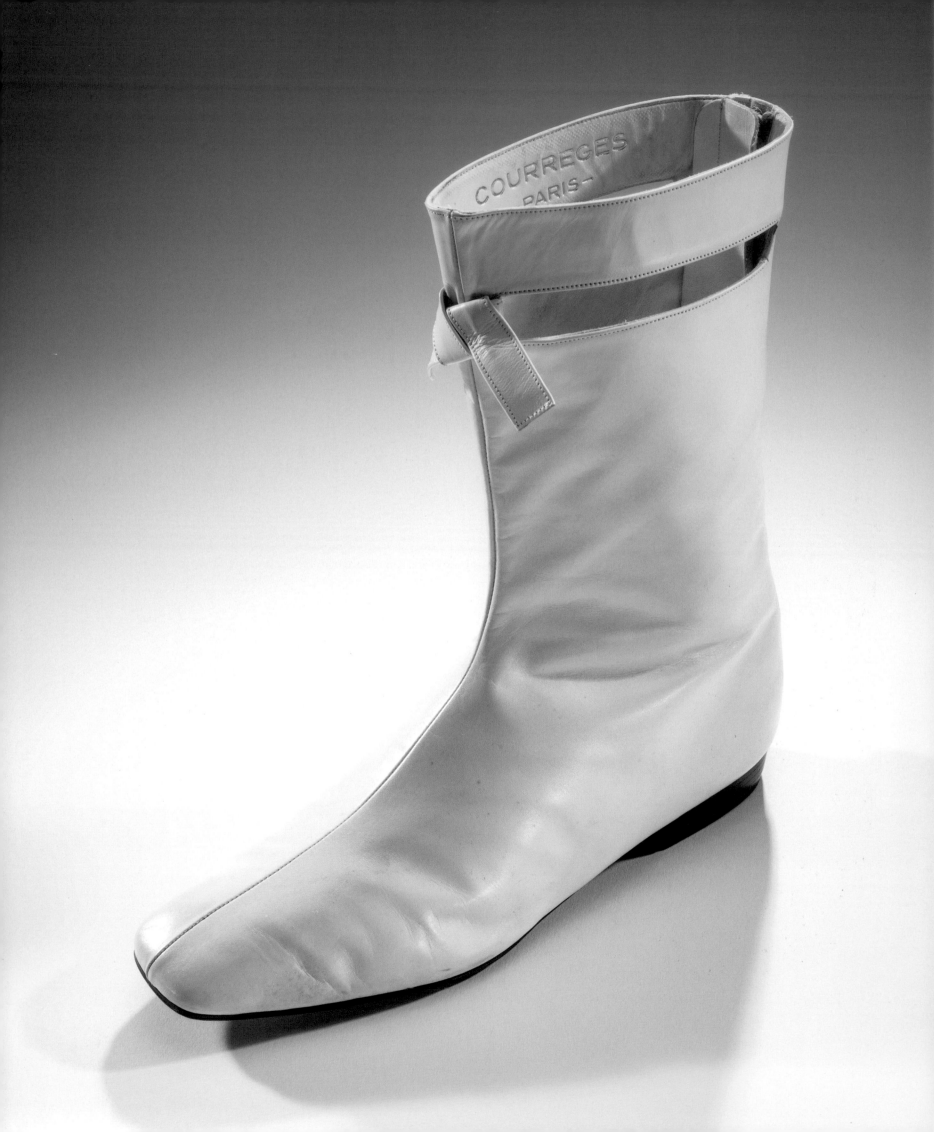

French designer André Courrèges was famous in the early 1960s for his futuristic fashions, which pushed the envelope of design. *Vogue* magazine described the "Courrèges woman" as being as "modern as the year after next ... she lives in the present and a little beyond it." One of the most famous Courrèges creations was a pair of minimalist white leather go-go boots from 1964. Paired with miniskirts, the boots defined the youthquake fashion of the decade and were widely imitated. This rare Courrèges boot in the collection of the Bata Shoe Museum still retains its original box.

FRENCH · DESIGNED BY
ANDRÉ COURRÈGES · 1964

In 2016 Nike asked fourteen of its female designers to reimagine two of Nike's most iconic sneakers, the Air Force I and the Air Jordan I. The timing for the Nike I Reimagined project was tight. The designers were only given two weeks, so they split into two groups, one focused on the Air Force I and the other on the Air Jordan I. The results were thoughtful, and of the final ten designs created, many were groundbreaking, including the Air Force I Rebel XX, which transformed the Air Force I silhouette by moving the lacing to the back of the shoe to create a corseting effect. The Uptown all-white colorway, however, remained untouched. The Air Force I was first released by Nike in 1982, but it was the 1986 version that became a classic.

AMERICAN · DESIGNED BY NIKE REIMAGINED TEAM
FOR NIKE · 2016 · GIFT OF NIKE

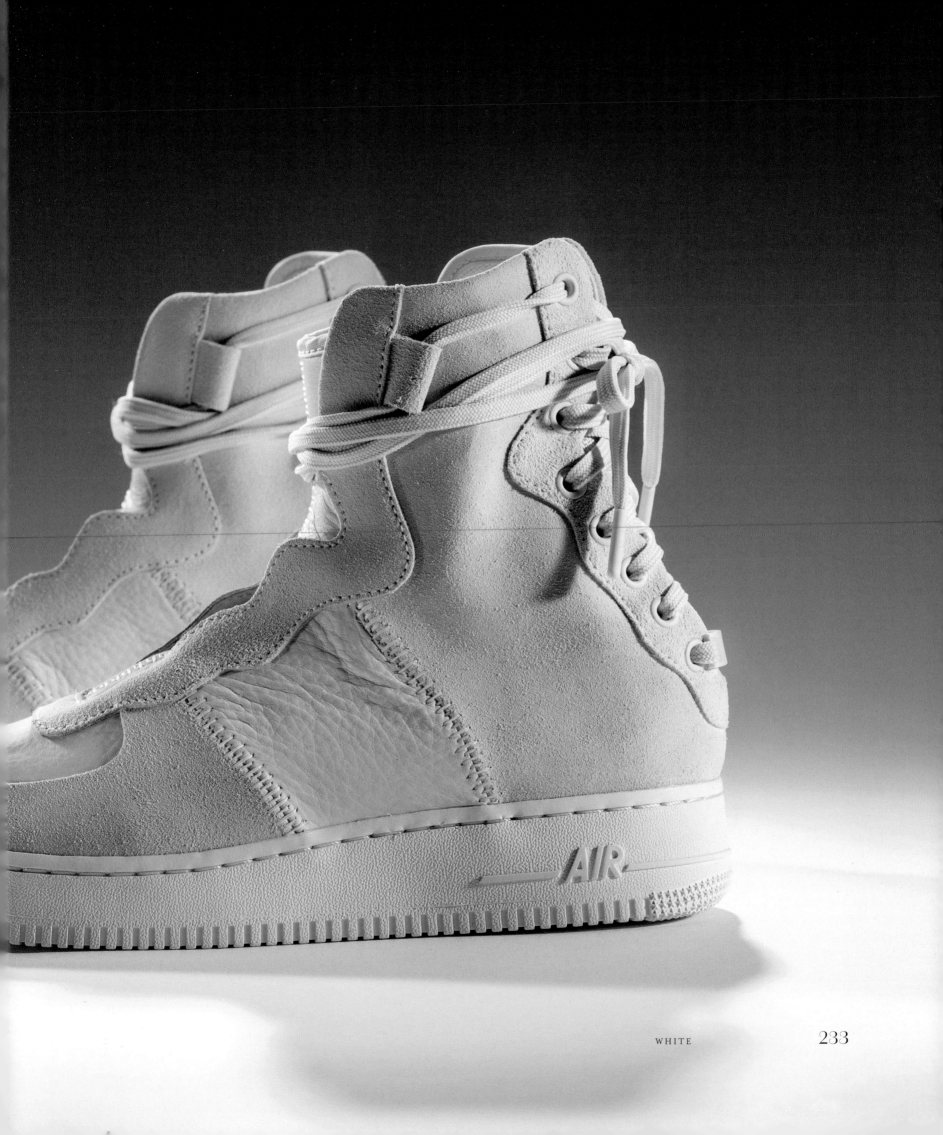

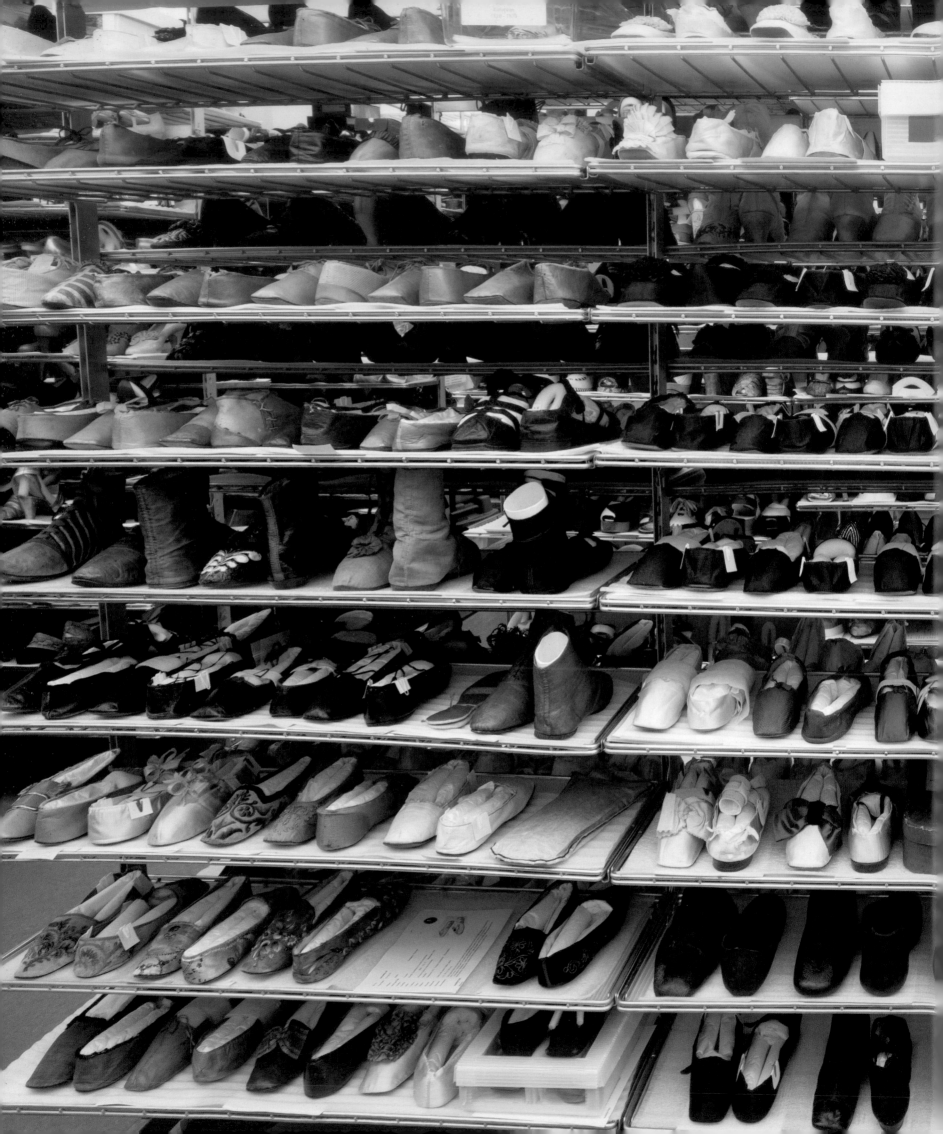

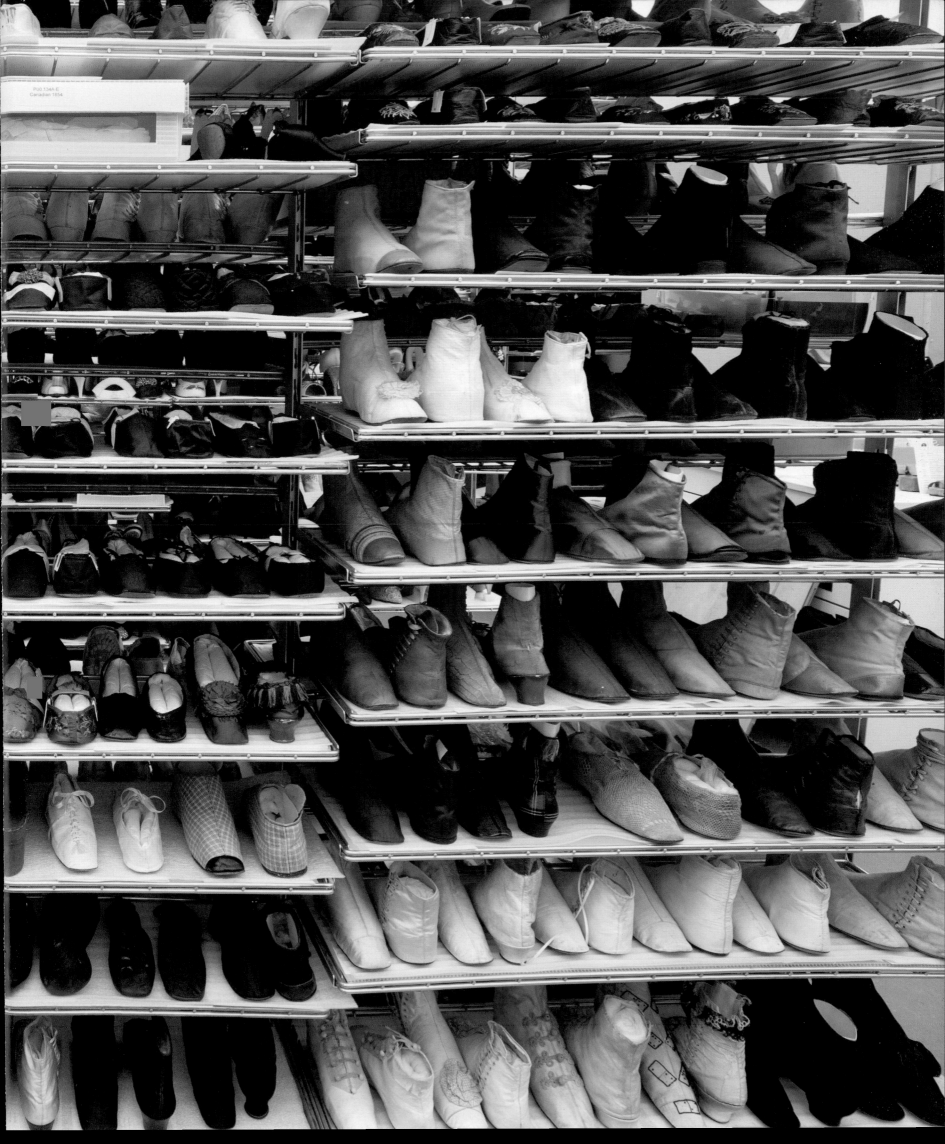

P60.134A-E
Canadian 1854

bibliography

SELECT BATA SHOE MUSEUM PUBLICATIONS

Jain-Neubauer, Jutta. *Feet & Footwear in Indian Culture*. Toronto/Ahmedabad: Bata Shoe Museum/Mapin Publishing, 2000.

Ko, Dorothy. *Every Step a Lotus: Shoes for Bound Feet*. Berkeley: University of California Press, 2001.

Oakes, Jill, and Rick Riewe. *Alaska Eskimo Footwear*. Fairbanks: University of Alaska Press, 2006.

-----. *Appeasing the Spirits: Alaskan Coastal Cultures*. Toronto: Bata Shoe Museum, 2004.

-----. *Footsteps on the Sacred Earth: Southwestern Collection of the Bata Shoe Museum*. Toronto: University of Toronto Press, 1999.

-----. *Our Boots: An Inuit Women's Art*. Vancouver: Douglas and McIntyre, 1995.

-----. *Spirit of Siberia: Traditional Native Life, Clothing, and Footwear*. Vancouver: Douglas and McIntyre, 1998.

Semmelhack, Elizabeth. *Fashion Victims: The Pleasures and Perils of Dress in the 19th Century*. Coauthored with Alison Matthews David. Toronto: Bata Shoe Museum, 2014.

-----. *Heights of Fashion: A History of the Elevated Shoe*. Pittsburgh: Periscope Publishing, 2008.

-----. *Icons of Elegance: The Most Influential Shoe Designers of the 20th Century*. Toronto: Bata Shoe Museum, 2005.

-----. *On a Pedestal: Renaissance Chopines to Baroque Heels*. Toronto: Bata Shoe Museum, 2009.

-----. *Out of the Box: The Rise of Sneaker Culture*. New York: Rizzoli, 2015.

-----. *Roger Vivier: Process to Perfection*. Toronto: Bata Shoe Museum, 2012.

-----. *Standing Tall: The Curious History of Men in Heels*. Toronto: Bata Shoe Museum, 2015.

Webber, Alika Podolinsky. *North American Indian and Eskimo Footwear: A Typology and Glossary*. Toronto: University of Toronto Press, 1989.

ADDITIONAL SELECT PUBLICATIONS BY ELIZABETH SEMMELHACK

Collab: Sneakers x Culture. New York: Rizzoli, 2019.

Dior by Roger Vivier. New York: Rizzoli, 2018.

Shoes: The Meaning of Style. London: Reaktion Press, 2017.

"From Lawn Tennis to Eugenics: A History of Women and Sneakers." *Costume* 53 (March 2019): 92–109.

"Playing Nice: The Making of Out of the Box." In *Interpreting Sports History at Museums and Historic Sites*. Lanham, MD: Rowman and Littlefield, 2019.

"Withering Heights: High Heels and Hegemonic Masculinity." In *Crossing Gender Boundaries: Fashion to Create, Disrupt, and Transcend*, edited by Ben Barry and Andrew Wiley. Bristol, United Kingdom: Intellect Books, 2019.

"The Allure of Height." In *Shoes: Pleasure and Pain*, edited by Helen Persson. London: Victoria and Albert Museum, 2015.

"Reveal or Conceal: Chopines and the Display of Material Wealth in Early Modern Valencia and Venice." In *The Matter of Art: Materials, Practices, Cultural Logics, c. 1250–1750*, edited by Christy Anderson, Anne Dunlop, and Pamela Smith. Manchester: Manchester University Press, 2015.

"Above the Rest: Chopines as Trans-Mediterranean Fashion." *Journal of Spanish Cultural Studies* 14 (January 2014): 120–42.

"As Worn By." In *Roger Vivier*. New York: Rizzoli, 2013.

"A Delicate Balance: Women, Power, and High Heels." In *Shoes: A History from Sandals to Sneakers*, edited by Peter McNeil and Giorgio Riello. London: Berg Publishers, 2006.

PREVIOUS SPREAD *A glimpse into artifact storage at the Bata Shoe Museum, 2019.*

OPPOSITE *Detail of a moccasin by a member of the Wabanaki Confederacy, 1860–80 (pages 196–97).*

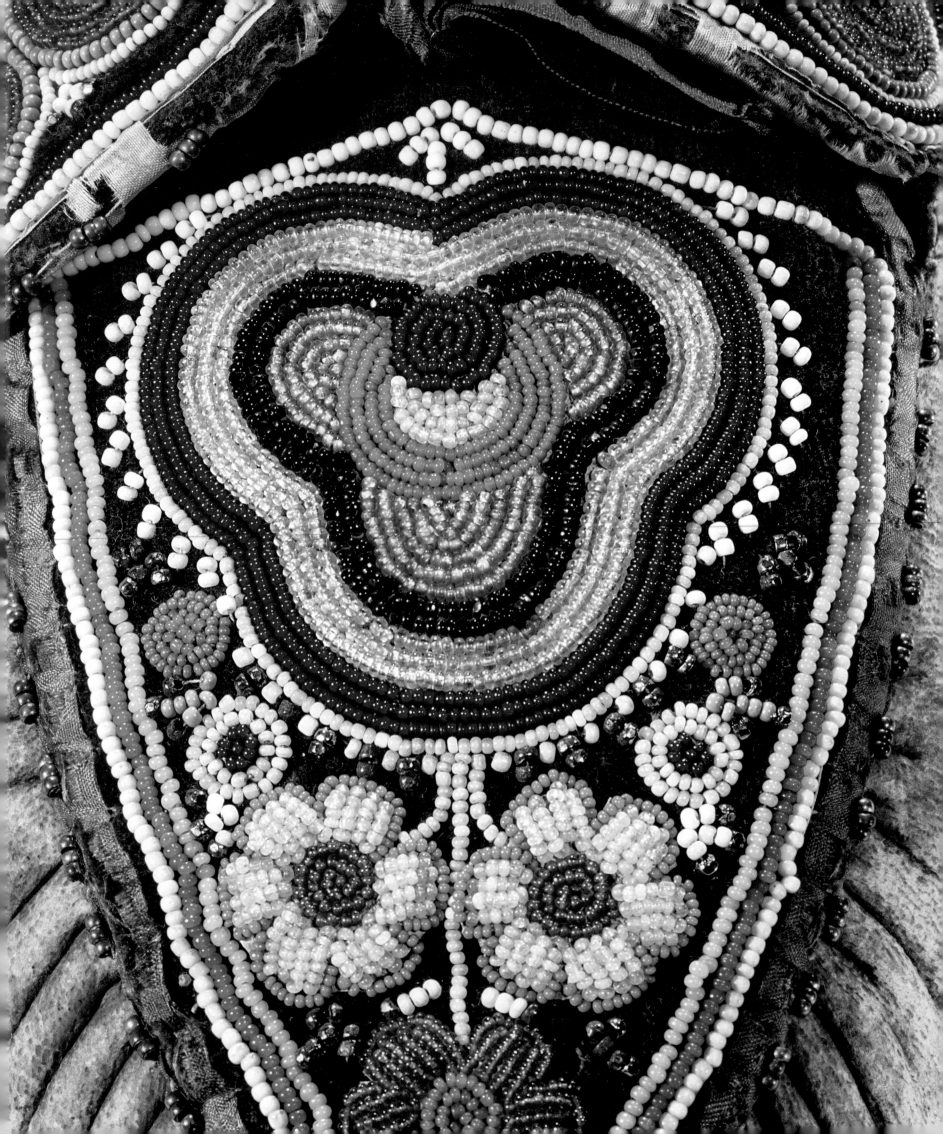

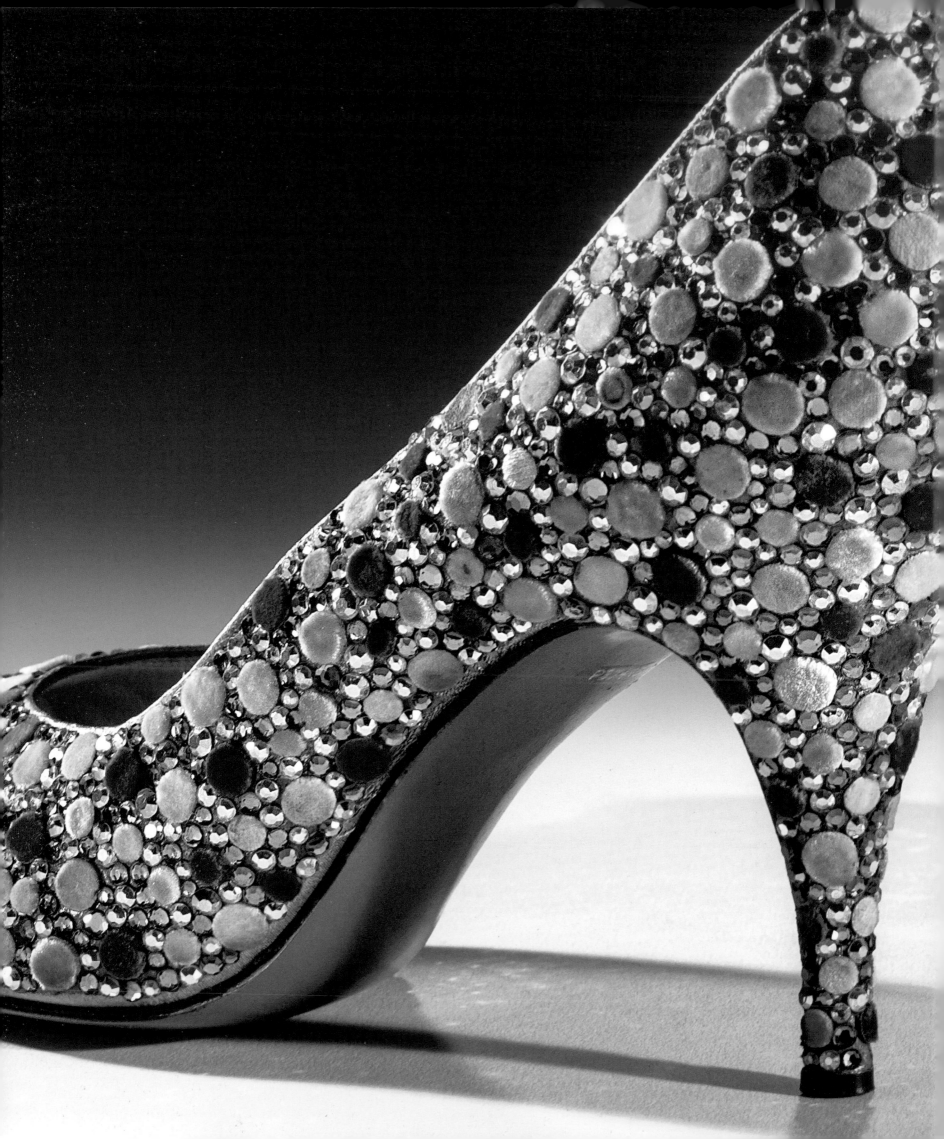

acknowledgments

This beautiful book was published in celebration of the Bata Shoe Museum's twenty-fifth anniversary. It owes its very existence to my mother, Sonja Bata, founder of the Bata Shoe Museum Foundation and the visionary behind its extraordinary collection. Her profound commitment to the history of footwear and design excellence continues to inspire.

Like the creation of the museum, this book could not have happened without the support and hard work of numerous people, each of whom deserves sincere thanks. Firstly, I would like to express my deep gratitude to Elizabeth Semmelhack, creative director and senior curator of the Bata Shoe Museum. Elizabeth's breadth of knowledge and compelling insights are evident on every page. This special publication reflects her passion for the collection. We are most grateful to Ron Wood for his spectacular photography, which captures the essence of each artifact. Tremendous thanks to our conservator, Ada Hopkins; collections manager, Suzanne Petersen; and assistant curator and manager of exhibitions, Nishi Bassi, for their tireless work on this project and their dedication to the museum. I also want to thank Annie Wood and Alex Lo for their assistance. Great thanks is also extended to Charles Miers, publisher of Rizzoli International Publications, for championing this project; to Andrea Danese for her wonderful editing; and to Sarah Gifford, whose beautiful book design has made this a volume to treasure.

I would also like to acknowledge the board of the Bata Shoe Museum Foundation for their enthusiasm and support.

To further honor its founder, the museum has chosen to use the Sonja Bata Memorial Fund to fund the creation of this book. We know that Sonja Bata would be deeply touched by each donation.

CHRISTINE BATA SCHMIDT

OPPOSITE *Evening shoe designed by Delman, 1960–63 (pages 180–81).*

First published in the United States of America in 2020 by
Rizzoli Electa, A Division of
300 Park Avenue South
New York, NY 10010
www.rizzoliusa.com

Images and text copyright © 2020 Bata Shoe Museum, Toronto
Foreword: Christine Bata Schmidt
Text: Elizabeth Semmelhack
Photographs: Ron Wood

Publisher: Charles Miers
Associate Publisher: Margaret Rennolds Chace
Editor: Andrea Danese
Design: Sarah Gifford
Production Manager: Barbara Sadick
Managing Editor: Lynn Scrabis

Printed in Hong Kong

2020 2021 2022 2023 / 10 9 8 7 6 5 4 3 2 1

ISBN: 978-0-8478-6785-1
Library of Congress Control Number: 2019957681

Visit us online:
Facebook.com/RizzoliNewYork
Twitter: @Rizzoli_Books
Instagram.com/RizzoliBooks
Pinterest.com/RizzoliBooks
Youtube.com/user/RizzoliNY
Issuu.com/Rizzoli